Gawan 基宏

Presents 呈獻

百變 梅 艷芳
Anita Mui

The Legend Of The Pop Queen
~ Part I

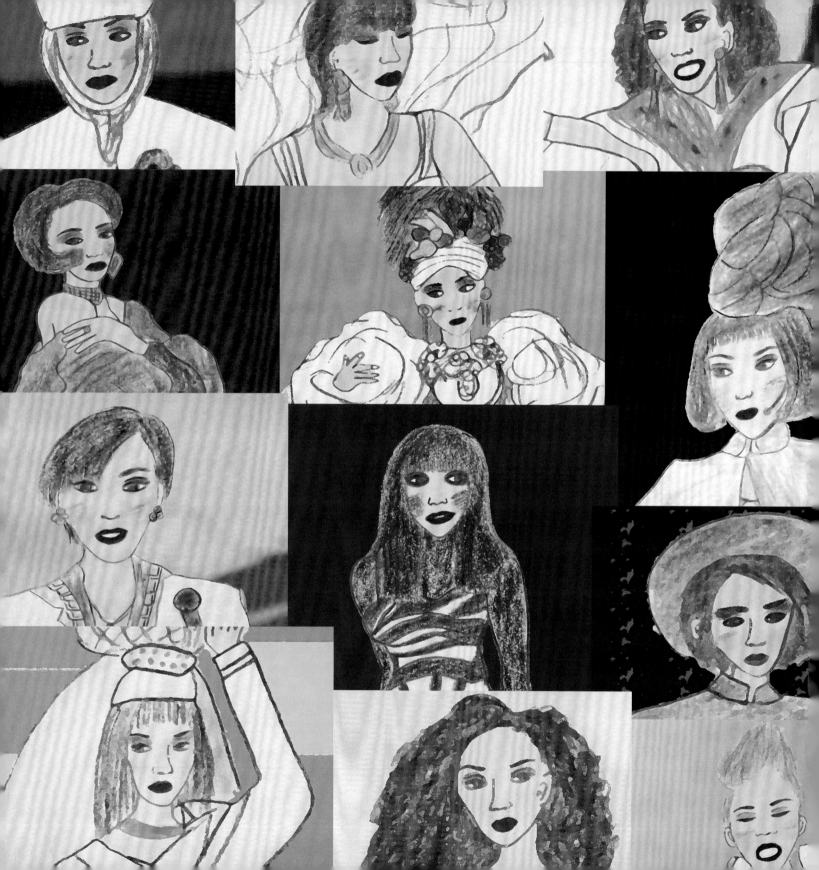

關於梅艷芳

梅艷芳（Anita Mui）在五歲的時候，已經有一個不平凡及不快樂的童年，並在媽媽所創辦的錦霞歌舞團開始了她的演唱藝術生涯，努力地尋獲自信。到她 18 歲的時候，參加了 1982 年第一屆香港新秀歌唱比賽，並以幾乎接近滿分的姿態，獻唱一首由殿堂級女歌手徐小鳳原唱的歌曲 –《風的季節》因而奪得冠軍，隨即踏上巨星的路途。1983 年 Anita 代表香港參加第十二屆東京音樂節，並同時奪得亞洲特別獎和 TBS 獎，及推出兩張日文單曲，因而得到不少日本人認識。1988 年 Anita 代表香港參於首爾奧運揭幕演唱會及接受當地報章訪問因而得到不少韓國人認識，並於 1990 年獲頒韓國十大最受歡迎外國女歌手 – 第五名大獎。

從 1984 年的一首歌曲 – 「夢幻的擁抱」後，Anita 一直以百變形象示人，並迅即登上八十年代中後期天之嬌女的位置。當時的香港樂壇是極男性主導，但 Anita 是唯一的女歌手均能與兩大當年最頂級的男歌手譚詠麟及張國榮一起被封為天皇巨星、叱吒樂壇。歌曲「夢伴」中的中性女人、「壞女孩」中的反叛女青年、「妖女」中的阿拉伯女郎、「愛將」中的冷酷女軍官、「似火探戈」中的黑色寡婦、「烈焰紅唇」中的高貴怨婦、「淑女」中的時尚婚紗女郎以及「慾望野獸街」中的外國女人形象等等，配合多變的狂野舞蹈，令最時保守的各地華人驚嘆嘩然。

Anita 有生以來舉辦的八次大型演唱會均是眾人的期待與焦點。她那攝人的磁性歌喉及台風令她輝煌地橫跨八、九十及千禧初年代，並有「東方麥當娜」及「香港樂壇大姐大」之稱。她一直是香港無綫電視台所舉辦的「十大勁歌金曲頒獎禮」中的獎項 – 「最受歡迎女歌星」的五連冠得主。另外，Anita 憑「壞女孩」一碟奪得八白金（即四十萬張銷量），唱片總銷量超過一千萬張，以及也是連開三十場演唱會的各項紀錄保持者。2009 年 Anita 以全球個人演唱會總計 292 場獲「世界紀錄協會」評定為「全球華人個人演唱會最多女歌手」。此外，Anita 於其 35 歲已獲得香港樂壇最高榮譽「金針獎」及其 40 歲獲得中國金唱片獎（國家級音樂獎）的藝術成就榮譽。

關於梅艷芳

Anita 除了是一代樂壇傳奇歌后，也是一代影后。Anita 生前主演電影超過 40 部，2 次獲頒香港電影金像獎最佳女配角獎，並憑 1987 年的「胭脂扣」獲得「第八屆香港電影金像獎」、「第一屆台灣金龍獎」及「第廿三屆臺灣金馬獎」的影后獎座，其精湛多變的演技及專業態度獲行內人一致讚賞。另外，Anita 也是華人樂壇獲得最多電影主題曲獎項的女歌手紀錄保持者。

可惜，於 2001 年 Anita 已發現患上子宮頸良性腫瘤，但為了於 2002 年她入行 20 周年的一連串慶祝表演活動放棄治療，直至到 2003 年 4 月 1:99 音樂會後經身體檢查確定其子宮頸癌的病情已到了末期。為了在往生前給自己和歌迷留下一個完美的句號，她頂著重病以頑強的意志舉辦了最後一次共 8 場的大型演唱會 －【梅艷芳經典金曲演唱會】，隨後又遠赴日本京都拍攝廣告和演出，回港約一個月後在 2003 年 12 月 30 日清晨逝世，她的傳奇與名字從此流傳千古。

Anita 是一位難得的超級巨星，她是八、九十年代深刻影響香港人成長的女歌手。她的逝世，確實是全世界華人的巨大文化和藝術損失。她是少有的藝術家，無論是在音樂界、電影界，還是對人對事的態度，都有一套獨特的哲學。

此外，Anita 在香港文化研究方面也有一定的貢獻。百變的形象，前衛的新女性歌曲、在男權音樂壟斷下冒起的女權主義及其對華人女歌手的舞台演出及商品化的先鋒的影響等。

另外，Anita 的生活態度也反映着七、八及九十年代典型香港人的拼搏精神，用不怕捱苦及求變的心態努力闖出一番事業，並參與不同的慈善活動去幫助有需要的兩岸三地的大中華同胞。因此，Anita 逝世後被大眾封為「香港的女兒」。

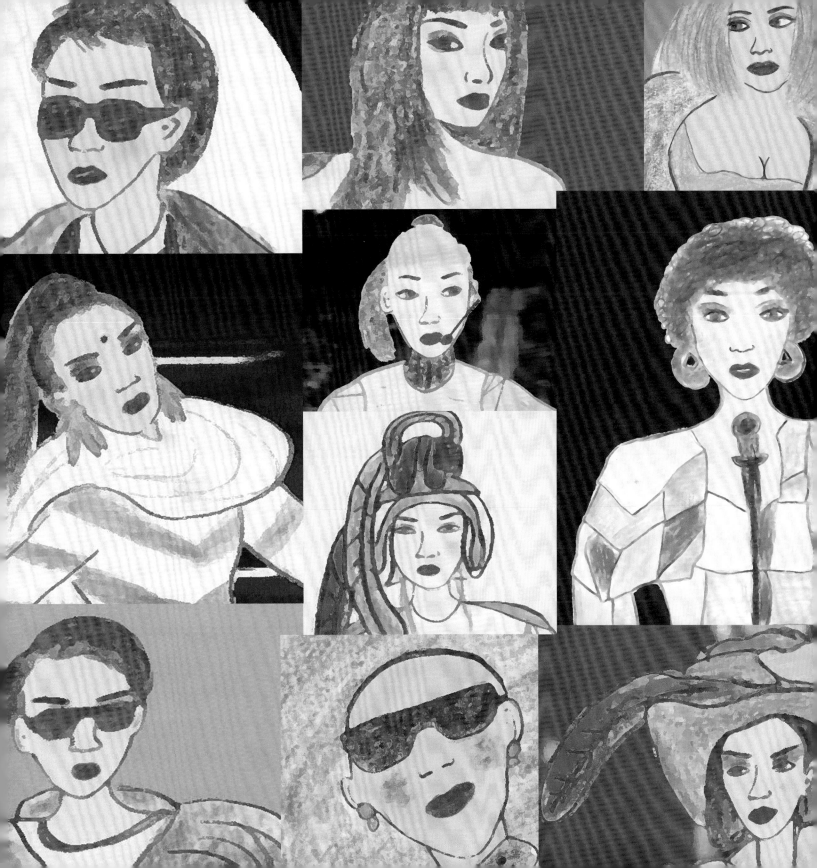

About Anita Mui

Anita Mui had an extraordinary and unhappy childhood when she was five years old. She started her singing career in Kam Ha Song and Dance Team founded by her mother, and worked hard to find her self-confidence. In 1982, when Anita was 18 years old, she had participated in the 1st TVB International Chinese New Talent Singing Championship and won the Final Champion Award by performing a song namely [The Season of the Wind] which is originally sung by the legendary female singer Paula Tsui with almost a perfect score, and then embarked on the road to superstardom. In 1983, Anita represented Hong Kong in the 12th Tokyo Music Festival, and won the Asian Special Award and TBS Award at the same time, as well as releasing 2 Japanese singes, so that she was recognized by quite a lot of Japanese people. In 1988, Anita represented Hong Kong to perform in the opening concert of the Seoul Olympic Games and was interviewed by the several local newspapers' journalists, so she was also recognized by quite a lot of Koreans. In 1990, she was awarded the 5th of the top ten most popular foreign female singers in Korea.

Since the song [Dream Embrace] in 1984, Anita has been showing people with her everchanging images, and quickly ascended to the position of the toppest female singer in the mid-to-late 1980s in Hong Kong. At that time, the Hong Kong music industry was extremely male-dominated, but Anita was the only female singer who could be titled as a superstar in the music industry together with Alan Tam and Leslie Cheung, the two toppest male singers in those years. The transversile male image for the song [Dream Partner], the rebellious young girl image for the song [Bad Girl], the Arabian girl image for the song [Temptress], the female lieutenant image for the song [Love Warrior], the black resentful widow image for the song [Burning Tango], the noble wife image for the song [Flaming Red Lips], the fashionable wedding dress woman image for the song [Lady], and the foreign woman image for the song [Jungle Of Desire] etc., combined with the changing wild dances, amazed the most conservative Chinese people everywhere.

The eight large-scale major concerts held by Anita in her lifetime are all the expectations and the focus of everyone. Her captivating magnetic singing voice and her unique stage performance style made her shine across the 80s, 90s and early millenniums, and she is known as [Eastern Madonna] and [Hong Kong Music Big Sister]. She has been the five-time winner of the "Most Popular Female Singer Award" in the Jade Solid Gold Best 10 Awards Presentation of TVB. In addition, Anita has 8 platinums (that is, sales of 400,000 copies) with the music album [Bad Girl]. In 2009, Anita was certified as the most global solo concerts by a Chinese female singer by the World Records Association with a total of 292 solo concerts around the world. In addition, Anita has won the highest honor in the Hong Kong music industry "The Golden Needle Award" at the age of 35 and the honor of artistic achievement at the China Golden Disc Award at the age of 40.

About Anita Mui

Anita is not only a generation of legendary music Queen of Pop, but also one of the legendary best actresses in Chinese movie industry. Anita starred in more than 40 films during her lifetime, she won the Best Supporting Actress Award twice in the Hong Kong Film Award, and won the Best Actress Award in the 8th Hong Kong Film Award, the 1st Taiwan Golden Dragon Award and the 23rd Taiwan Golden Horse Awards, her superb acting skills and professional attitude were unanimously appreciated by insiders of the Chinese movie industry. In addition, Anita is also the record holder of the female singer who received the most movie-themed song award in the Chinese music industry.

Unfortunately, in 2001 Anita was found to be suffering from a benign tumor of the cervix, but in 2002 she gave up treatment for a series of performances for celebration of her 20th anniversary singing career. Anita conducted a physical examination after finishing her organized 1:99 Concert in April 2003, she was diagnoized at the last stage of cervical cancer. In order to leave a perfect ending for herself and the fans before her death, she held the last large-scale concert – [Anita Mui Classic Moment Live] in total of 8 shows with tenacious willpower despite severe illness, and then went to Kyoto, Japan to shoot commercials. After a month she returned to Hong Kong, she passed away in the early morning of 30th December 2003. Her legend and name has been famous forever since then, and it will be passed down forever.

Anita is a rare superstar. She is a female singer who deeply influenced the growth of Hong Kong people in the 1980s and 1990s. Her death is indeed a great cultural and artistic loss to Chinese people all over the world. She is a rare artist who has a unique set of philosophies no matter in the music world, the film world, or her attitude towards people and things.

In addition, Anita has contributed to local cultural studies. Her everchanging images, progressive new female songs, the rise of feminism under the monopoly of patriarchal music situtaion, and her influence on the stage performances and commercialization of Chinese female singers, etc.

Apart from that, Anita's life attitude also reflects the fighting spirit of typical Hong Kong people in the 1970s, 1980s and 1990s. She worked hard to create a career with the attitude of not being afraid of suffering and seeking change, and participated in different charity activities to help the needy Greater Chinese compatriots. As such, she was titled as [The Daughter of Hong Kong] by the public after her death.

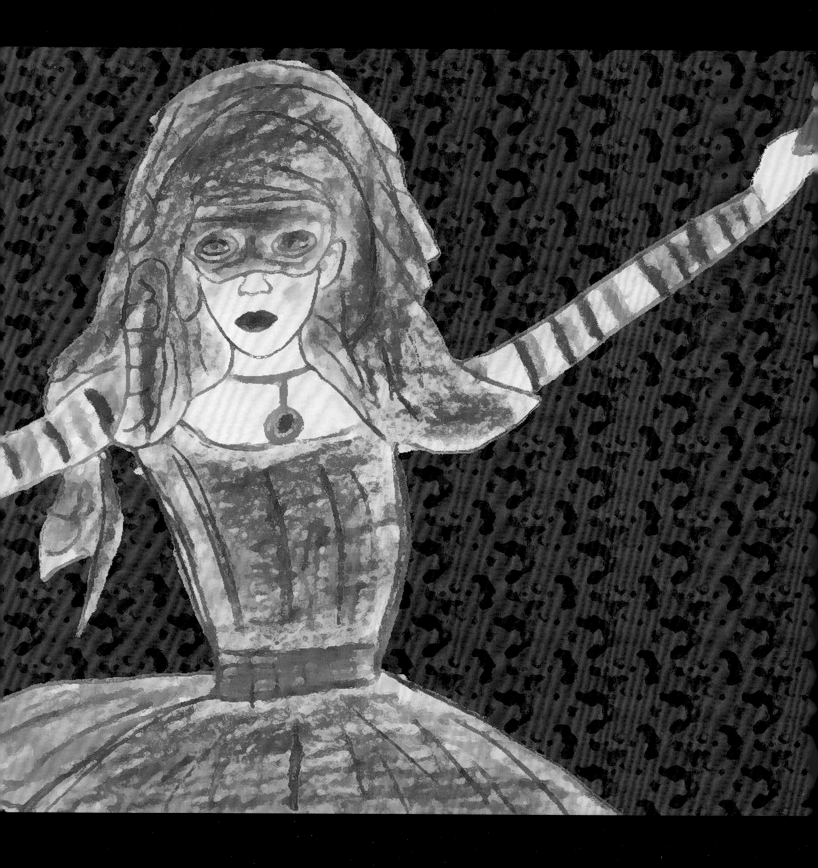

梅艷芳經典金曲演唱會
Anita Classic Moment Live
(2004)

<table>
<tr><td>

01. Overture
02. 夢裡共醉
03. 是這樣的
04. Classic Moment 1 (Talk)
05. 抱緊眼前人
06. 心肝寶貝
07. 何日 + 李香蘭
08. Classic Moment 2 (Talk)
09. 心債
10. 第四十夜
11. 夏日戀人
12. O Sole Mio (Music)
13. 親密愛人
14. Classic Moment 3 (Talk)
15. 愛情的代價
16. 我願意
17. 似夢迷離
18. 今生今世
19. 深愛著你
20. 孤身走我路
21. 胭脂扣
22. Classic Moment 4 (Talk)
23. 似是故人來
24. Classic Moment 5 (Talk)
25. 似水流年
26. Sukiyaki (Music)
27. 花月佳期
28. Classic Moment 6 (Talk)
29. 夕陽之歌

</td><td>

01. Overture
02. Drunk In Dreams Together
03. It's Like This
04. Classic Moment 1 (Talk)
05. Embrace The One In Front Of Your Eyes
06. Sweetheart
07. When Will It Be + Li Xianglan
08. Classic Moment 2 (Talk)
09. Debts Of The Heart
10. Fortieth Night
11. Summer Lover
12. O Sole Mio (Music)
13. Intimate Lover
14. Classic Moment 3 (Talk)
15. The Price Of Love
16. I Am Willing
17. Dream Like Blur
18. This Life And Presence
19. Love You Deeply
20. Walking My Way Alone
21. Rouge
22. Classic Moment 4 (Talk)
23. Like An Old Friend Comes
24. Classic Moment 5 (Talk)
25. The Years Flow Like Water
26. Sukiyaki (Music)
27. Flower Moon Best Period
28. Classic Moment 6 (Talk)
29. Song Of The Sunset

</td></tr>
</table>

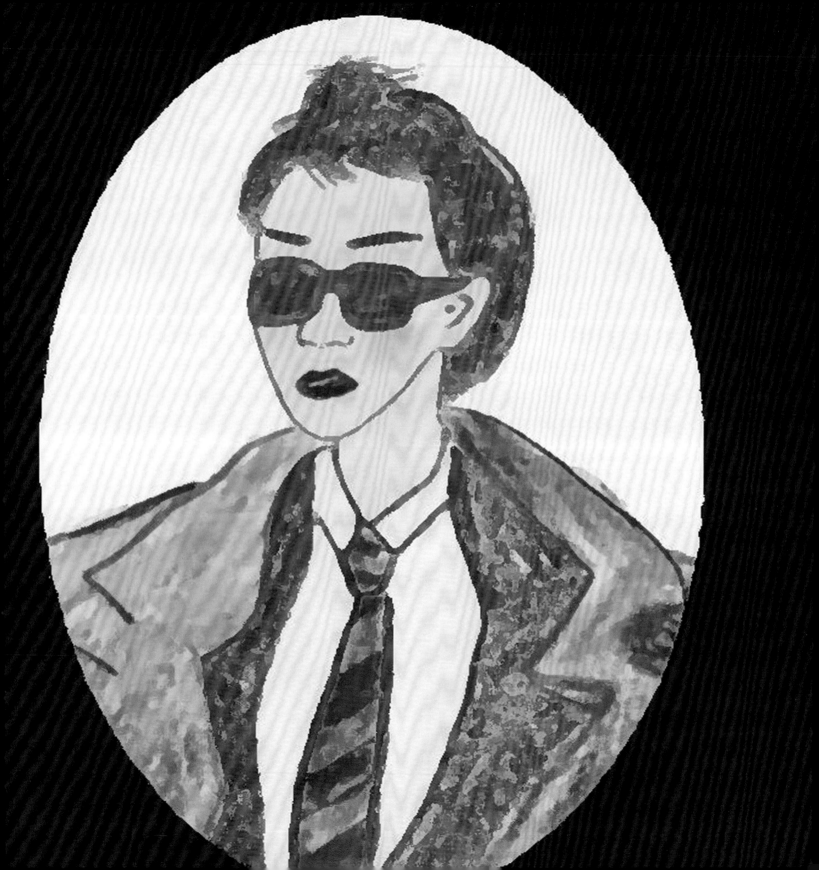

似水流年
The Years Flow Like Water
(1985)

01. 夢幻的擁抱 **

02. 蔓珠莎華 **

03. 似水流年 **

04. 人在風裡
 （電影《歌舞昇平》插曲）

05. 問一問你

06. 歌衫淚影 **
 （TVB 電視劇《香江花月夜》主題曲）

07. 紗籠女郎 **
 （TVB 電視劇《香江花月夜》插曲）

08. 一點相思
 （TVB 電視劇《香江花月夜》插曲）

09. 舊歡如夢
 （TVB 電視劇《香江花月夜》插曲）

10. 覓愛重重
 （TVB 電視劇《香江花月夜》插曲）

11. 多少柔情
 （TVB 電視劇《香江花月夜》插曲）

01. Dream Embrace **

02. Manjusaka **

03. The Years Flow Like Water **

04. One In The Wind
 (Theme Song of the Movie
 [The Musical Singer])

05. Asking You

06. Tears' Shadow on the Stage **
 (Theme Song of the TVB Drama
 [Summer Kisses Winter Tears])

07. Sarong Girl **
 (Interlude of the TVB Drama
 [Summer Kisses Winter Tears])

08. A Little Lovesickness
 (Interlude of the TVB Drama
 [Summer Kisses Winter Tears])

09. Old Love Is Like A Dream
 (Interlude of the TVB Drama
 [Summer Kisses Winter Tears])

10. Looking For Love Heavily
 (Interlude of the TVB Drama
 [Summer Kisses Winter Tears])

11. How Much Tenderness
 (Interlude of the TVB Drama [
 Summer Kisses Winter Tears])

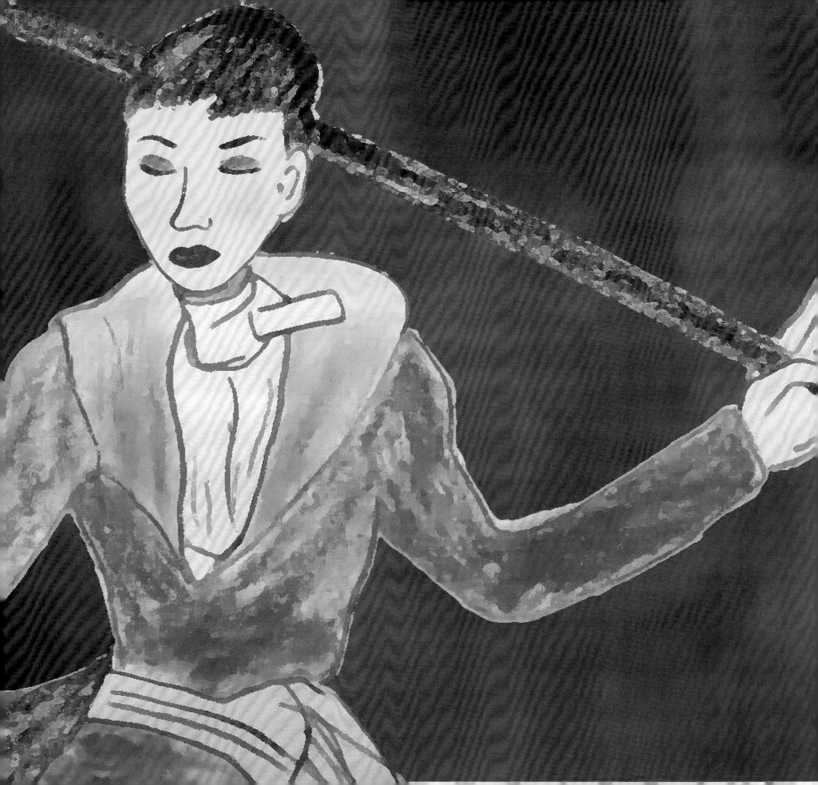

Larger Than Life (1999)

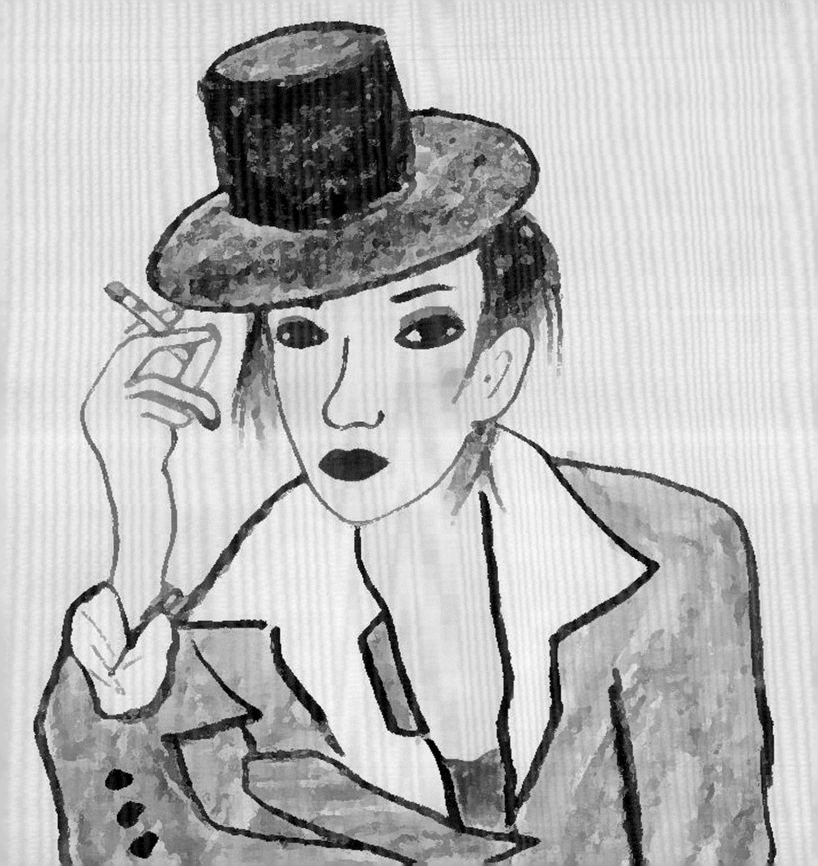

是這樣的
It's Like This
(1994)

01. 情歸何處 **
02. 感激 **
03. 請你快回來
04. 愛是個傳奇
05. 悲情城市
06. 如夜 **
07. 蝶舞
08. 愛情來了報佳音
09. 是這樣的 **
10. 朦朧夜雨裡 **

01. Where Does Love Belong **
02. Grateful **
03. Please Come Back Soon
04. Love Is A legend
05. City Of Sadness
06. Like The Night **
07. Butterfly Dance
08. Love Comes To Announce Good News
09. It's Like This **
10. In The Hazy Rainy Night **

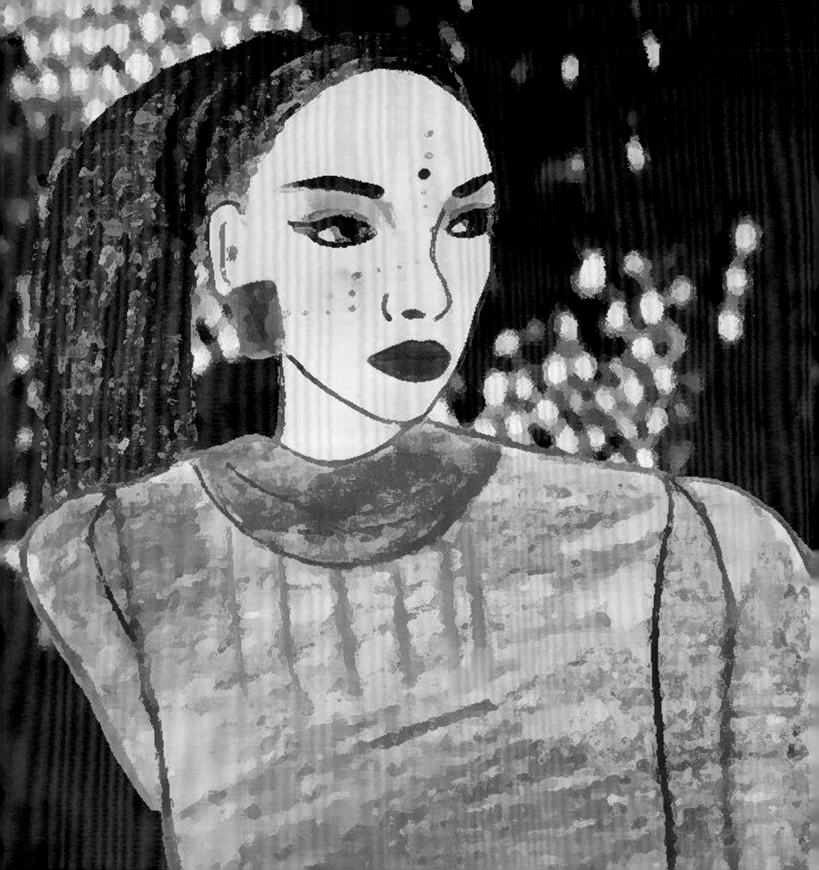

似火探戈
Burning Tango
(1987)

01. 序曲～將我送給你
02. Oh No! Oh Yes! **
03. 百變
04. 心魔 **
05. 無淚之女
06. 黑色婚紗
07. 似火探戈 **
08. 裝飾的眼淚 **
09. 放鬆 **
10. 反覆的愛
11. 珍惜再會時 **
12. 妄想

01. Prelude ~ Gift Me To You
02. Oh No! Oh Yes! **
03. Everchanging
04. Devil Of Heart **
05. Daughter Without Tears
06. Black Wedding Dress
07. Burning Tango **
08. Decorated Tears **
09. Relax **
10. Repeated Love
11. Cherish When We Meet Again **
12. Delusion

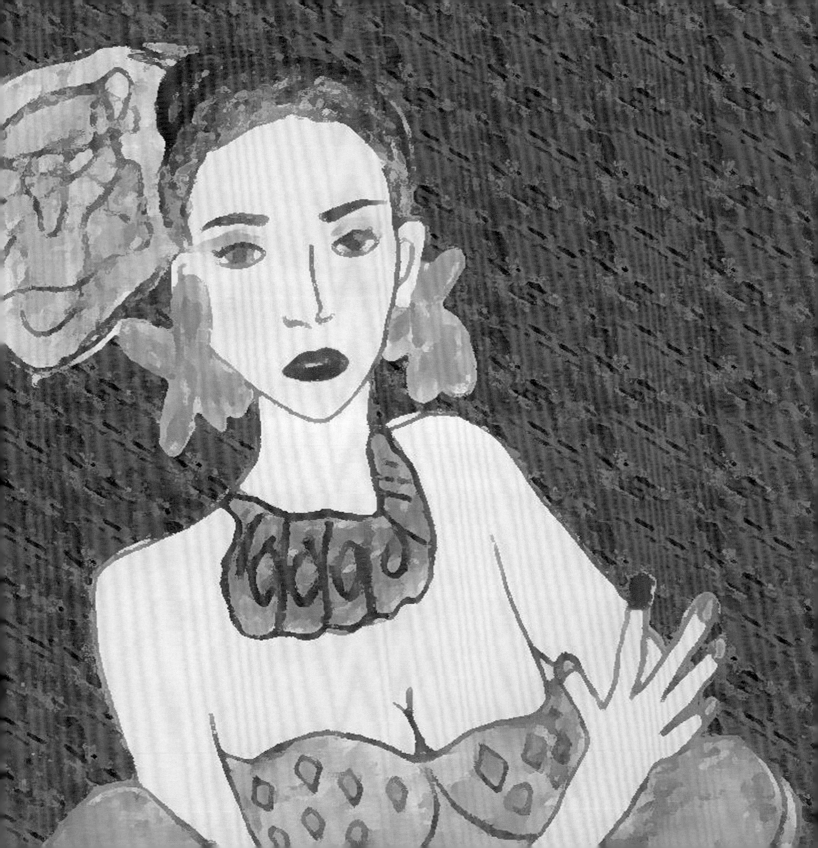

烈焰紅唇
Flaming Red Lips
(1987)

01. 烈焰紅唇 **
 （電影《精裝追女仔 2》主題曲）
02. 傷心教堂 **
03. 她的前半生
04. 魅力在天橋
05. 孤單
06. 暫停厭倦
07. 回復真我
08. 假如我是男人 **
 （電影《花心夢裏人》插曲）
09. 我肯
 （電影《花心夢裏人》插曲）
10. 尋愛
11. 胭脂扣 **
 （電影《胭脂扣》主題曲）
12. 最後一次

01. Flaming Red Lips **
 (Theme Song of the Movie
 〔The Romancing Star II〕)
02. Church Of Sadness **
03. The First Half Of Her Life
04. The Charm Is In The Flyover
05. Lonely
06. Suspend Boredom
07. Get Back To Me
08. If I Were A Man **
 (Interlude of the Movie〔Dream of Desire〕)
09. I Will
 (Interlude of the Movie〔Dream of Desire〕)
10. Find Love
11. Rouge **
 (Theme Song of the Movie〔Rouge〕)
12. Last Time

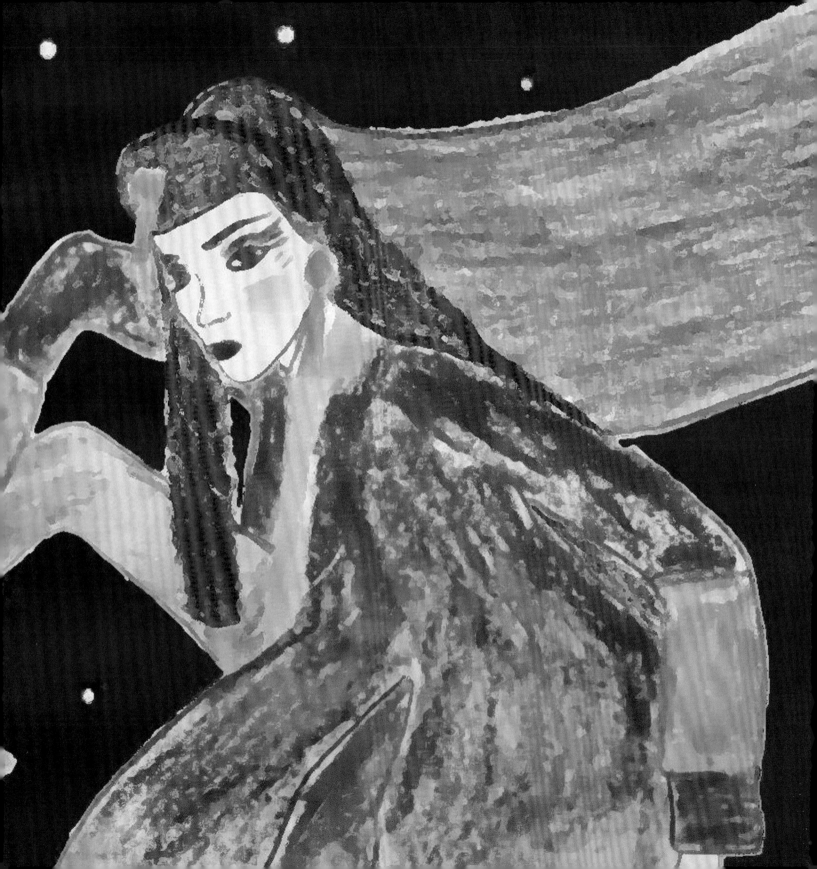

妖女
Temptress
(1986)

01. 妖女 **
02. 來來星屑港
03. 癡癡愛一次 **
　　（電影《一屋兩妻》主題曲）
04. Crazy Love
05. 征服他 **
　　（電影《花心夢裏人》插曲）
06. 將冰山劈開 **（許志安合唱）
07. 愛將 **（草猛合唱）
08. 緋聞中的女人 **
09. 某一天
10. 唯一伴侶
　　（電影《夜之女》主題曲）

01. Temptress **
02. Come To Stardust Harbor
03. Love Once Crazily **
　　(Theme Song of the Movie
　　〔The Happy Bigamist〕)
04. Crazy Love
05. Conquer Him **
　　(Interlude of the Movie
　　〔Dream Of Desire〕)
06. Break The Iceberg **
　　(Duet with Andy Hui)
07. Love Warrior **
　　(Duet with Grasshopper)
08. Gossip Girl **
09. One Day
10. The Only Mate
　　(Theme Song of the Movie
　　〔Woman of Night〕)

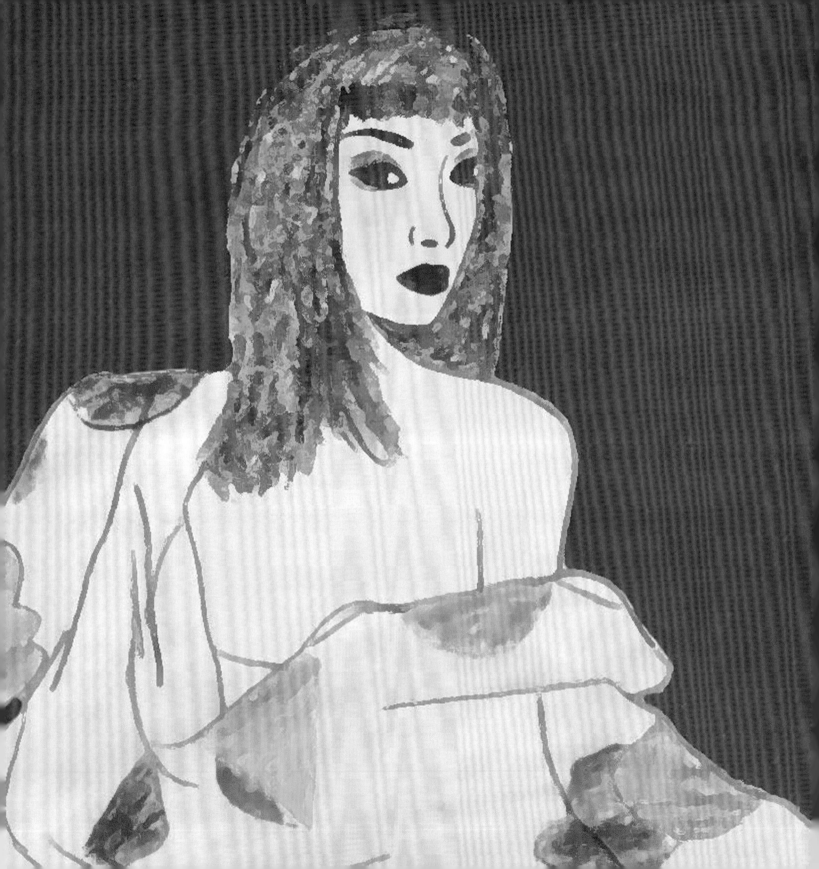

梅艷芳個人資料
Anita Mui's Personal Background

出生日期 ： 1963 年 10 月 10 日
往生日期 ： 2003 年 12 月 30 日
出生地點 ： 香港
藉貫 ： 中國廣西合浦
高度 ： 5 呎 6 吋半 5
生肖 ： 兔
宗教 ： 佛教
星座 ： 天秤座
家庭成員 ： 母親梅覃美金、大哥梅啟明、二哥梅德明及三姐梅愛芳
契爺 / 契媽： 何冠昌 / 博瑞娜
徒弟：草猛、許志安、譚耀文、何韻詩及彭敬慈
好朋友： 蘇孝良、張敏儀、黎小田、劉培基、倫永亮、張耀榮、張國榮、近藤真彥、羅文、陳百強、
　　　　林子祥、成龍、譚詠麟、曾志偉、岑建勳、陳百祥、陳友、顏聯武、夏妙然、鍾鎮濤、張學友、
　　　　劉德華、梁家輝、梁朝偉、連炎輝、林憶蓮、張曼玉、羅美薇、曾華倩、劉嘉玲、楊紫瓊、
　　　　何超瓊、童安格、鄭秀文、蘇永康、梁漢文、陳小春、Kim Robinson、連士良、陶喆
　　　　及謝霆鋒等

Date of Birth : 10th October 1963
Date of Death : 30th December 2003
Place of Birth : Hong Kong
Native Place : Hepu, Guangxi, China
Height : 5 feet 6.5 inches
Zodiac : Rabbit
Religion : Buddhism
Constellation : Libra
Family Members : Mui Tam Mei Kam (Mother), Mui Kai Ming (Eldest brother), Mui Tak Ming
　　　　　　　　(Elder Brother) and Mui Oi Fong (Elder Sister)
Godfather/ Godmother : Leonard Ho/ Fu Sui Na
Apprentices : Grasshopper, Andy Hui, Patirck Tam, Hocc Ho and Samuel Pang
Best Friends : So Hau Leung, Cheung Man Yee, Michael Lai, Eddie Lau, Anthony Lun, Cheung
　　　　　　　Yiu Wing, Leslie Cheung, Kondo Masahiko, Roman Tam, Danny Chan, Geroge
　　　　　　　Lam, Jackie Chan, Alan Tam, Eric Tsang, John Shum, Natalis Chan, Anthony
　　　　　　　Chan, Gary Ngan, Serina Ha, Kenny Bee, Jacky Cheung, Andy Lau, Tony Leung
　　　　　　　Ka Fai, Tony Leung, Alan Lin, Sandy lam, Maggie Cheung, May Lo, Margie
　　　　　　　Tsang, Carina Lau, Michelle Yeoh, Pansy Ho, Angus Tung, Sammi Cheng,
　　　　　　　William So, Edmond Leung, Jordon Chan, Kim Robinson、Lien Shih Liang,
　　　　　　　David Tao and Nicholas Tseetc

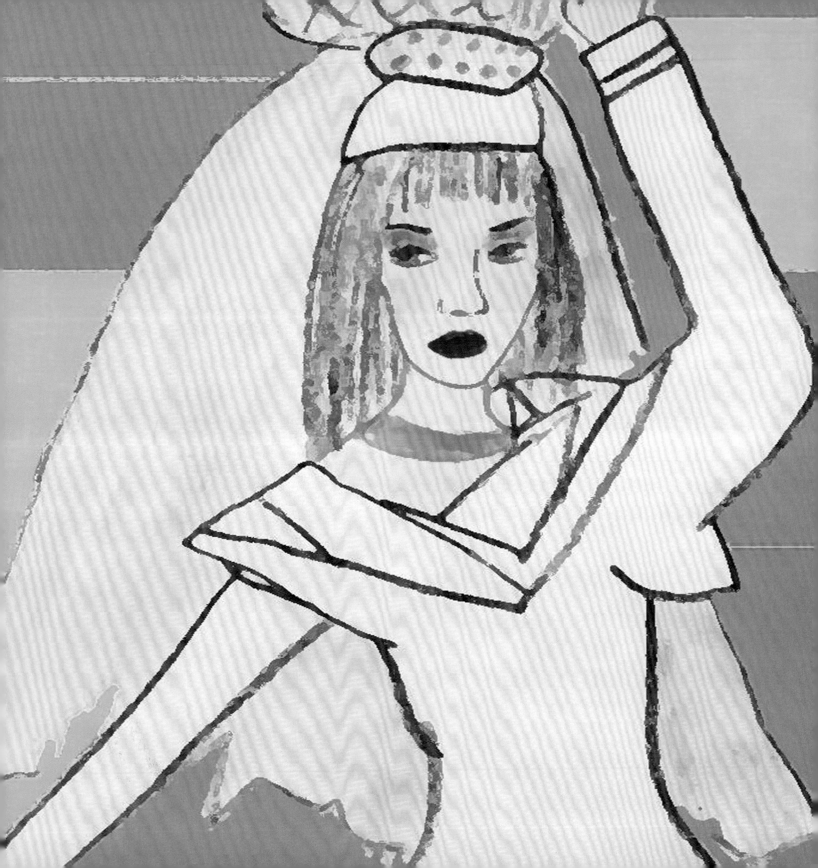

淑女
Lady
(1989)

01. 淑女 **
02. 傲慢
03. 幾多個幾多
04. 轉走舊時夢
05. 朝朝暮暮 **
06. 黑夜的豹 **
07. 曾被我擁有 **
08. 戀愛 Part-time
　　（電影《花心夢裏人》插曲）
09. 一舞傾情 **
10. 今夜只因你

01. Lady **
02. Arrogance
03. How Much And How Much
04. Turn Away Old Dreams
05. Day And Night **
06. Night Leopard **
07. Owned By Me **
08. Love Part-time
(Interlude of the Movie〔Dream of Desire〕)
09. Love At First Dance **
10. Tonight Only Because Of You

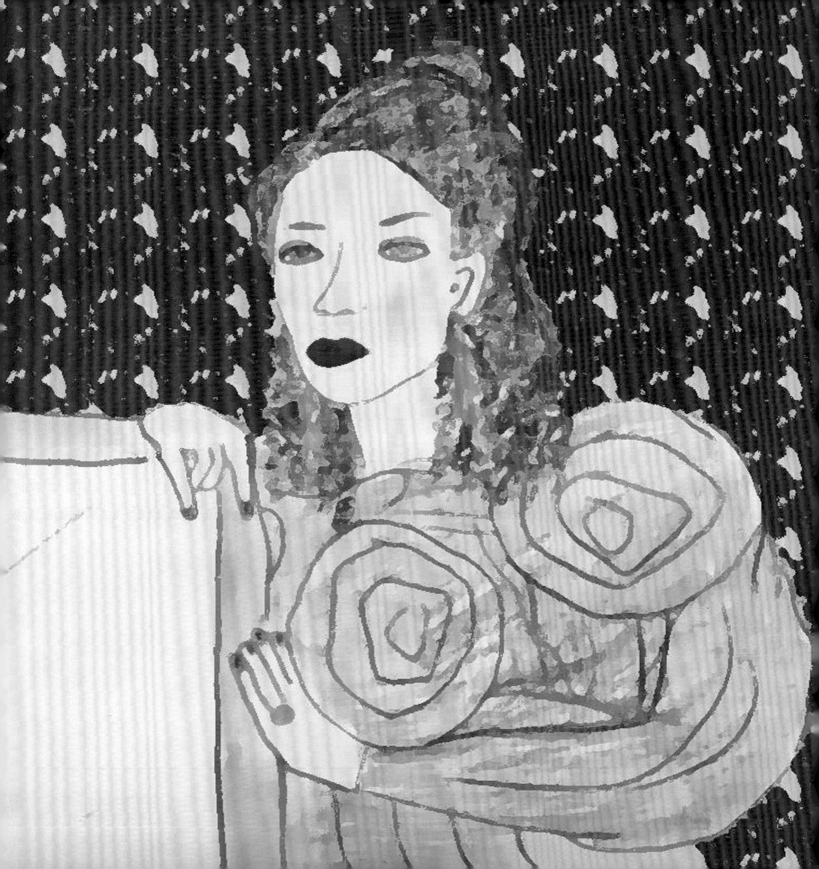

梅艷芳的最愛
Anita Mui's Favorite

事情 ： 與偶像西城秀樹在日本舉行的亞洲青年音樂節中同台演出
偶像 ： 山口百惠、西城秀樹、許冠傑、林子祥及碧咸
城市 ： 日本及夏威夷
顏色 ： 黑、白及紫
寵物 ： 貓狗
服飾 ： 牛仔褲
花 ： 黃玫瑰
自己的歌曲：「似水流年」、「孤身走我路」、「珍惜再會時」、「Stand By Me」、「夕陽之歌」、「Faithfully」、「似是故人來」及「歌之女」

Matter : Performed on the same stage with idol Saijo Hideki at the Asian Youth Music Festival in Japan
Idols : Momoe Yamaguchi, Hideki Saijo, Sam Hui, George Lam and David Beckham
City : Japan and Hawaii
Colour : Black White and Purple
Pet : Cats and Dogs
Clothes : Jeans
Flower : Rose in Yellow
Her Own Song : "The Years Flow Like Water", "Walking My Way Alone","Cherish When We Meet Again", "Stand By Me", "Song Of Sunset", "Faithfully", "Like An Old Friend Comes" and "Songtress"

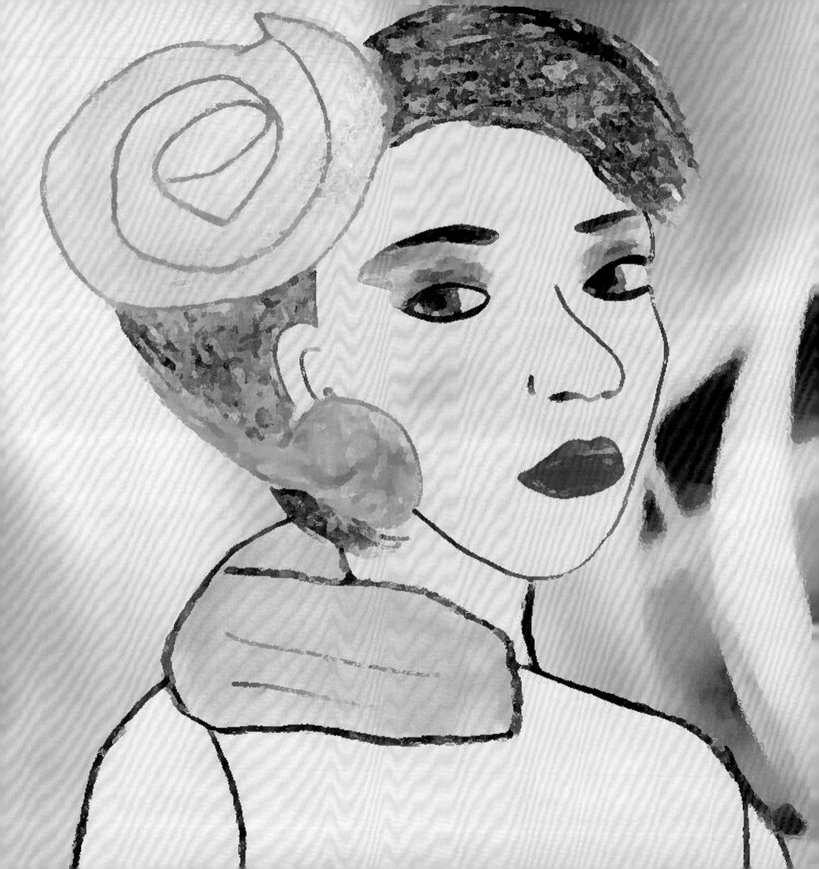

飛躍舞台
Leaping In The Spotlight
(1984)

01. 留住你今晚
02. 飛躍舞台 **
　　（TVB 電視劇《五虎將》主題曲）
03. 寂寞的心
04. 獨愛荊途
05. 不信愛有罪 **
06. 他令我改變
　　（TVB 電視劇《五虎將》插曲）
07. 逝去的愛 **
08. 不許再回頭
09. 莫逃避 **
10. 發電一千 VOLT
11. 點起你慾望
12. 今晚記住我

01. Keep You Tonight
02. Leaping In The Spotlight **
　　(Theme Song of the TVB Drama
　　〔The Rise & Fall of a Stand-In〕)
03. Lonely Heart
04. Only Love Bramble Path
05. Don't Believe Love Is A Crime **
　　(Interlude of the TVB Drama
　　〔The Rise & Fall of a Stand-In〕)
06. He Changed Me
07. Love Is Gone **
08. Don't Look Back
09. Don't Run Away **
10. Generate 1000 VOLT
11. Start Your Desire
12. Remember Me Tonight

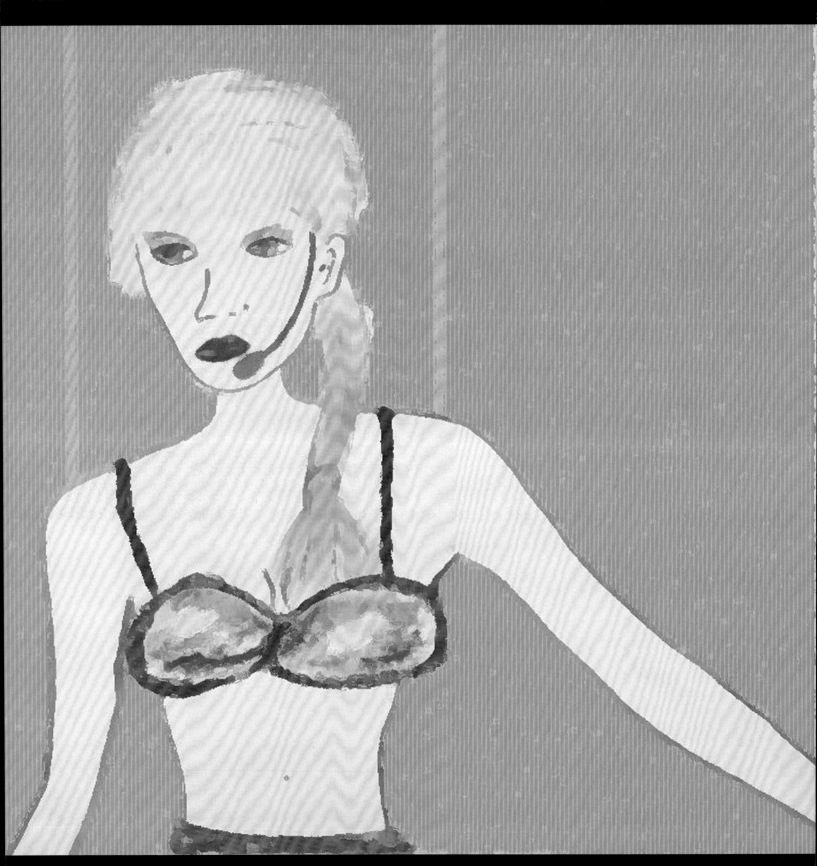

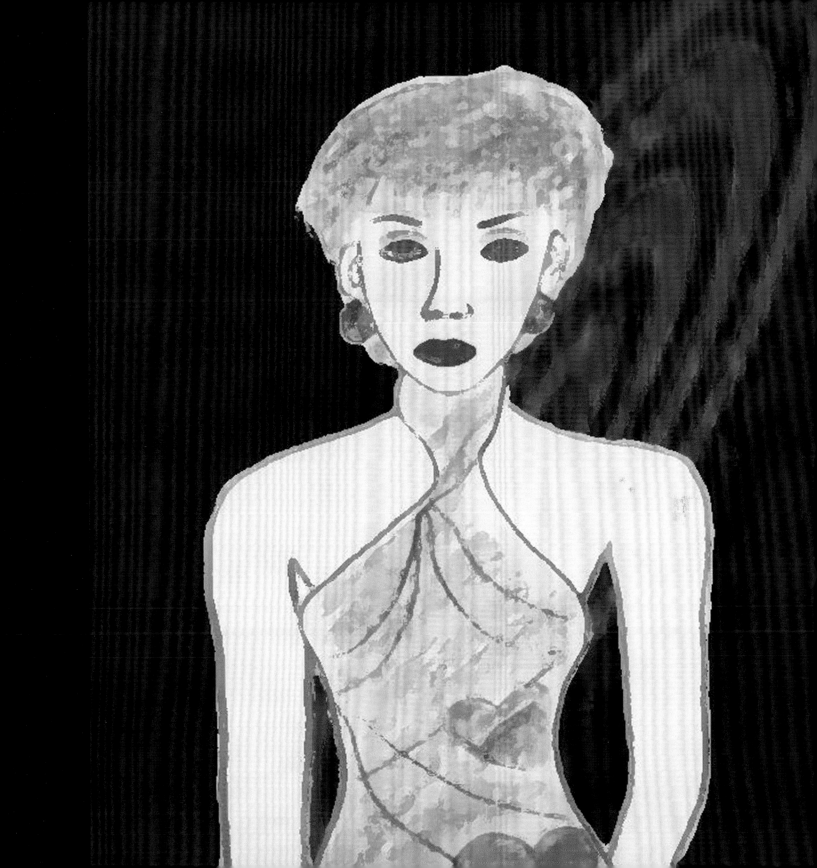

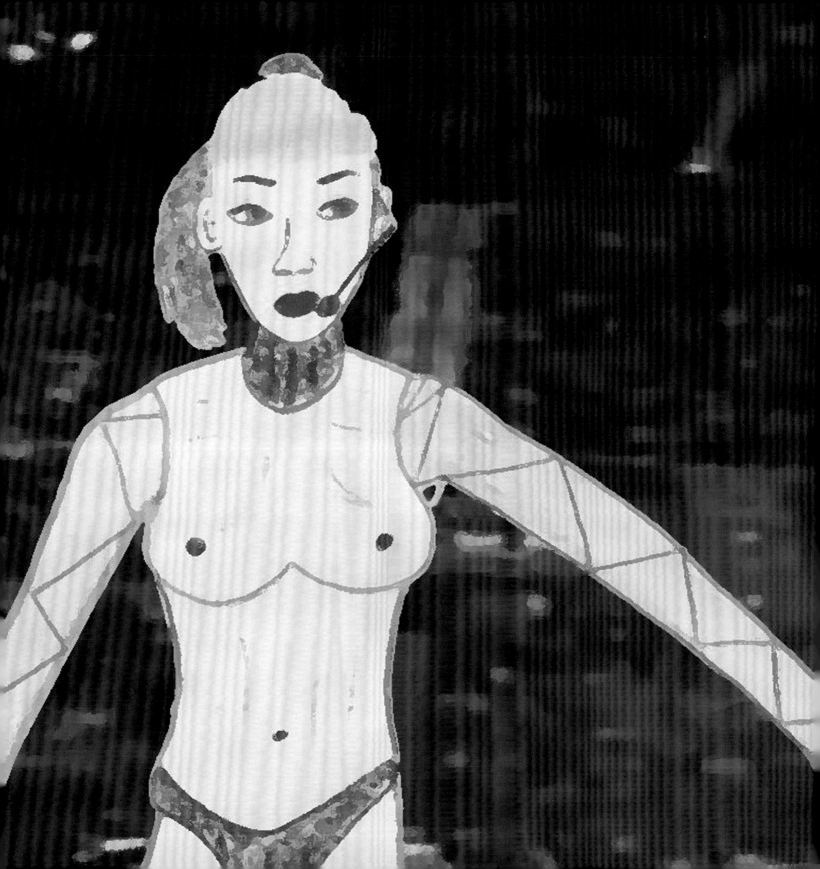

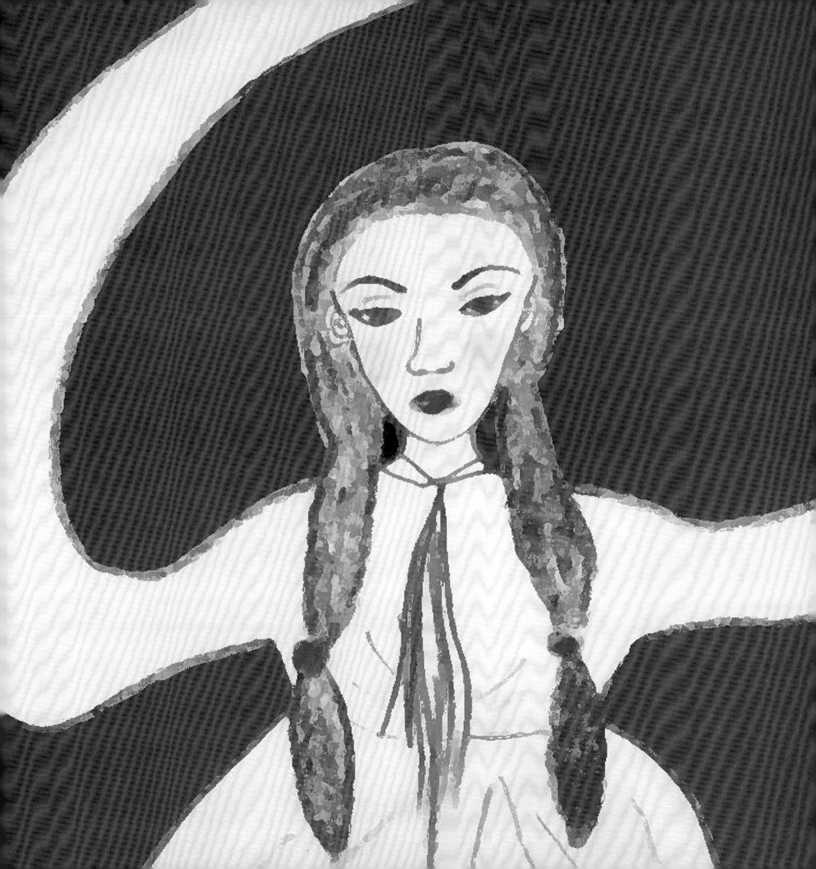

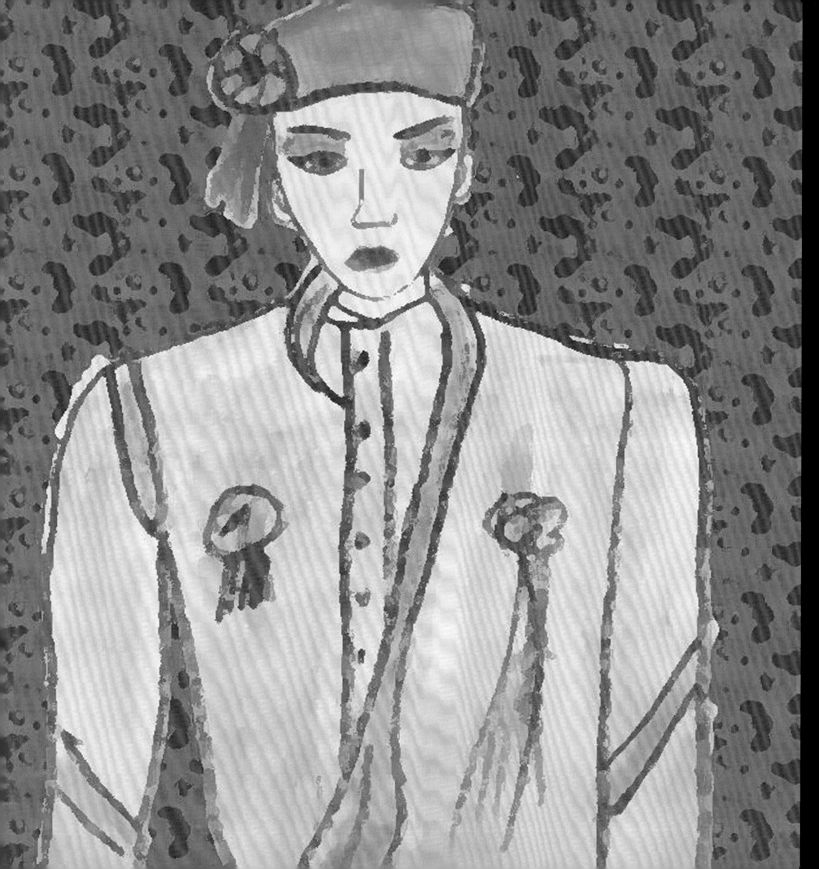

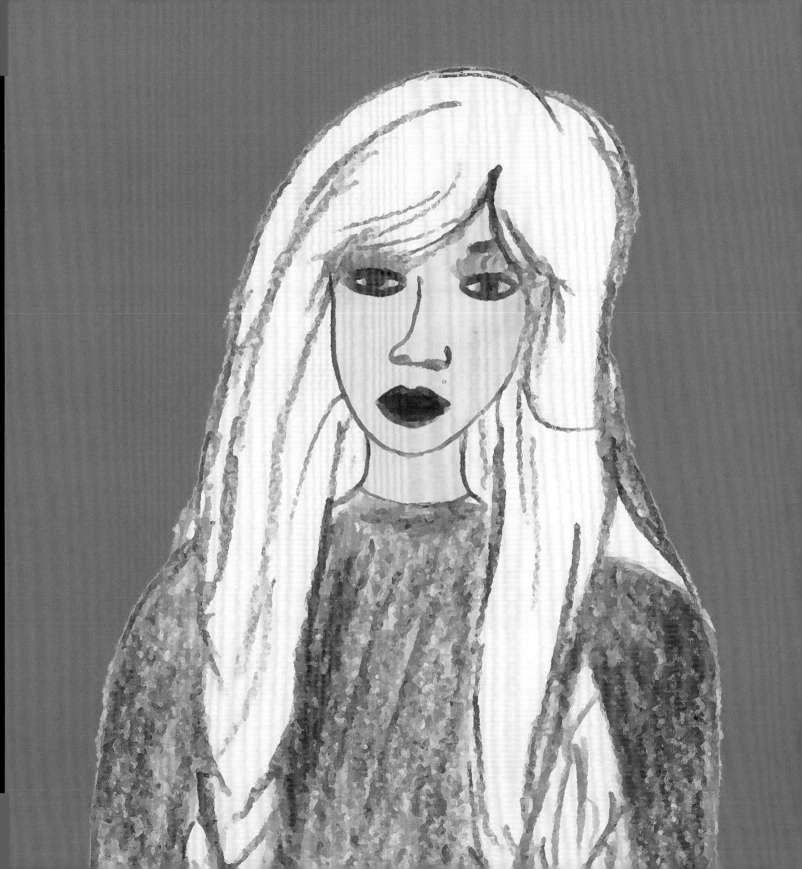

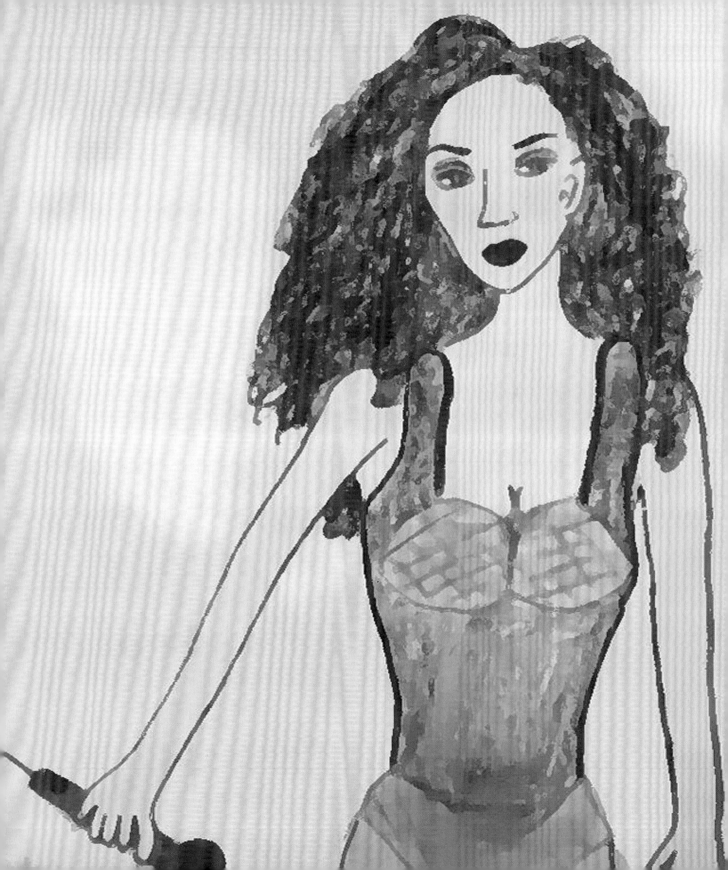

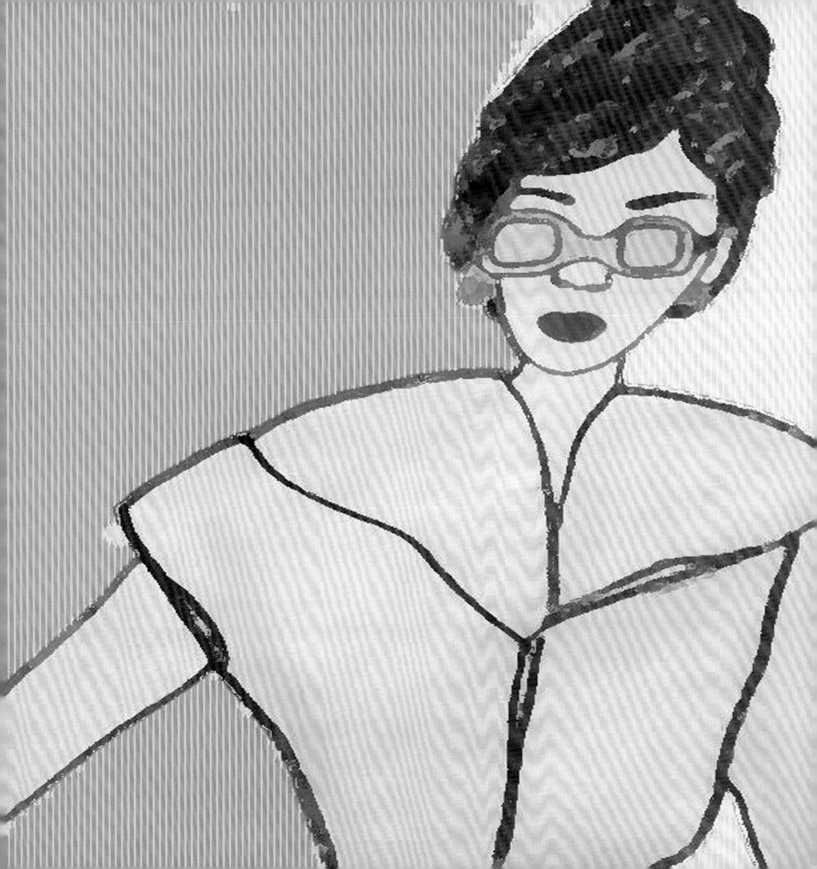

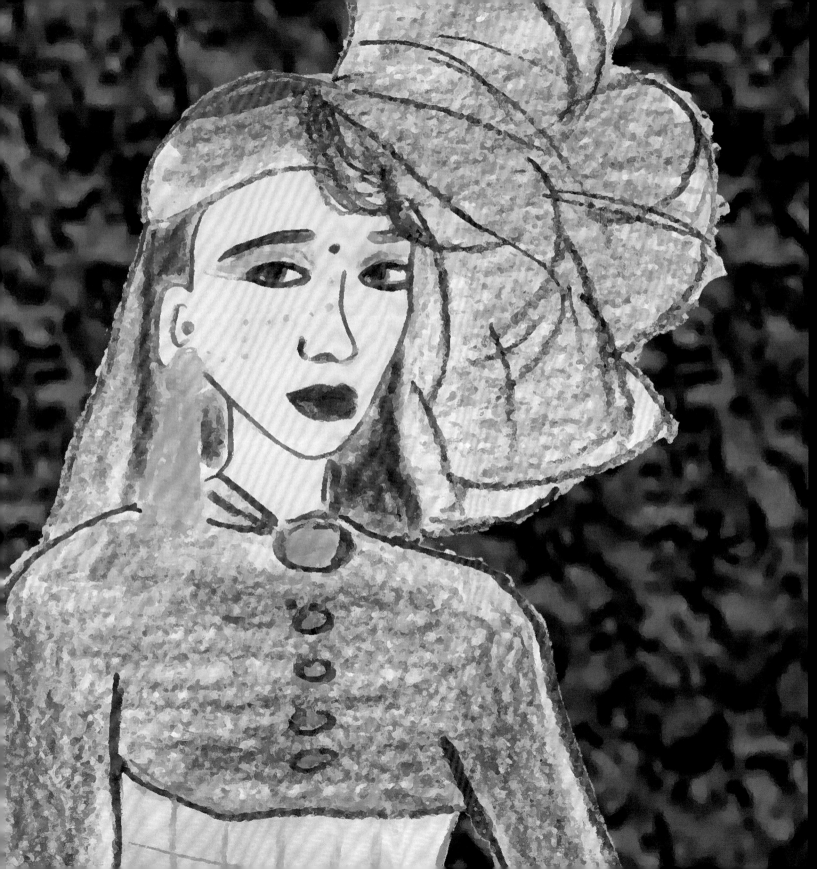

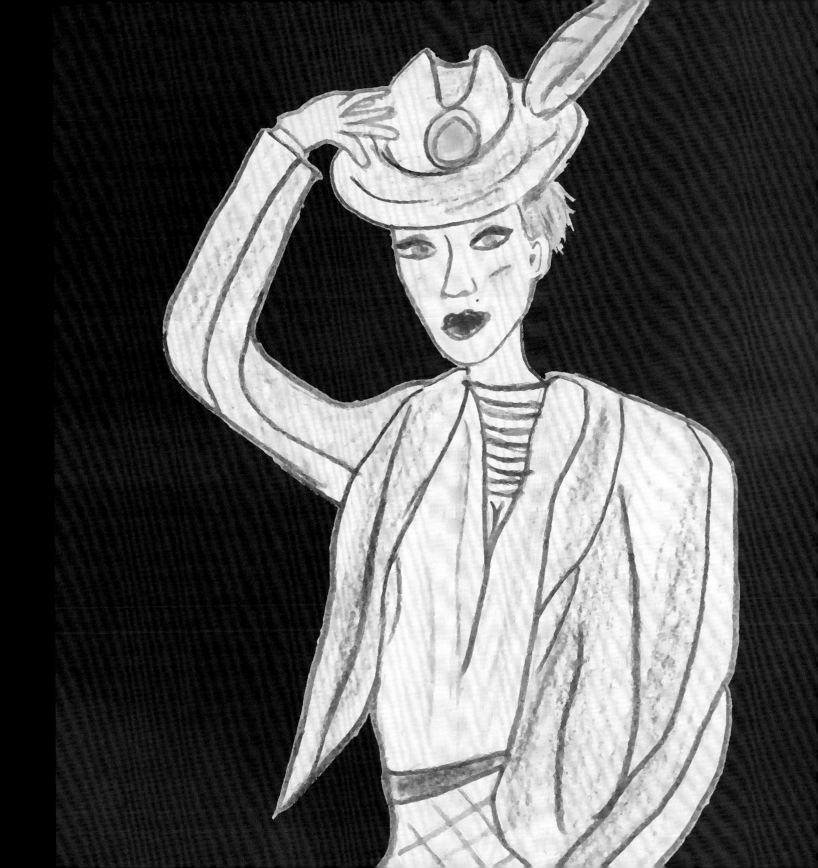

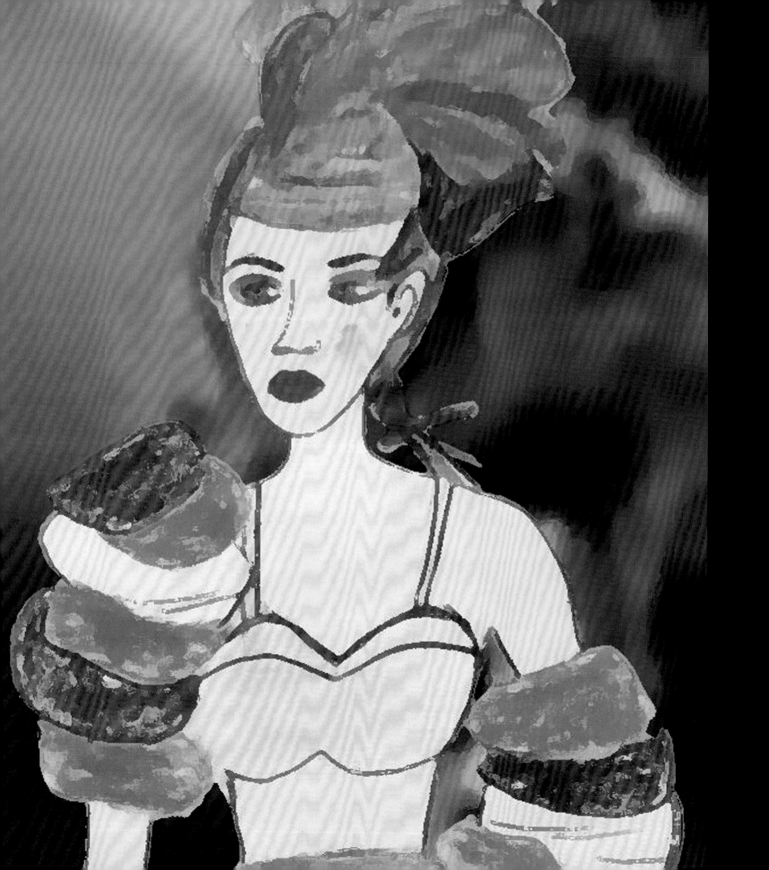

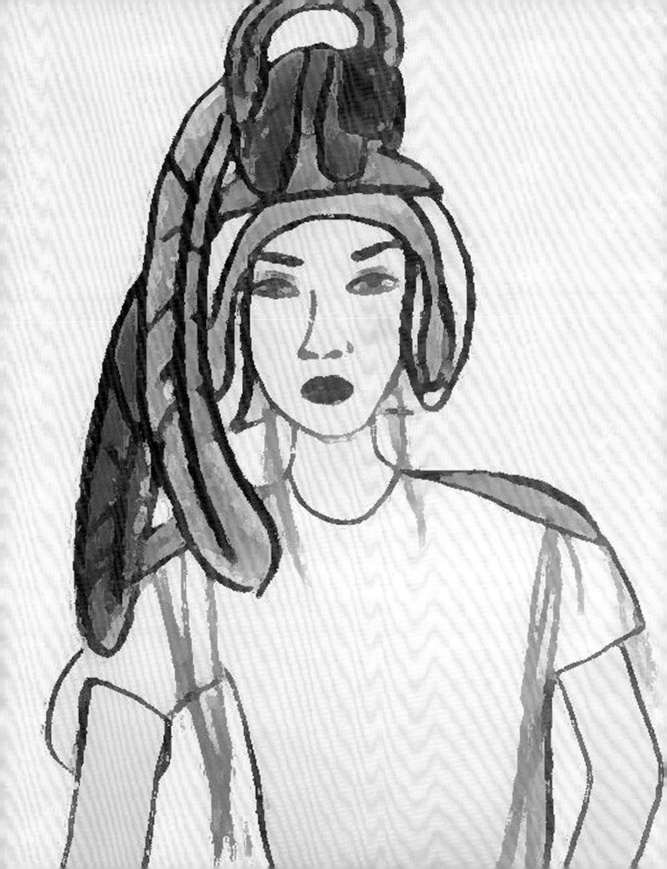

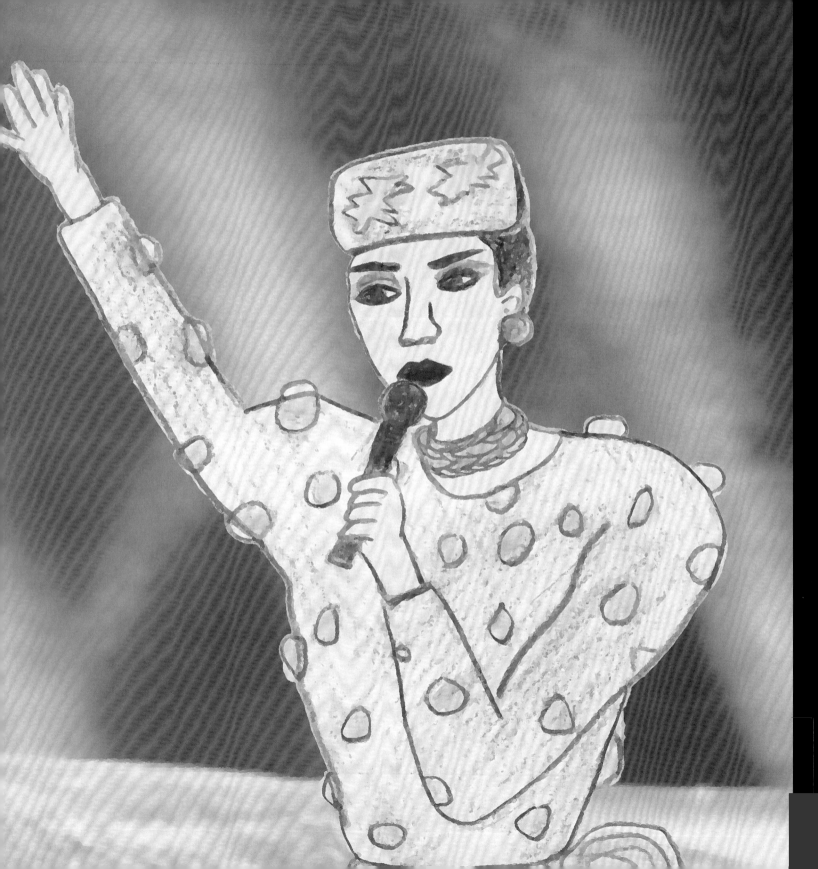

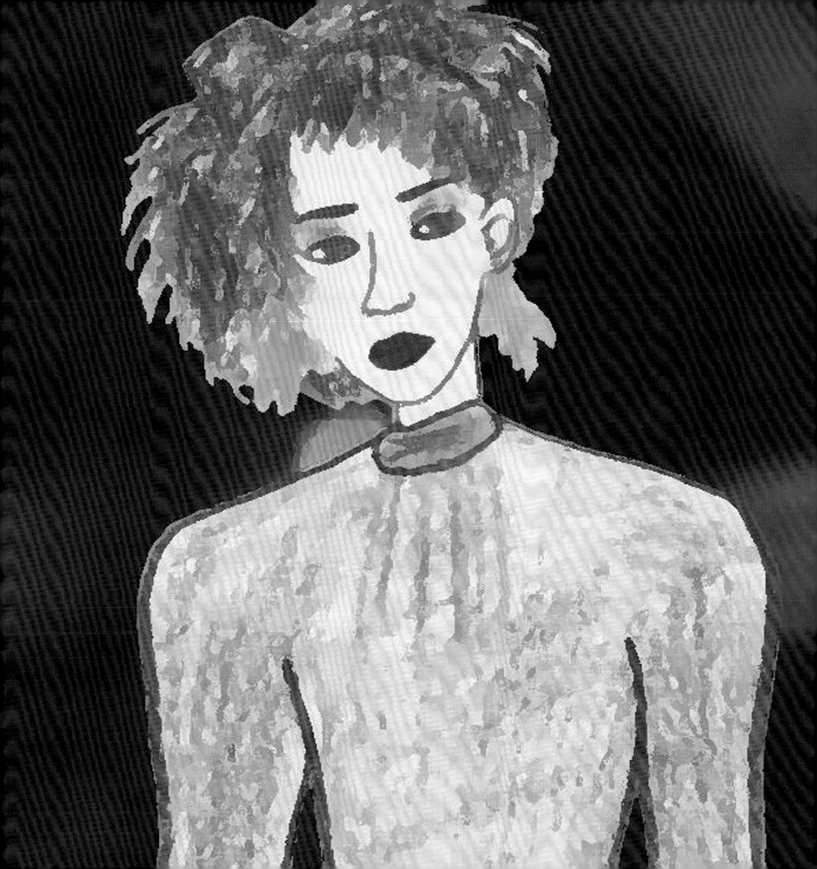

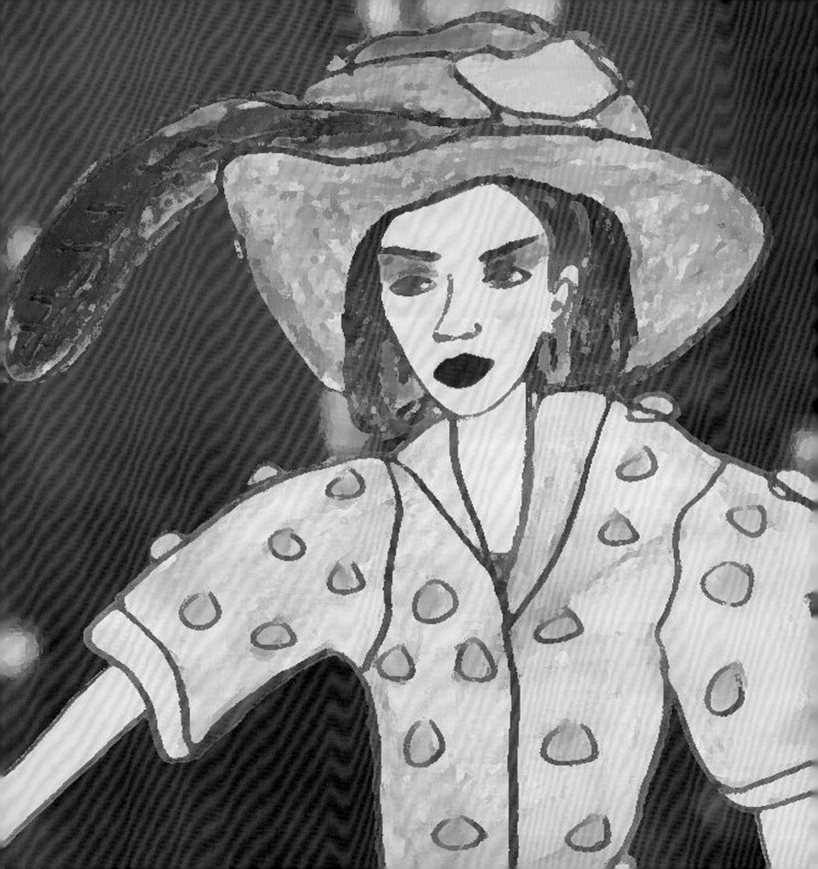

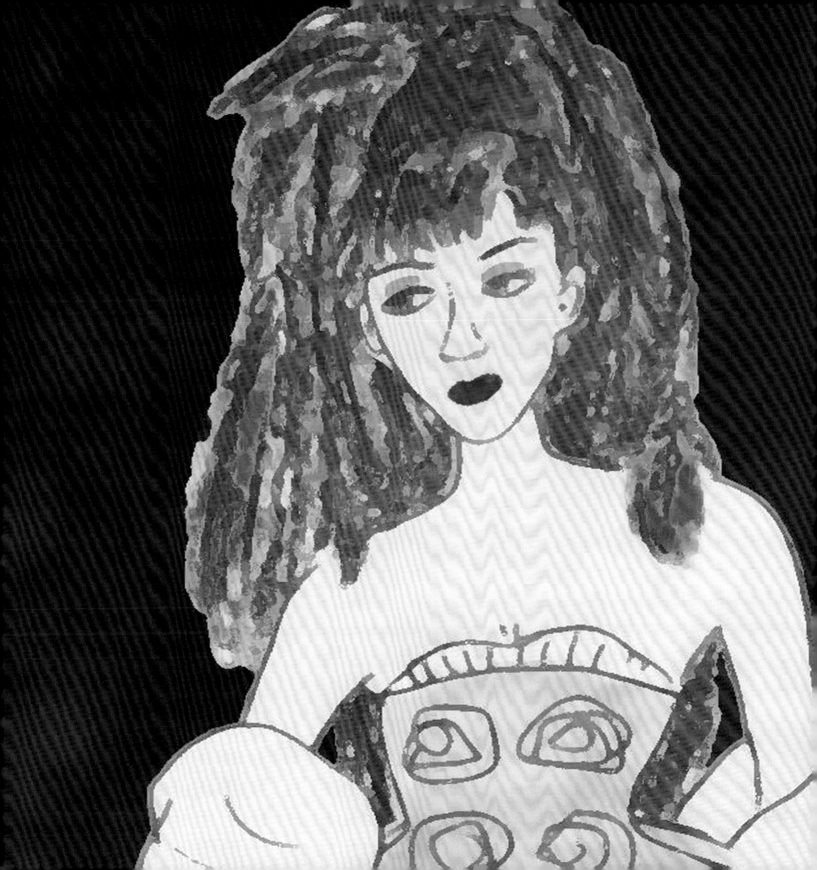

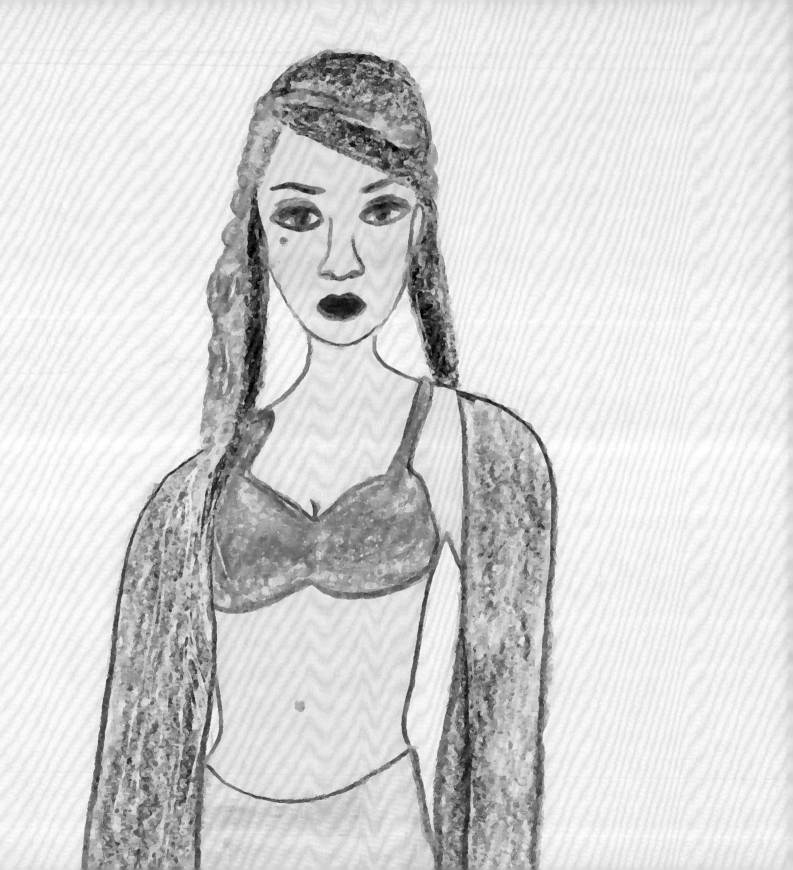

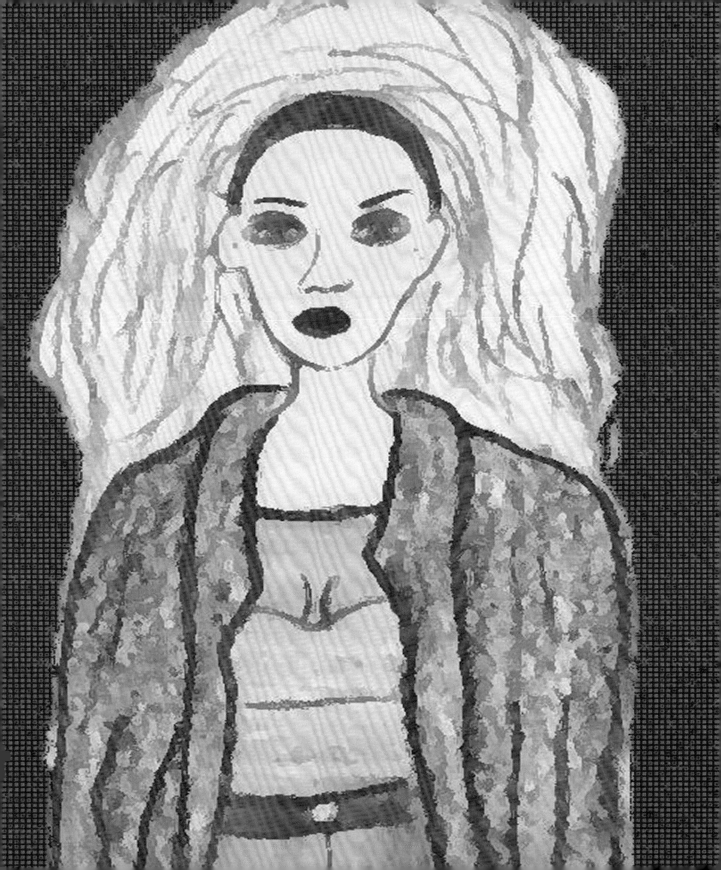

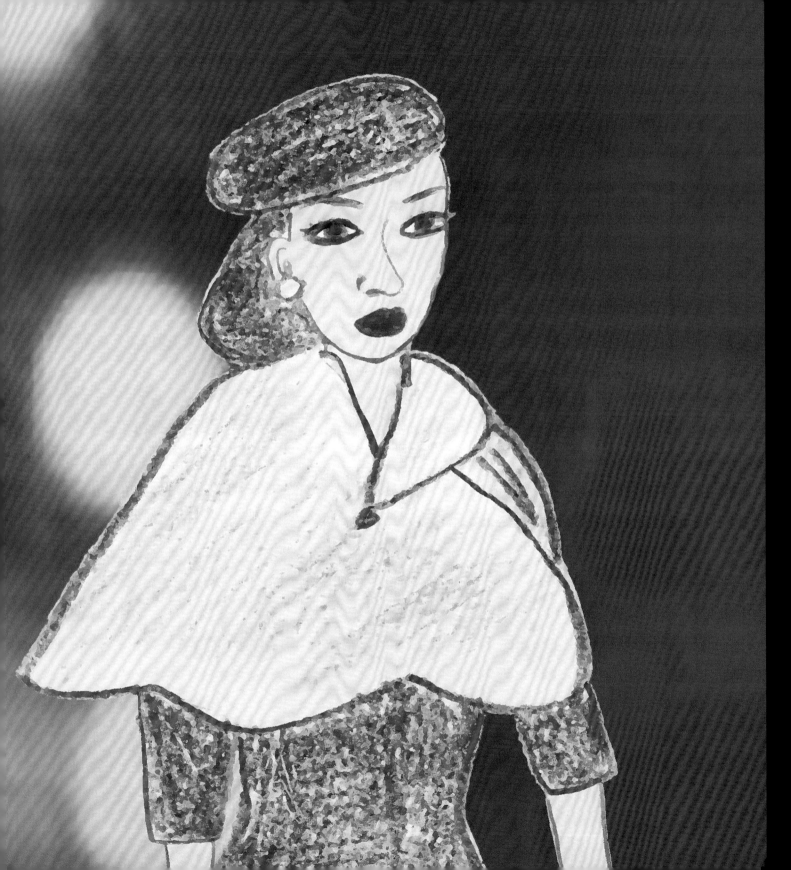

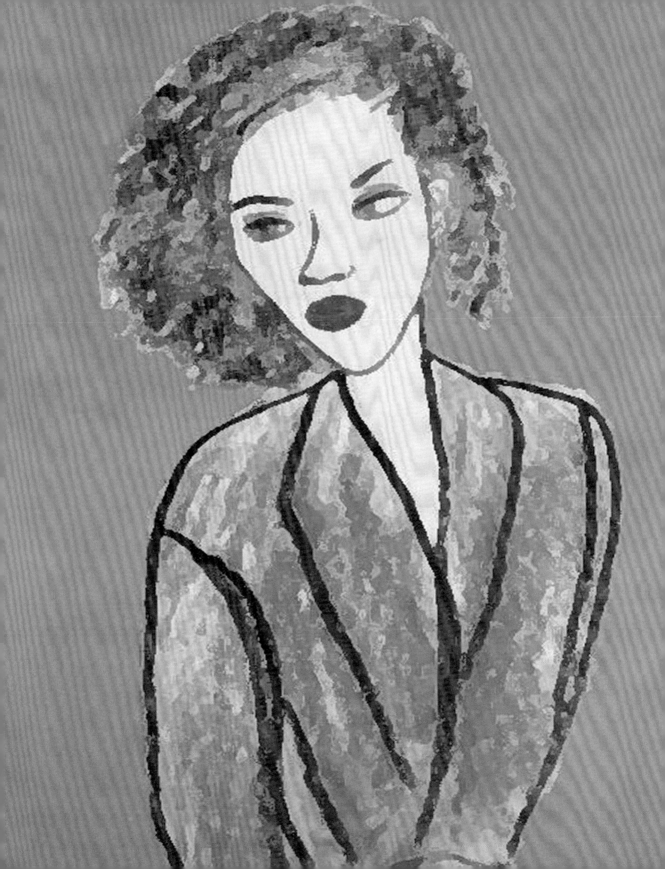

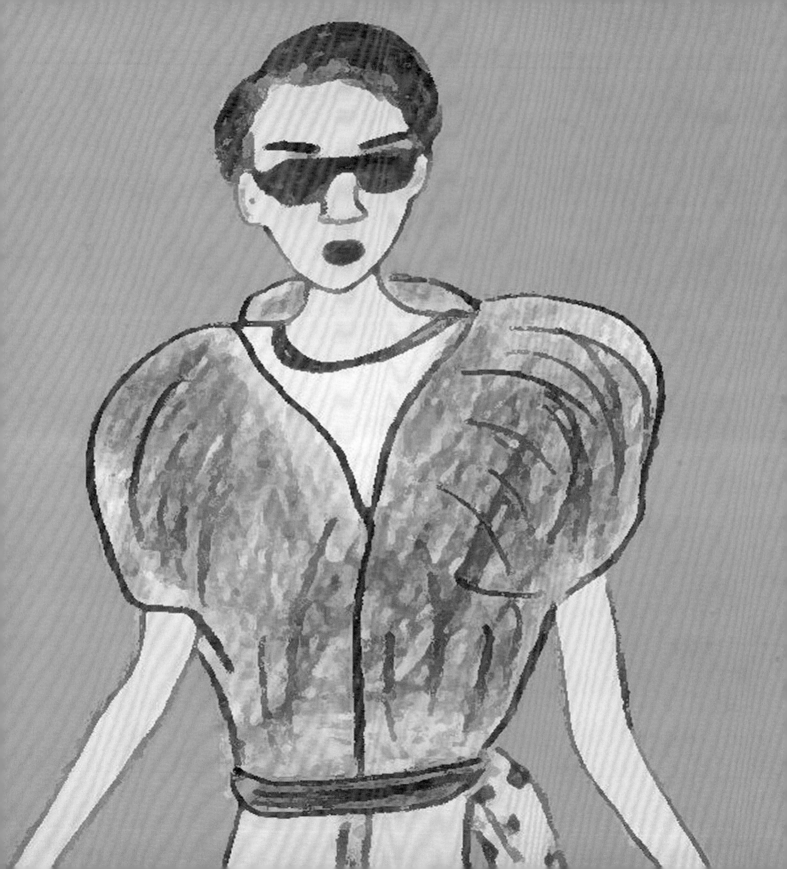

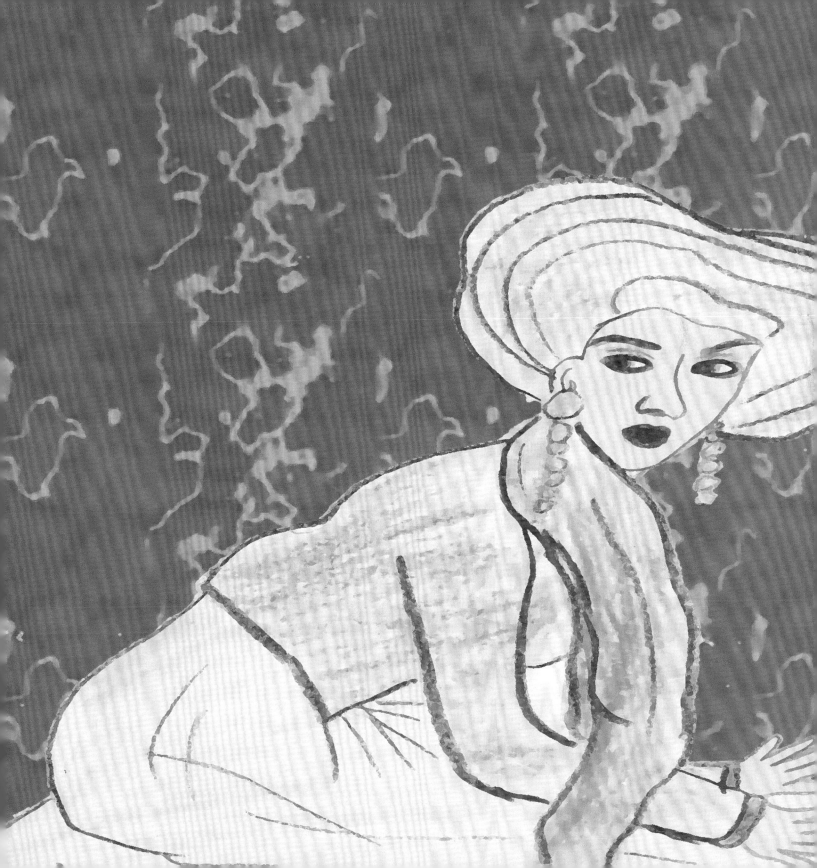

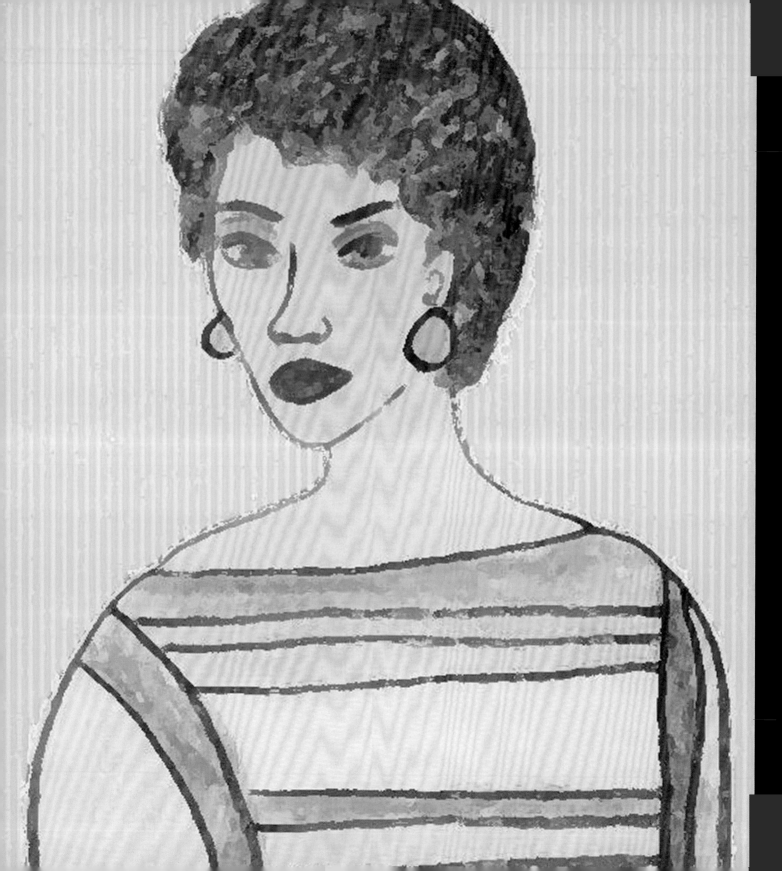

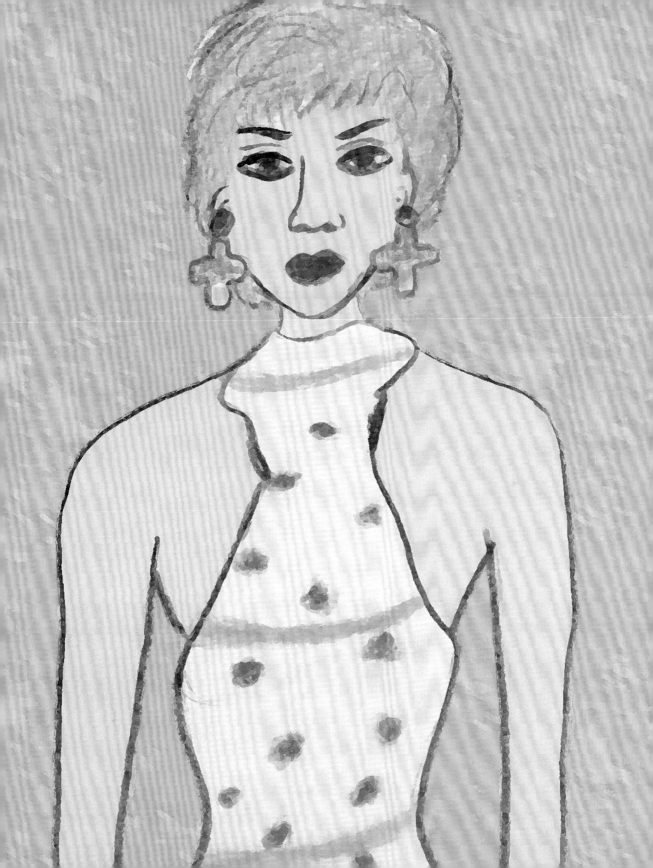

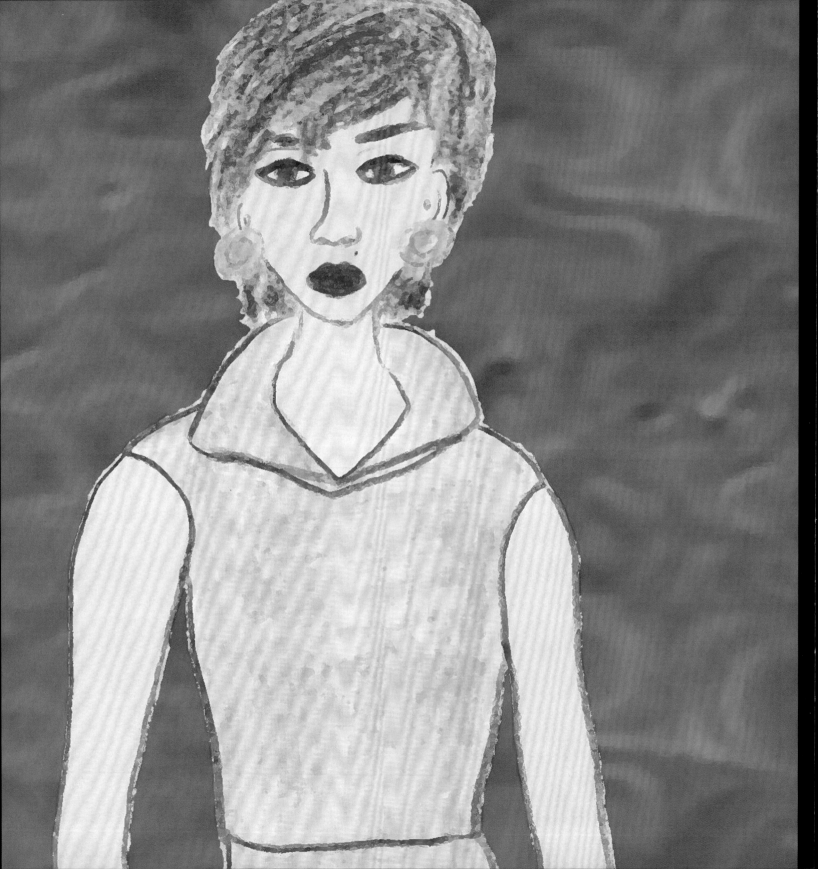

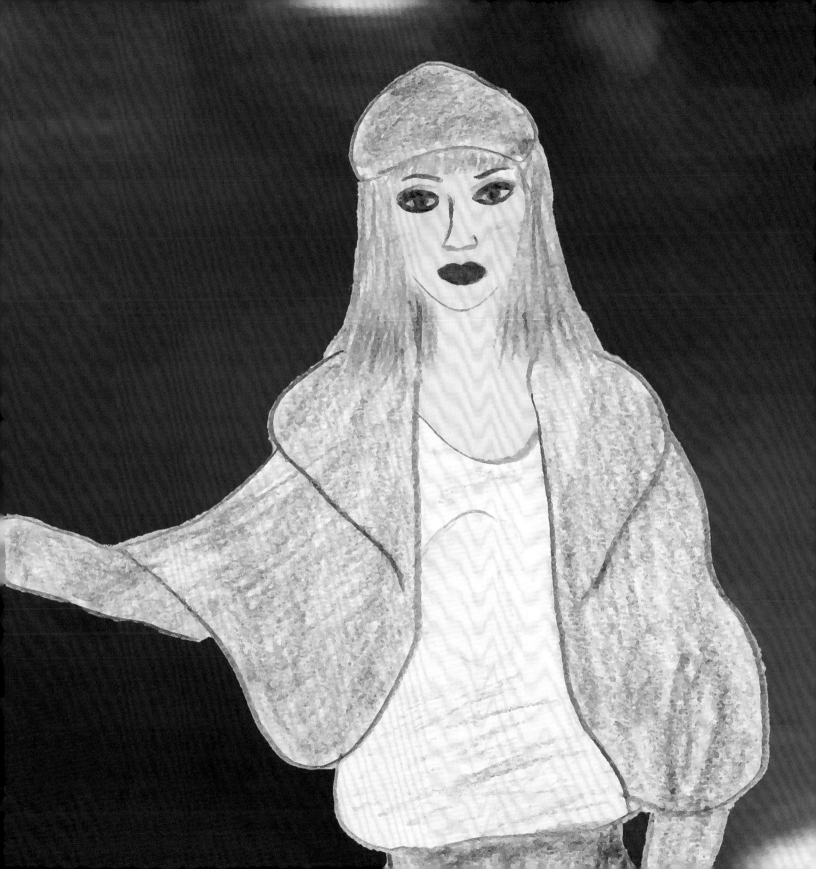

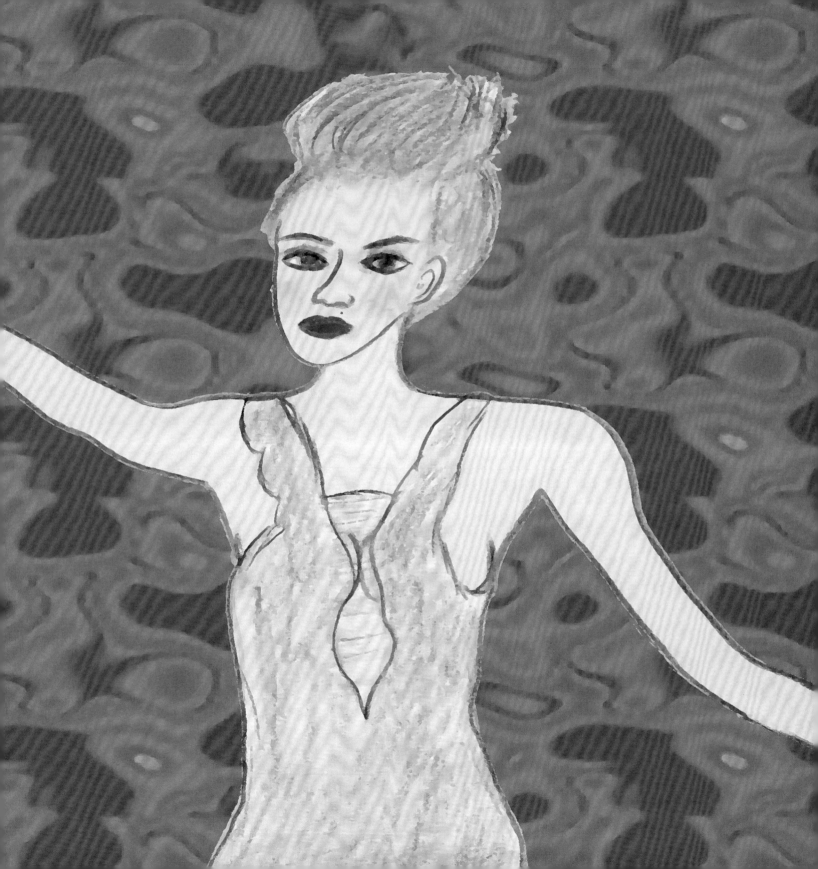

梅艷芳的個人音樂特輯
Anita Mui's TV Music Special

1984 ： 三色梅艷芳
1988 ： 梅艷芳之夢裏風情
1989 ： 梅艷芳巴西熱浪嘉年華
1991 ： 梅艷芳飛越舞台十載情
1994 ： 梅艷芳音樂特輯之情歸何處
1997 ： 梅艷芳音樂特輯之三誓盟
2001 ： 梅艷芳芳華絕代傾情夜
2003 ： 梅艷芳真心相聚

1984 : Three Colors Anita Mui
1988 : Anita Mui's Amorous Dream
1989 : Anita Mui Brazil Heat Wave Carnival
1991 : Anita Mui Flies Over The Stage For Ten Years Of Love
1994 : Anita Mui Music Special: Where Does The Love Goes To
1997 : Anita Mui Music Special - The Three Pledges
2001 : Anita Mui's Peerless Love Night
2003 : Anita Mui Met Sincerely

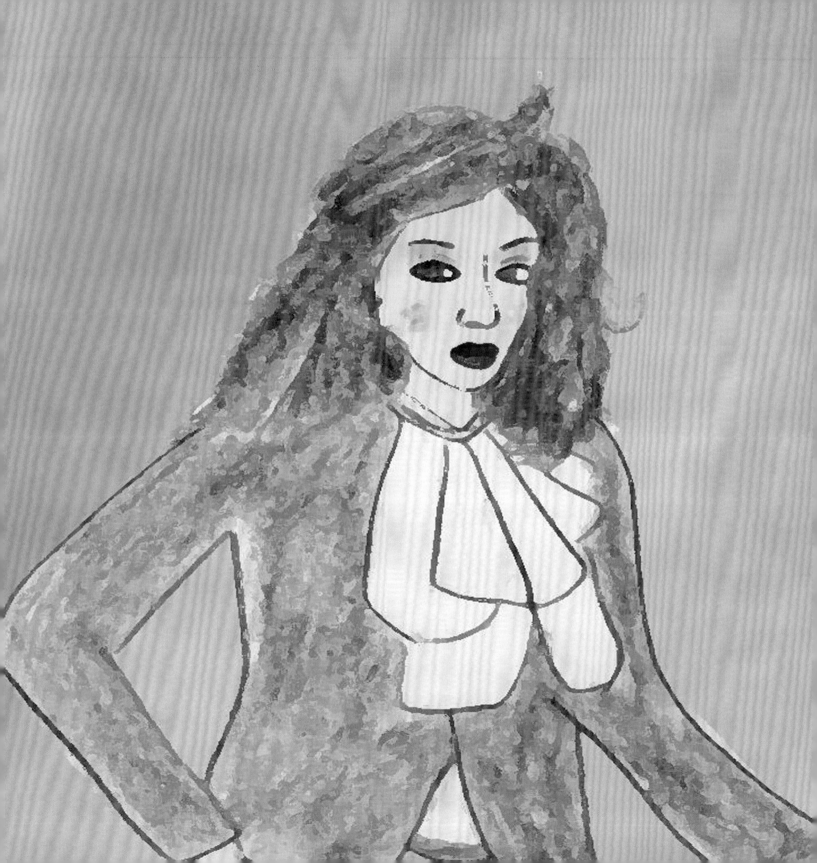

心債
Debts Of The Heart
(1982)

01. 心債 **
(TVB 電視劇《香城浪子》主題曲)
02. 情愛火花
03. 一生為你癡
04. 日夜懷念我
05. 莫問起
06. 不必想我

01. Debts Of The Heart **
(Theme Song of the TVB Drama
[Soldier of Fortune])
02. The Spark Of Love
03. Crazy For You All My Life
04. Miss Me Day And Night
05. Don't Ask
06. Don't Miss Me

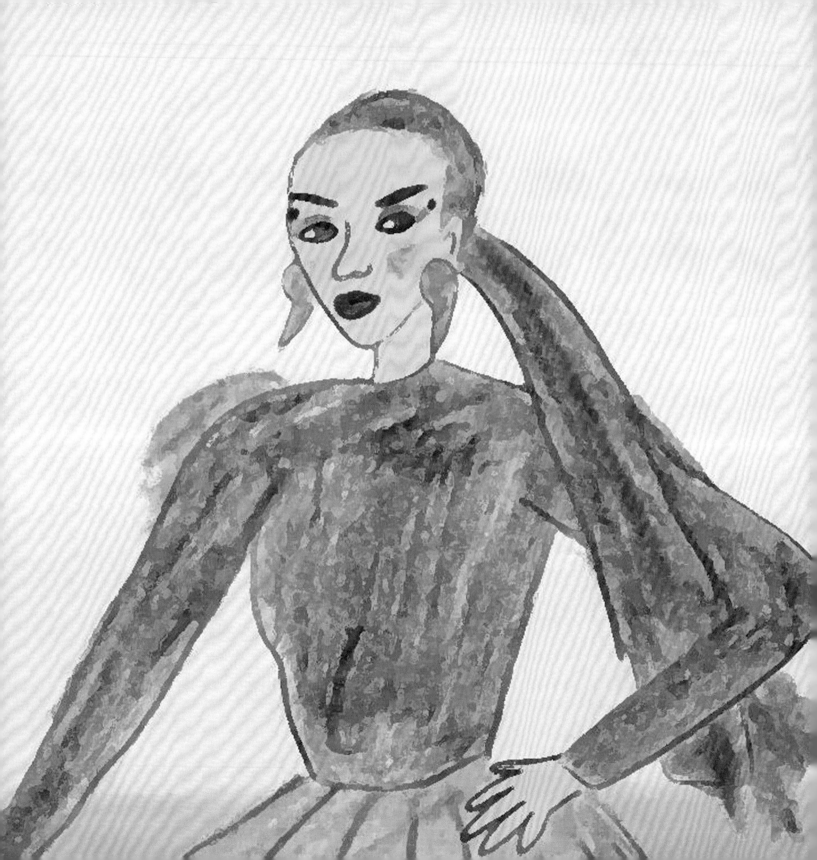

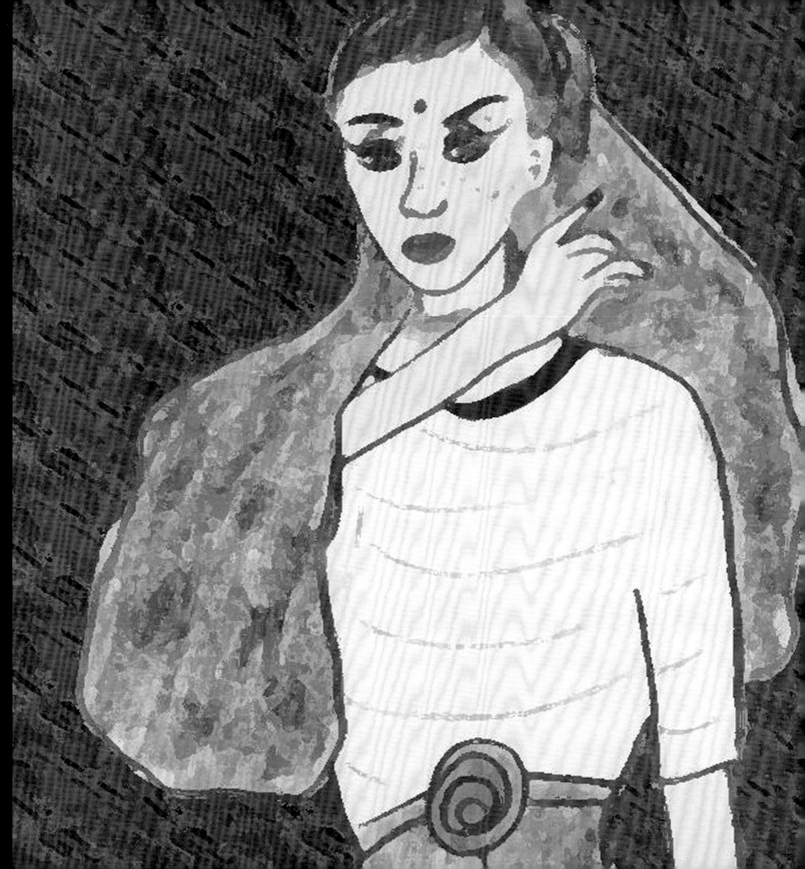

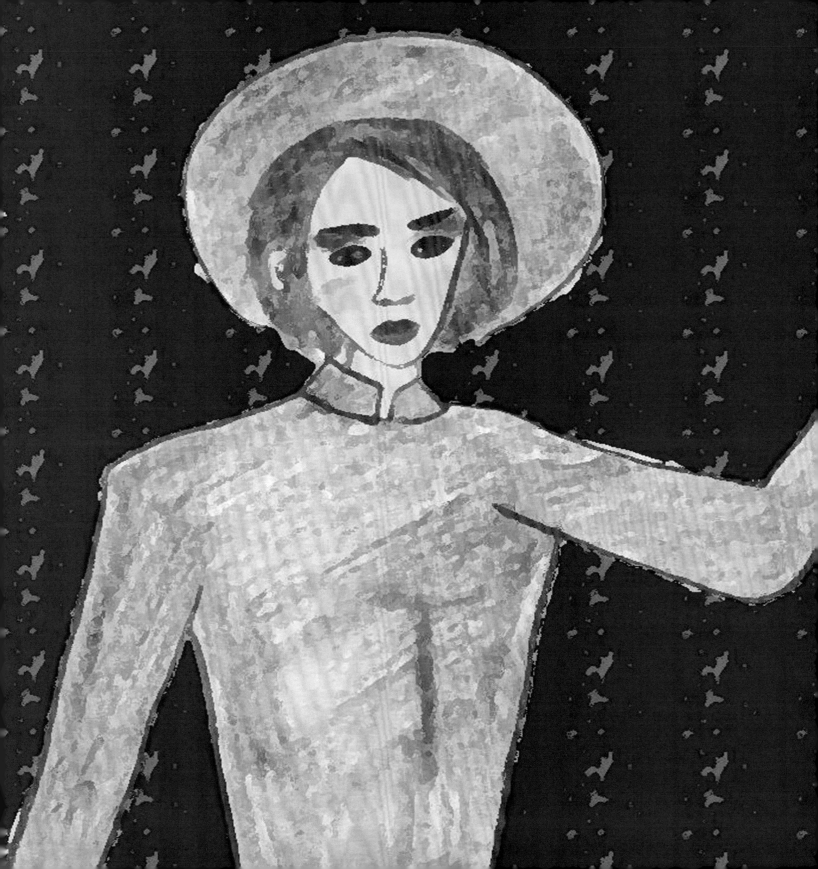

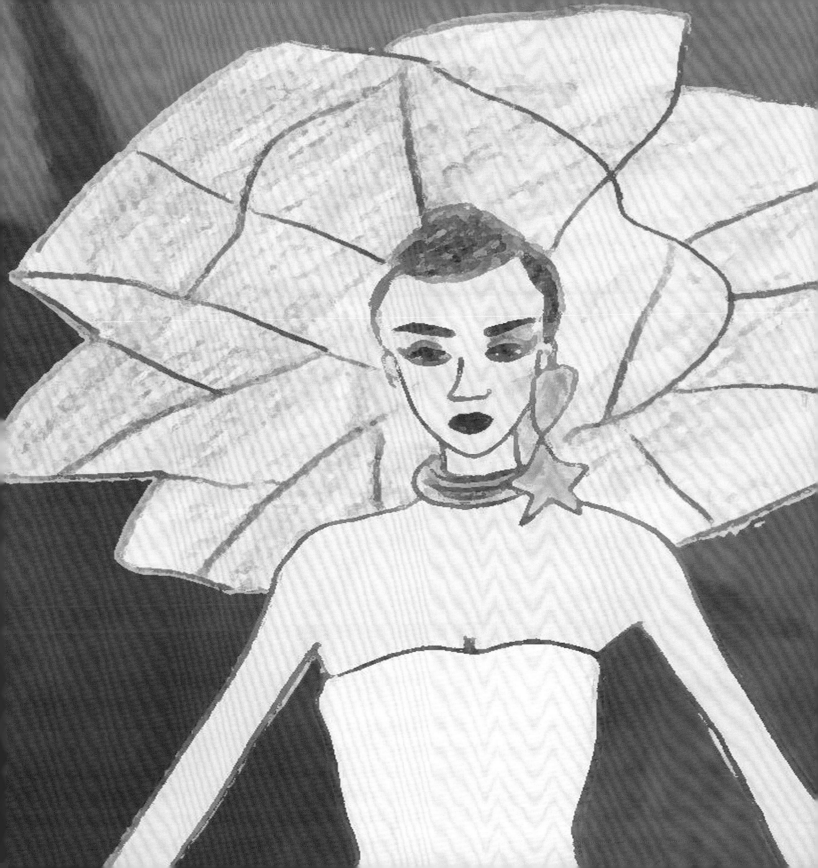

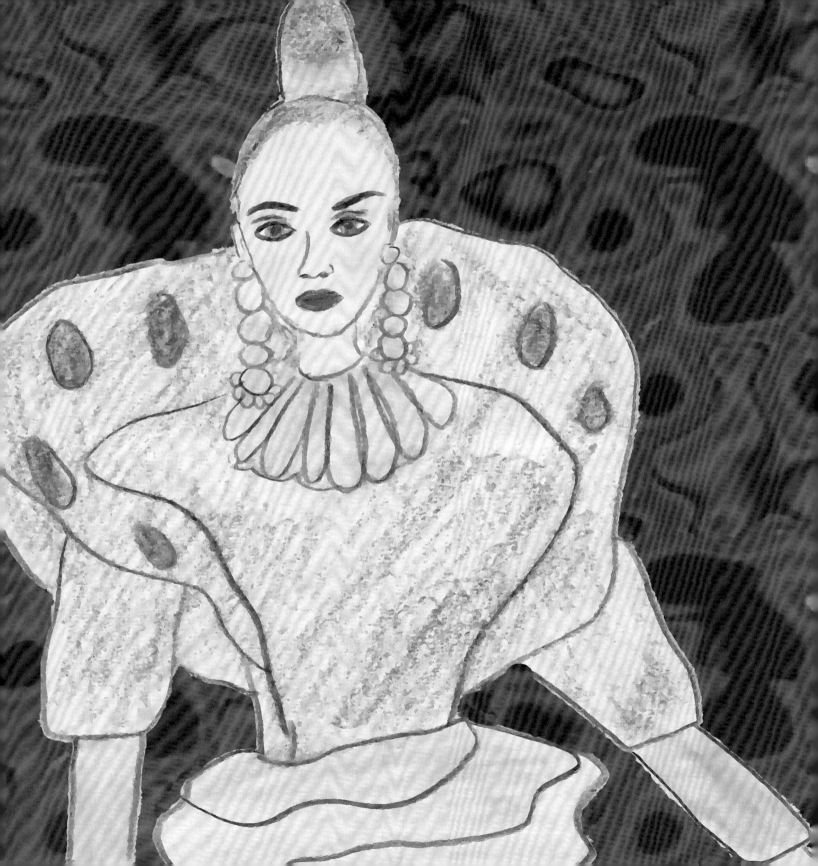

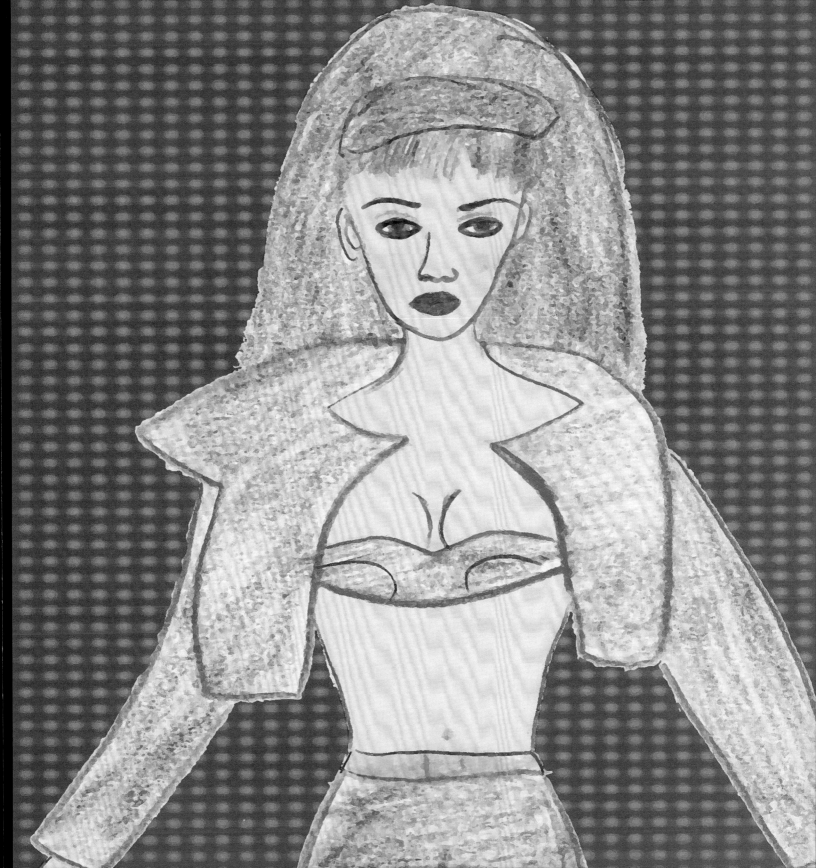

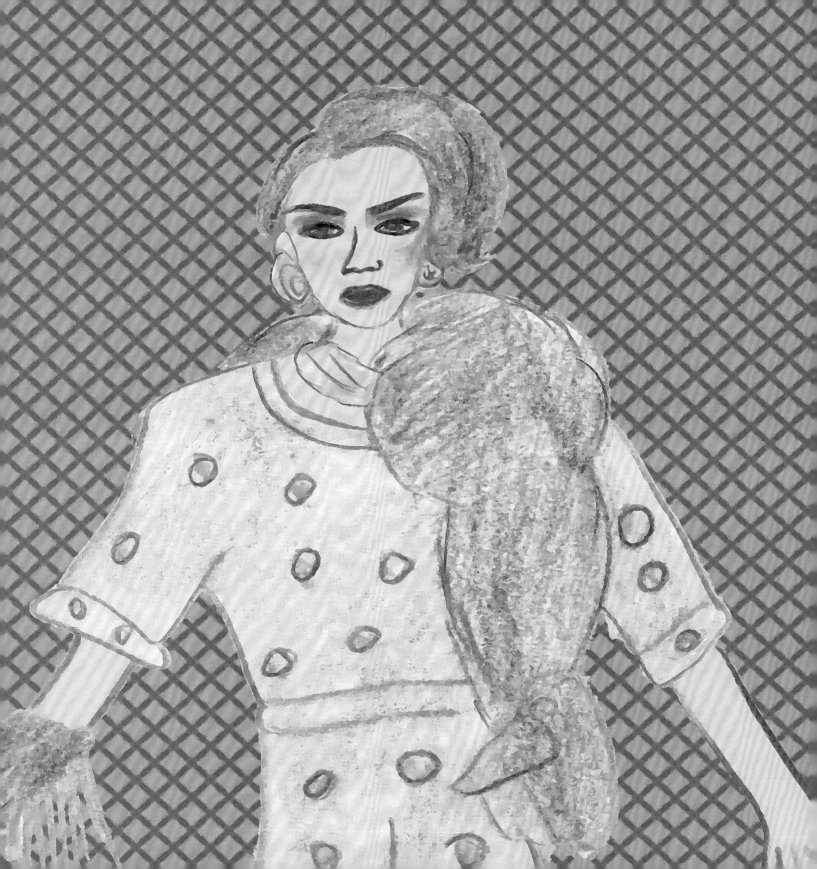

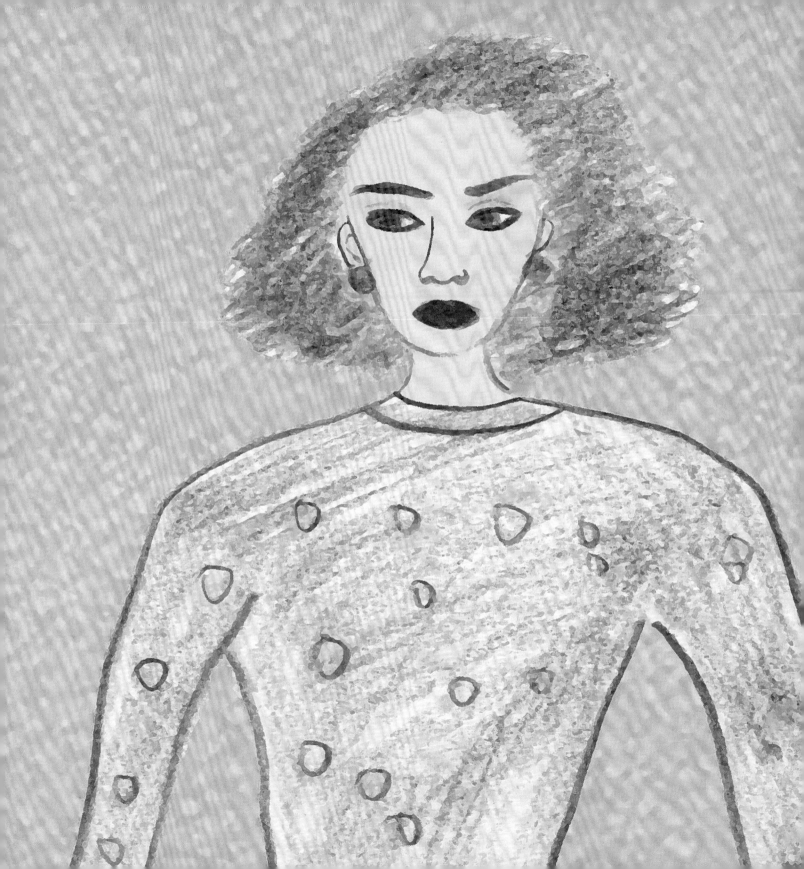

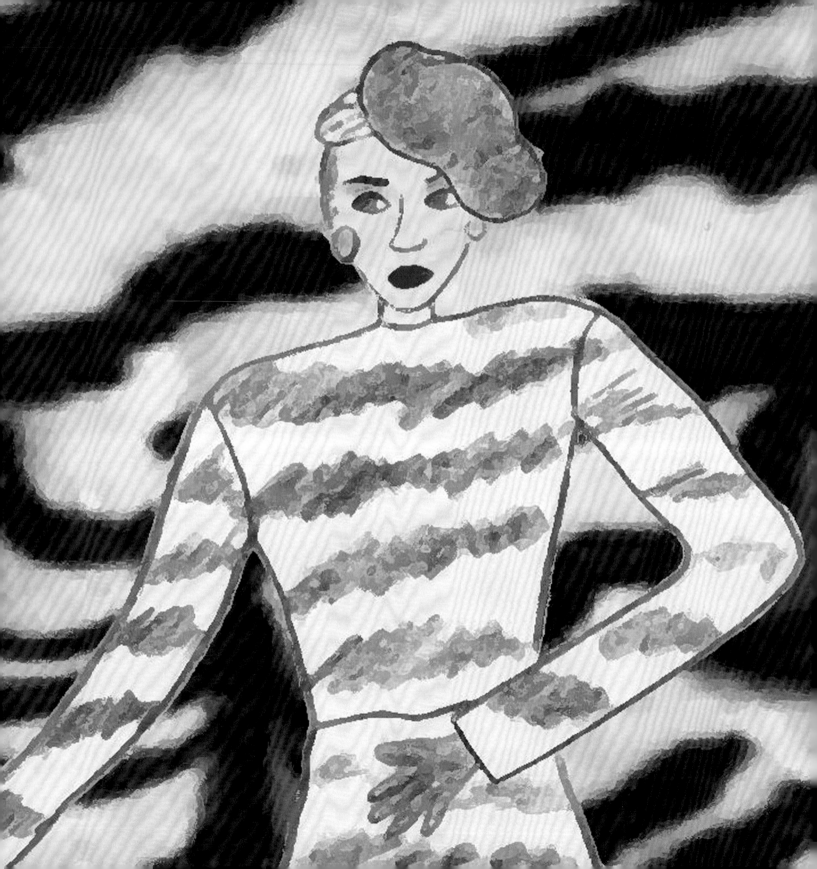

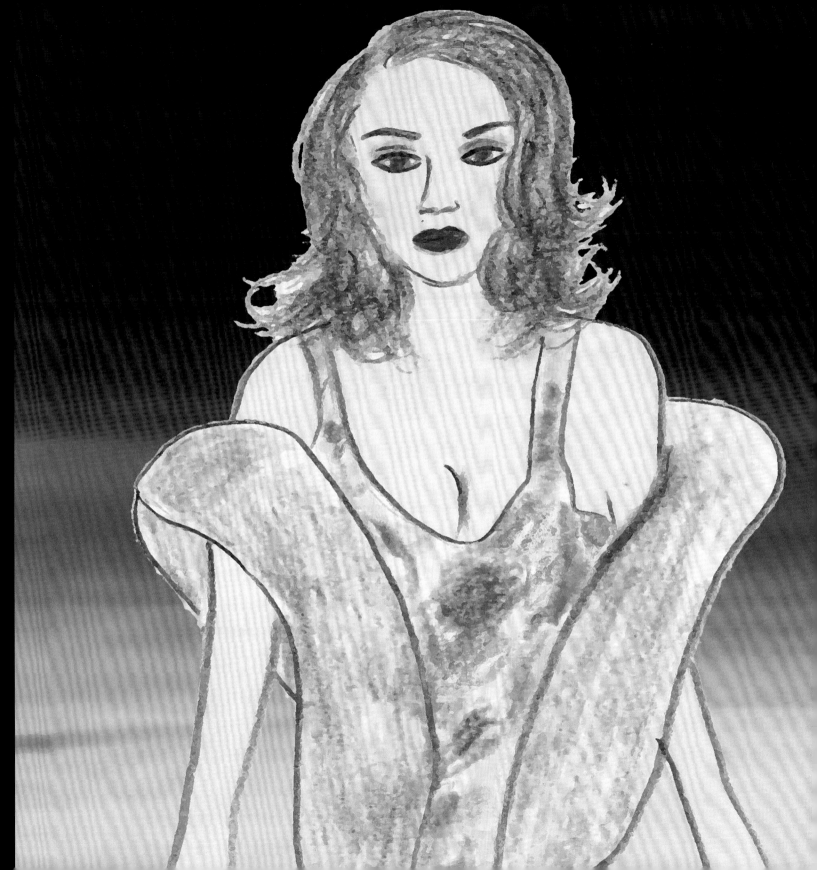

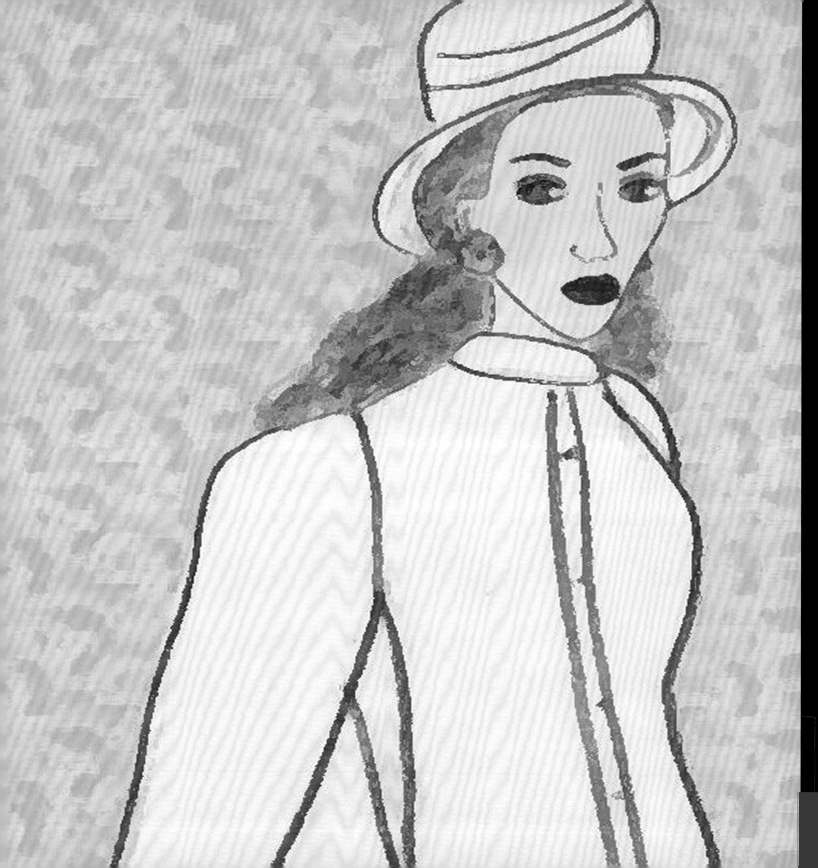

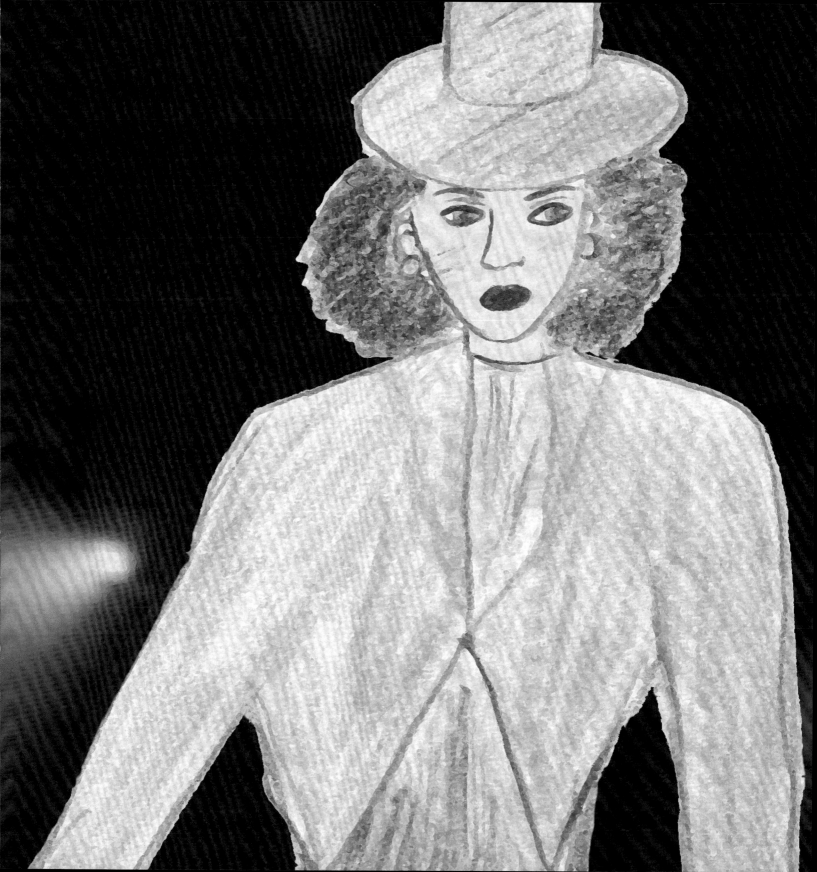

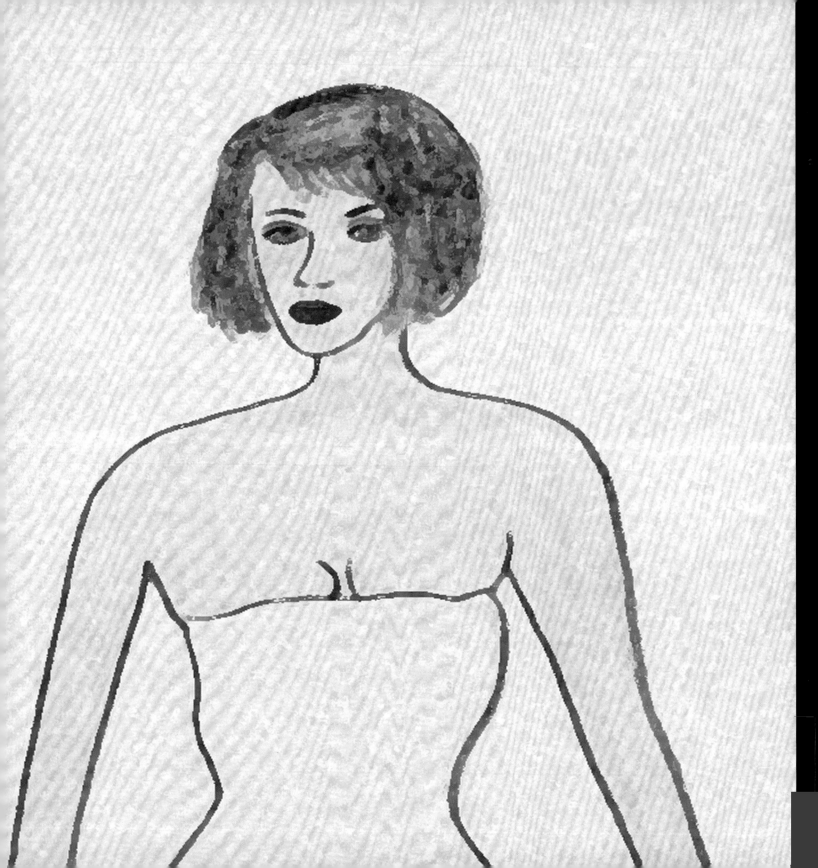

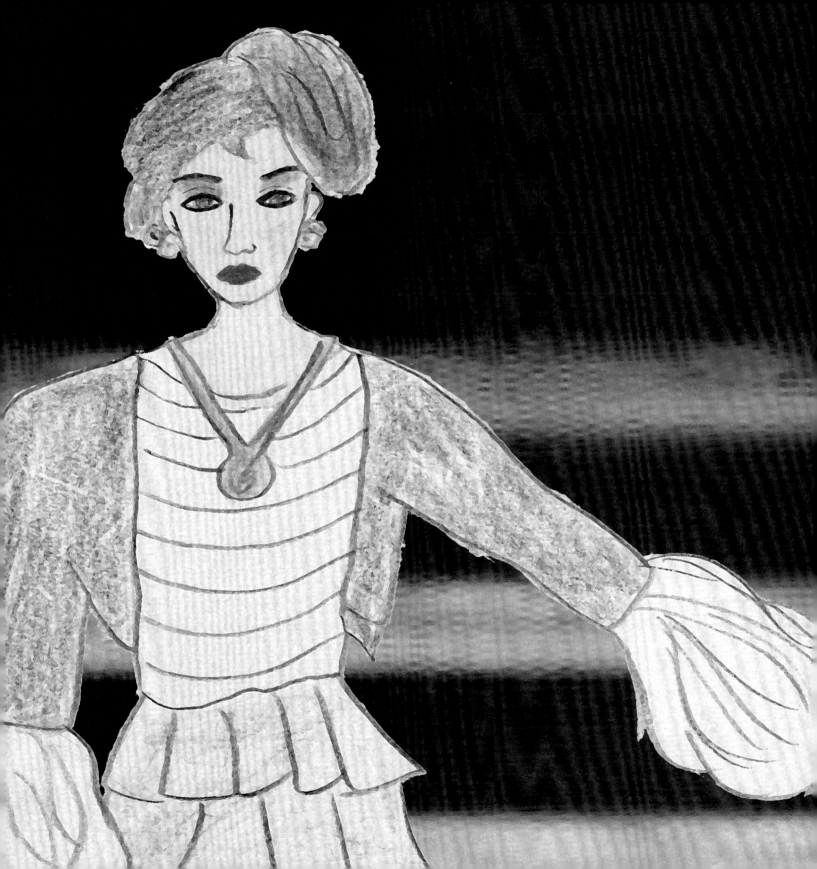

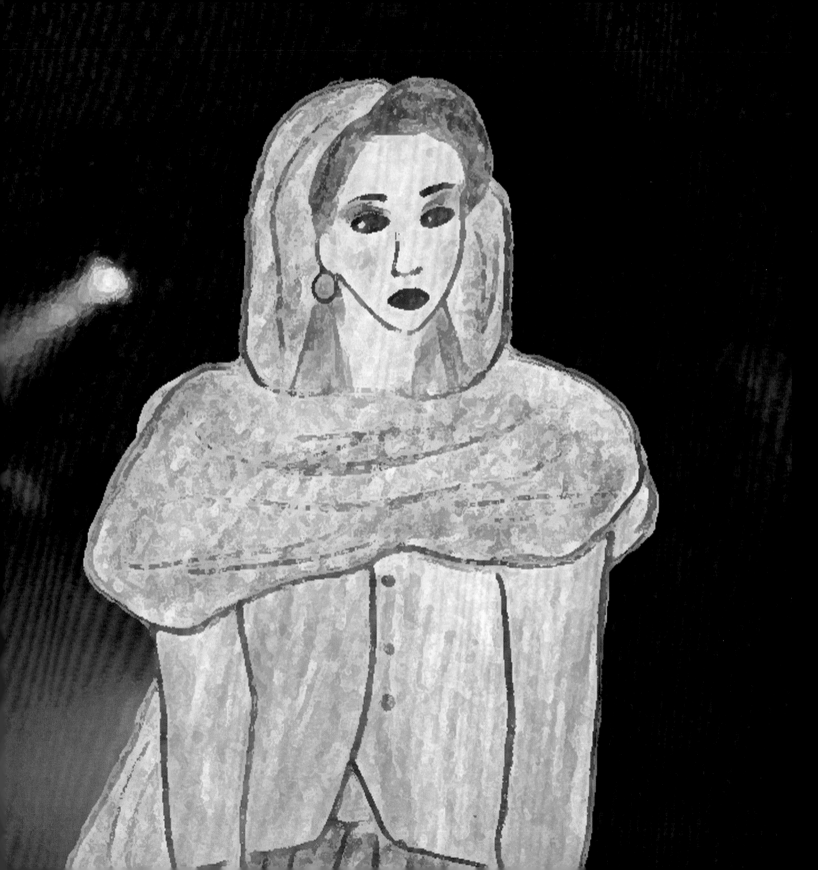

梅艷芳參與的主持節目
Hosted Programs With Anita Mui

1984 ： 亞洲青年流行音樂會
1986 ： 龍鳳呈祥賀台慶
1990 ： 萬千星輝賀台慶
1991 ： 第 10 屆香港電影金像獎頒獎典禮
1991 – 1995 ： 翡翠歌星賀台慶
1992 ： 歡樂滿東華
1992 ： 第 15 屆十大中文金曲獎頒獎典禮
1994 ： 反翻版行動

1984 : Hong Kong Asian-Pop Music Festival
1986 : TVB Anniversary Gala Show
1990 : TVB Anniversary Gala Show
1991 : The 10th Hong Kong Film Awards
1991 – 1995 : Jade Singers Celebrate TVB Anniversary
1992 : Tung Wah Charity Show
1992 : The 15th Top Ten Chinese Gold Songs Award Concert
1994 : Anti-Piracy Action

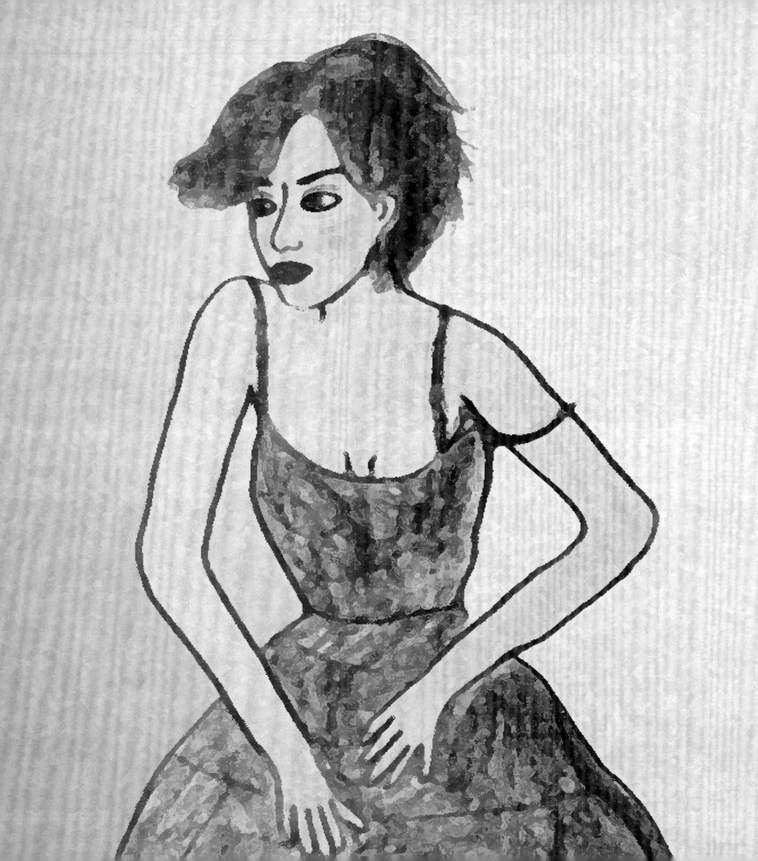

床前明月光
Moonlight On My Bed
(1998)

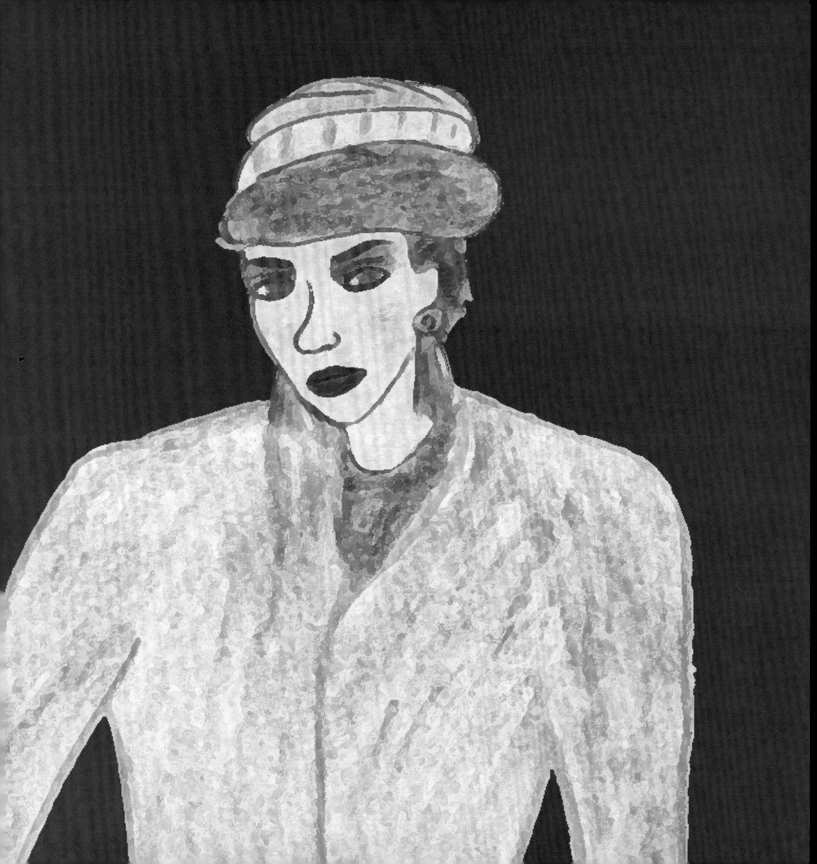

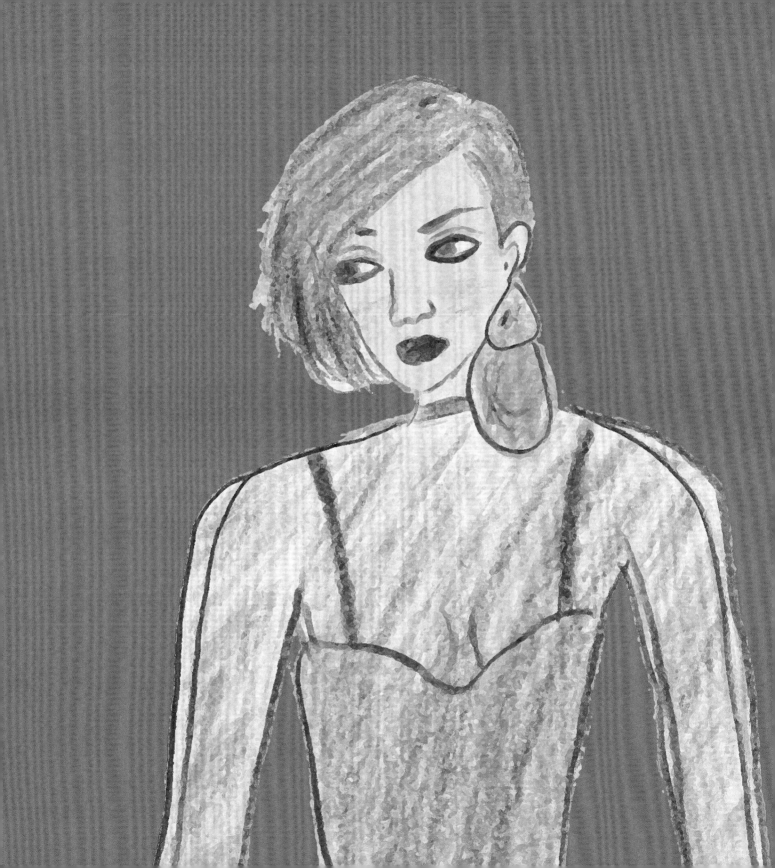

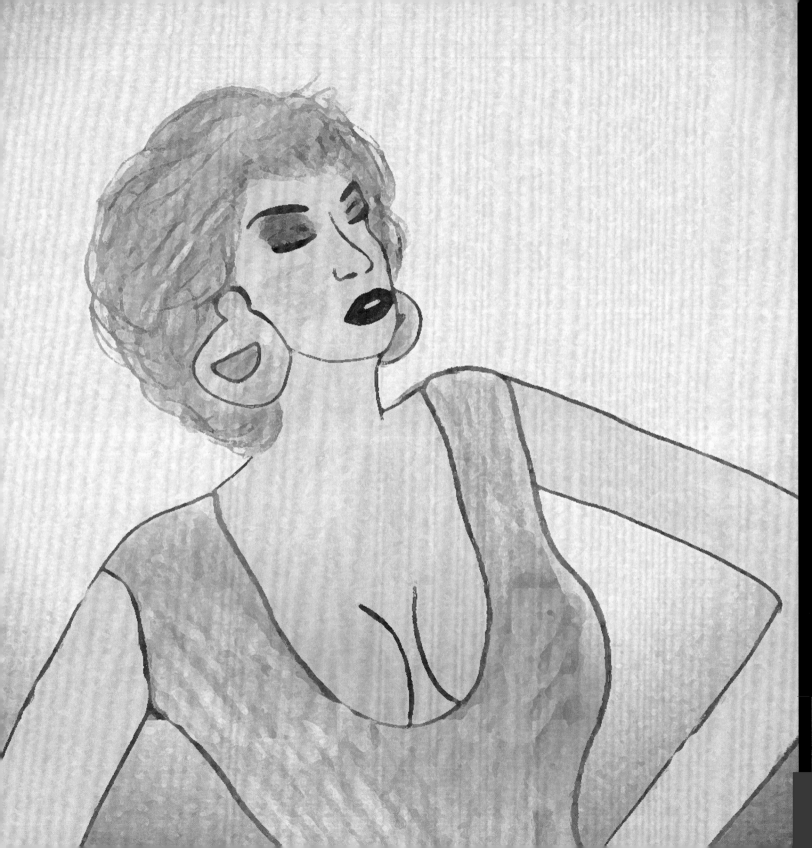

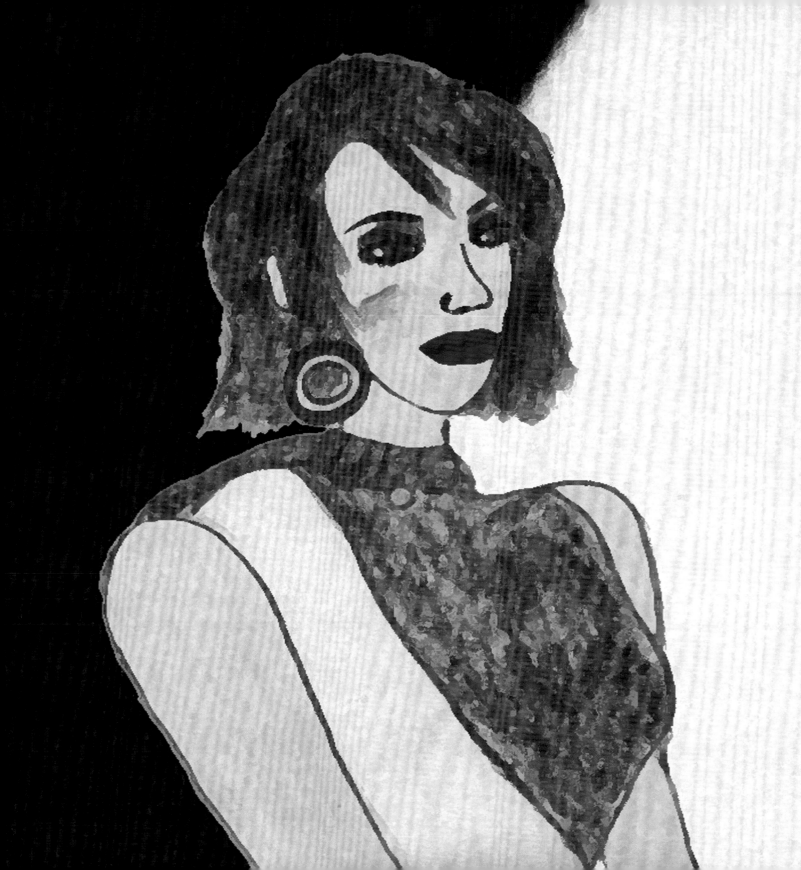

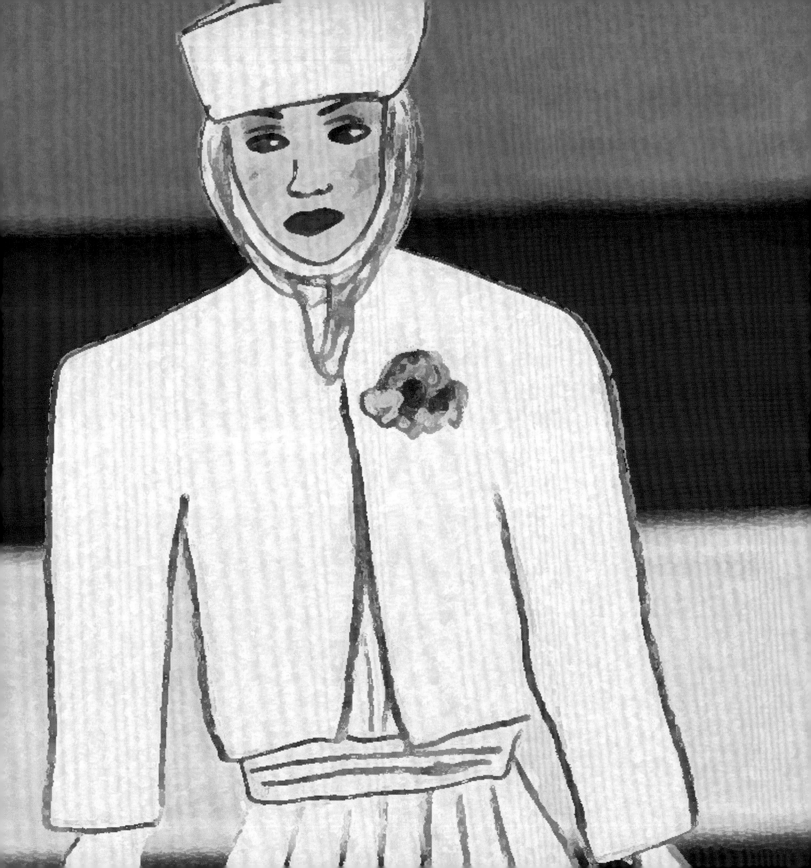

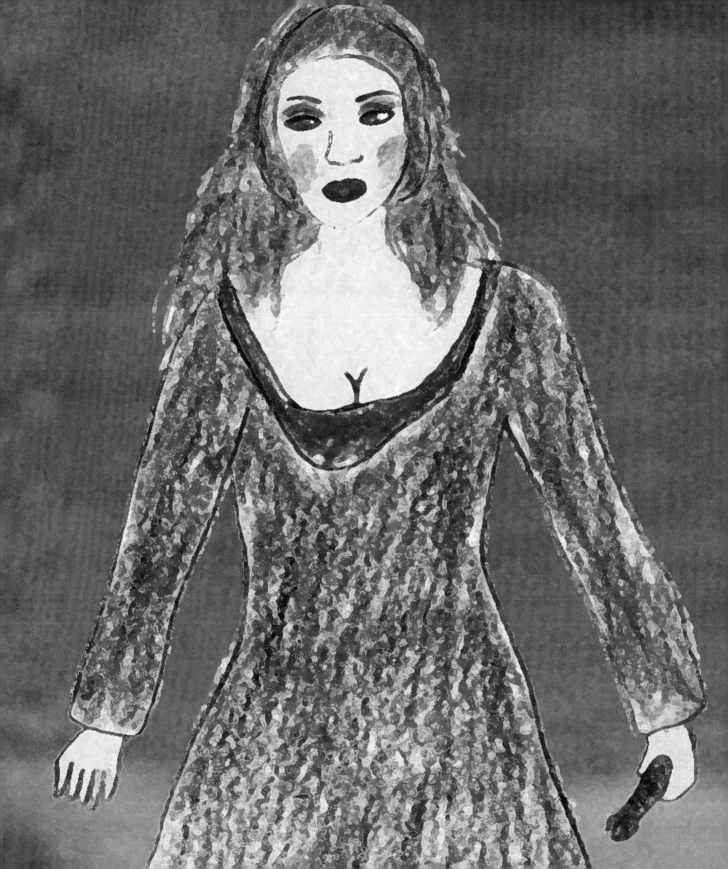

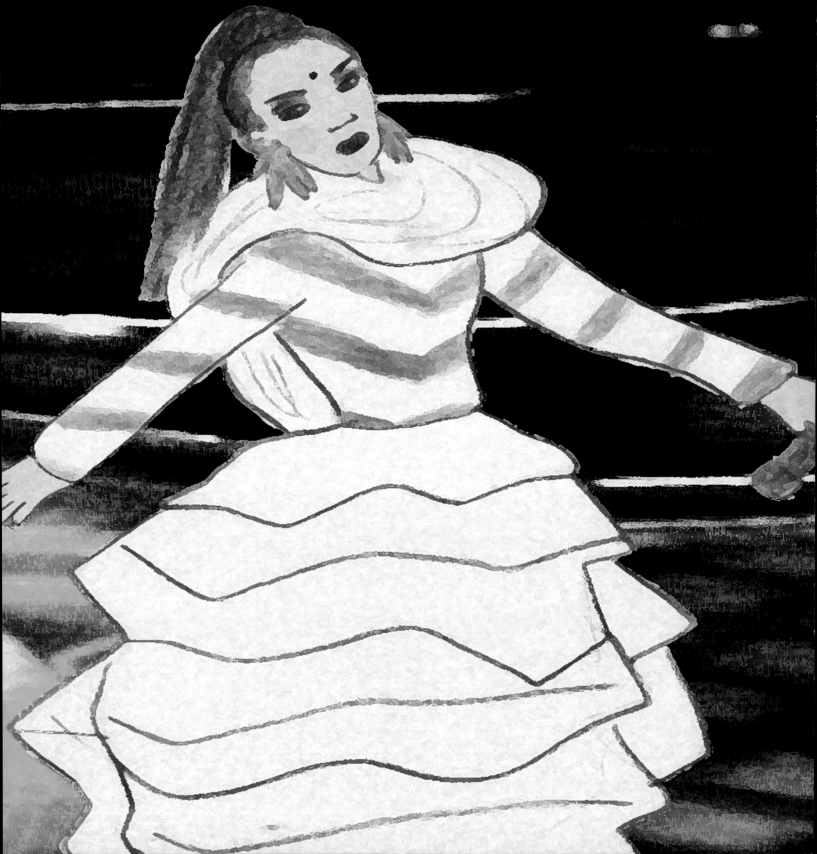

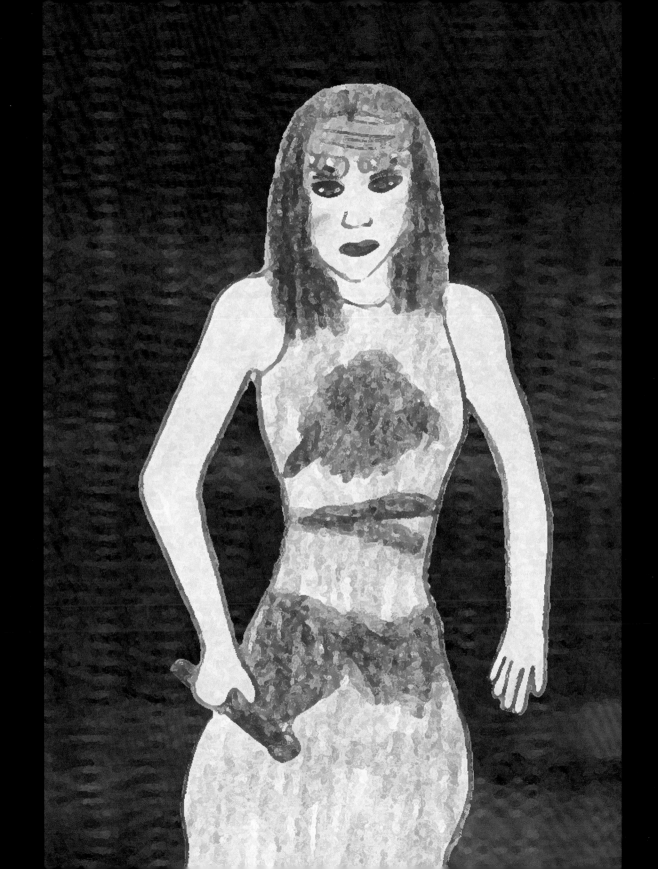

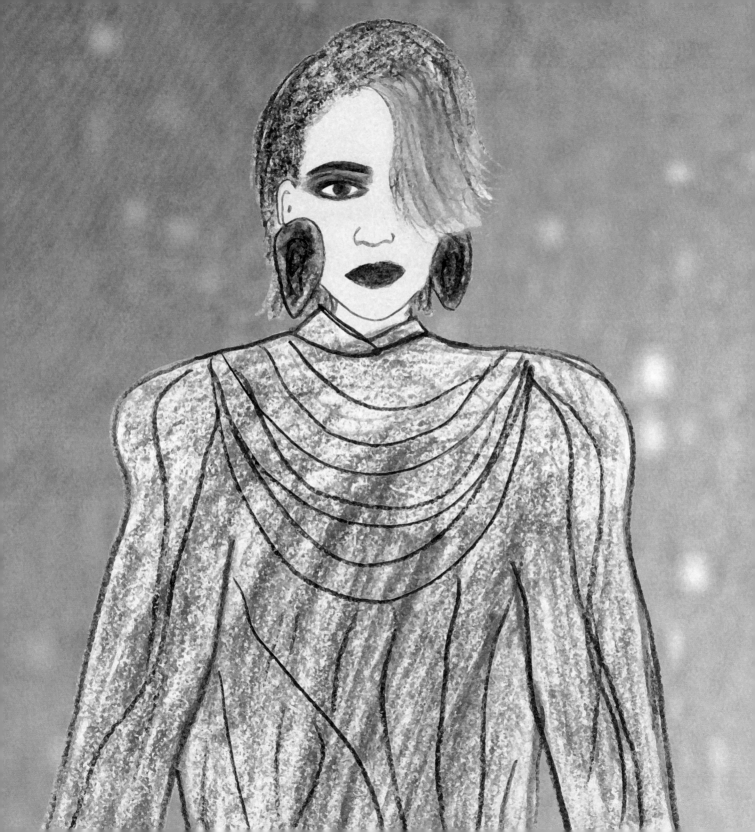

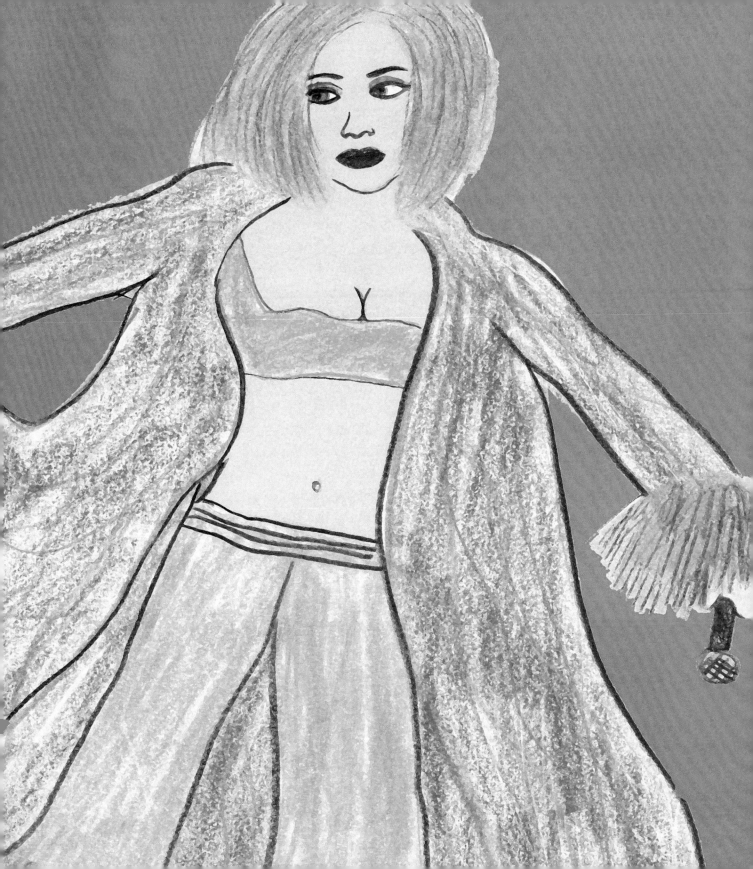

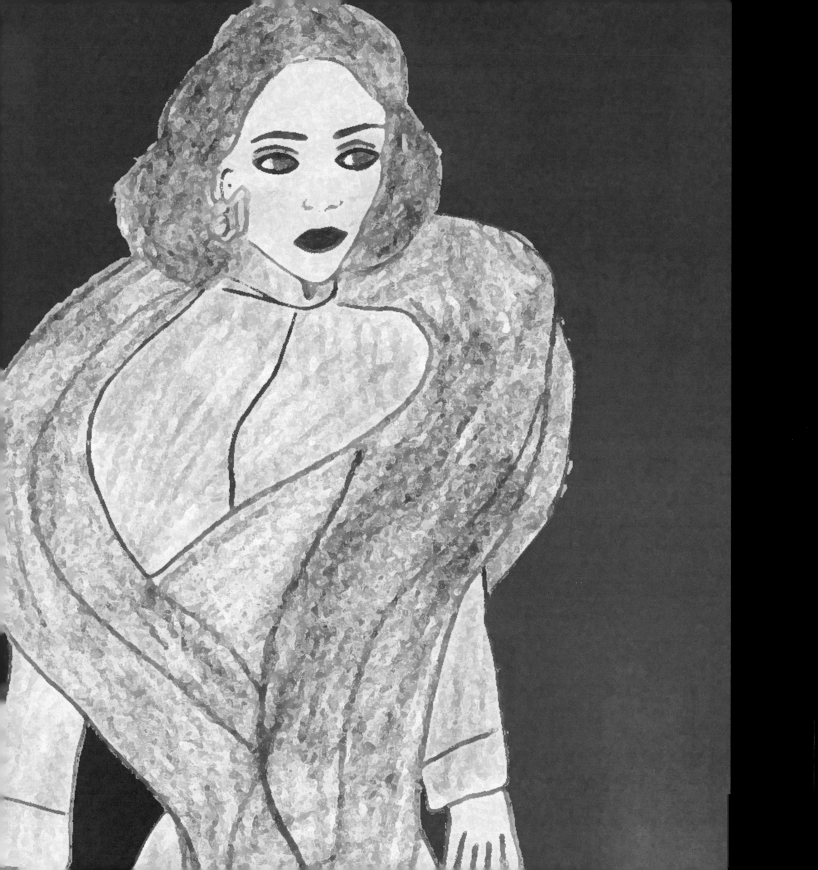

梅艷芳參與的電台廣播劇
Anita Mui's Radio Dramas

《鬼咁多情》(1988)
《年輕只有一次》(1989)
《雪融後的餘溫》(1996)
《情書》(1999)

〔Ghostly Love〕(1988)
〔Young Only Once〕(1989)
〔The Aftermath Of The Snow Melt〕(1996)
〔Love Letter〕(1999)

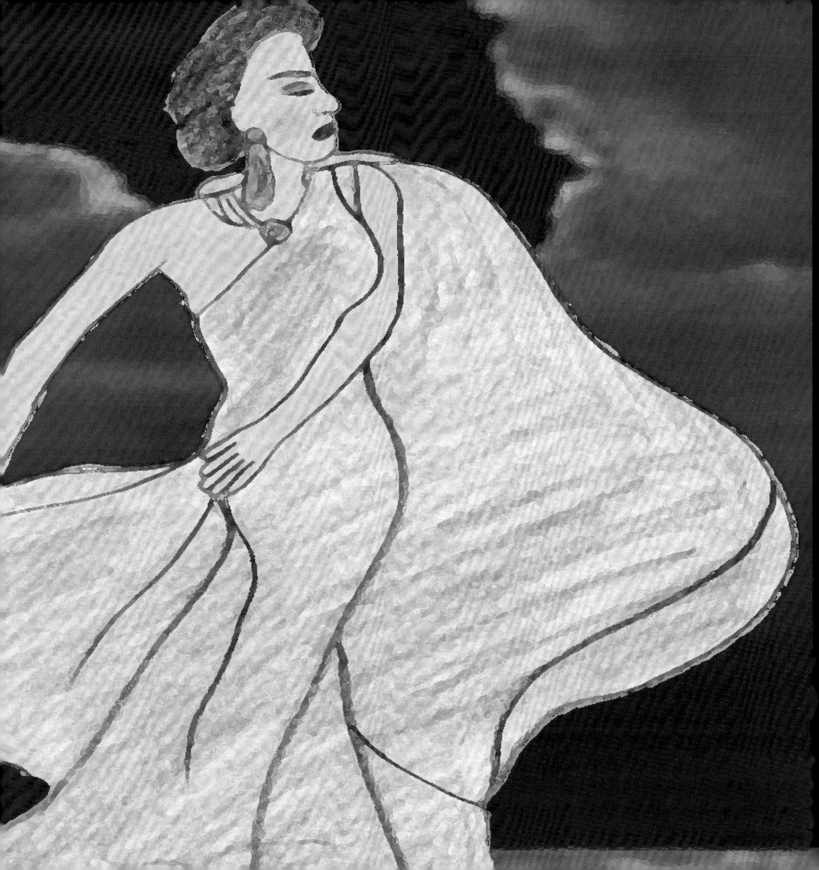

The Legend Of Pop Queen
Part I
(1992)

01. Touch **
02. 我最愛自己
03. 回頭已是百年身 **
04. 烈女 **
05. 四海一心 **
06. 逝去的愛
07. 緋聞中的女人
08. 夢幻的擁抱
09. 赤的疑惑
10. 心仍是冷（寒冬版）
　　　（倫永亮合唱）

01. Touch **
02. I Love Myself The Most
03. Too Late To Turn Back **
04. Tough Girl **
05. United In Heart **
06. Love Is Gone
07. Gossip Girl
08. Dream Embrace
09. Red Doubts
10. Heart Remains Cold
　　　(Winter Version)
　　　(Duet with Anthony Lun)

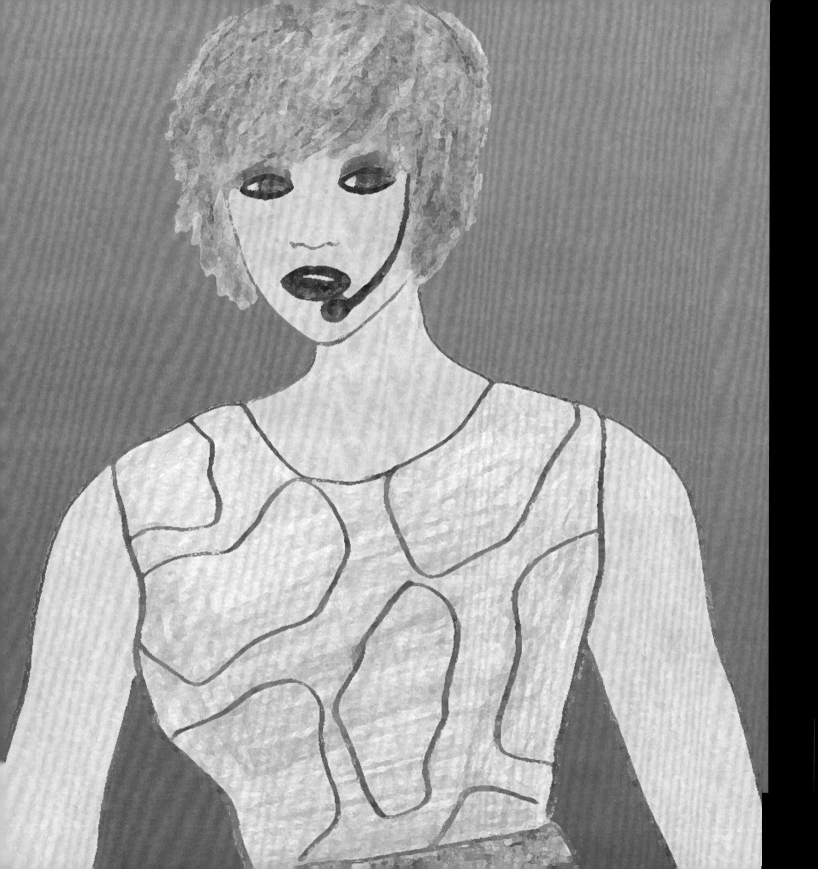

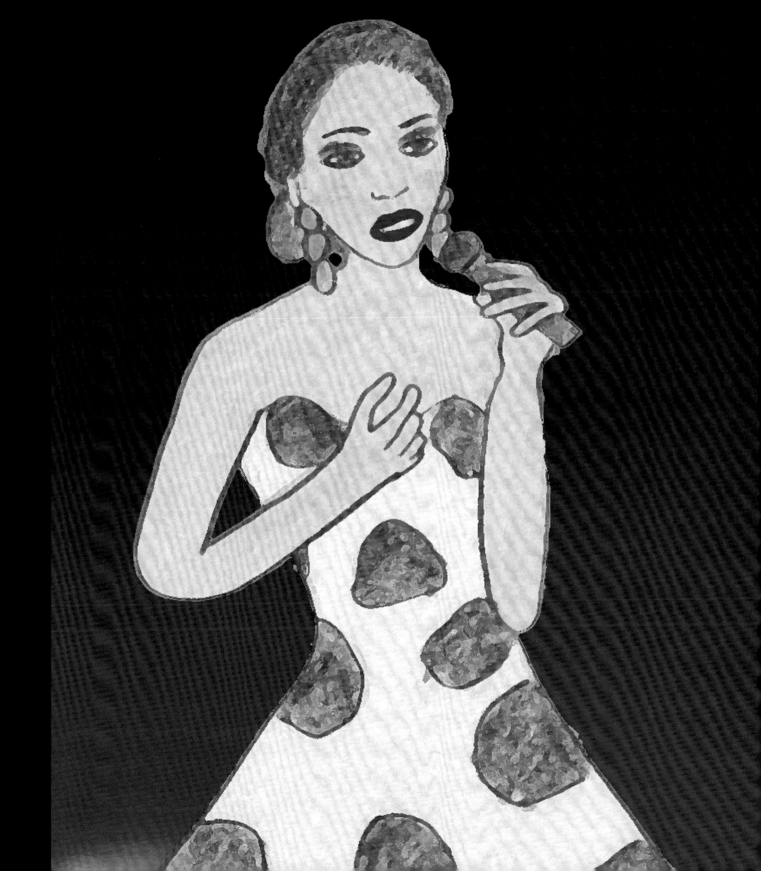

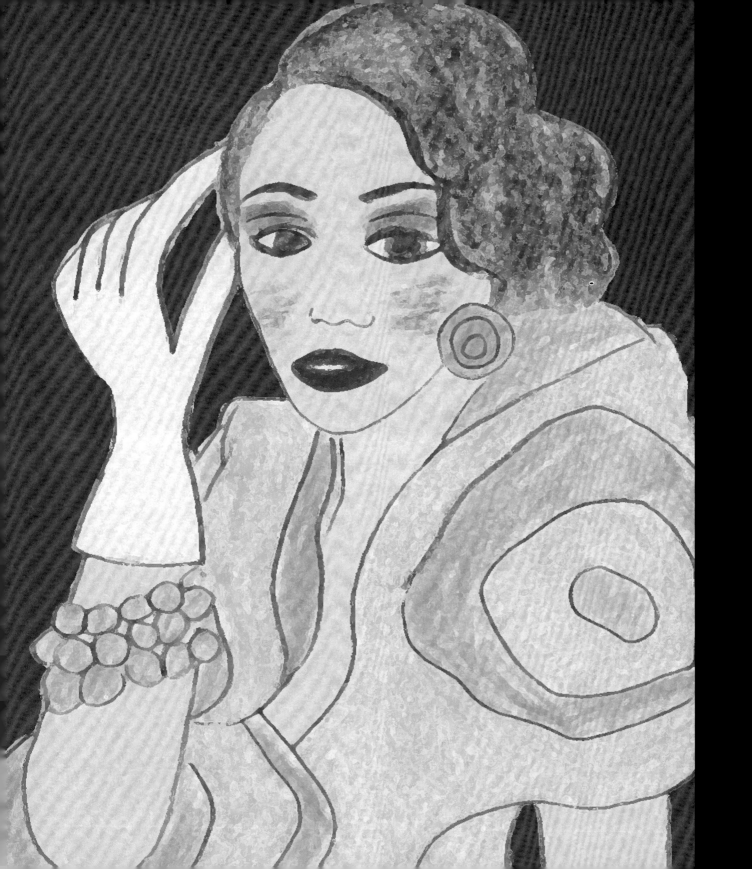

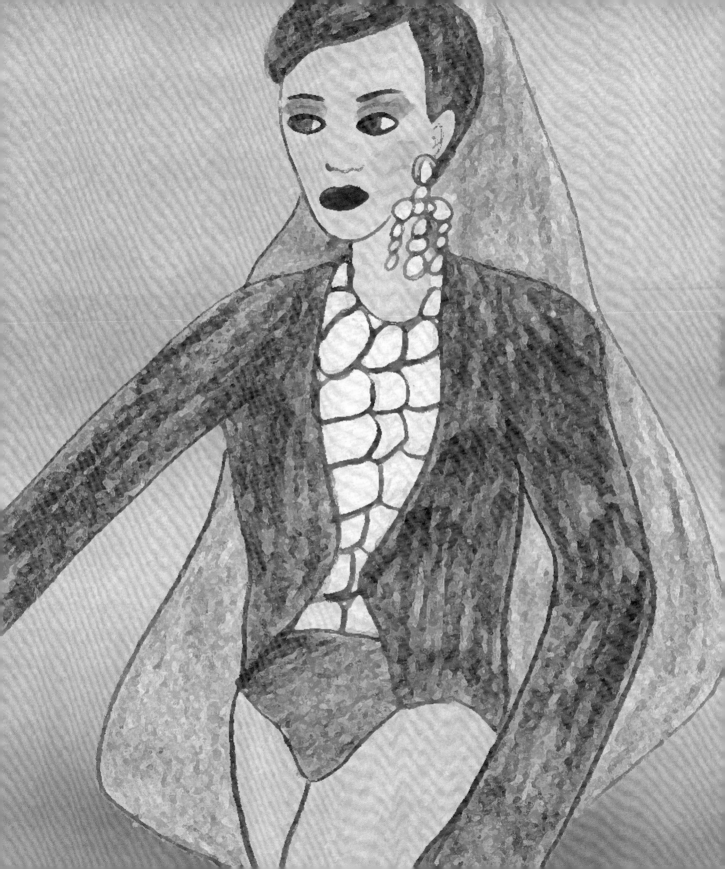

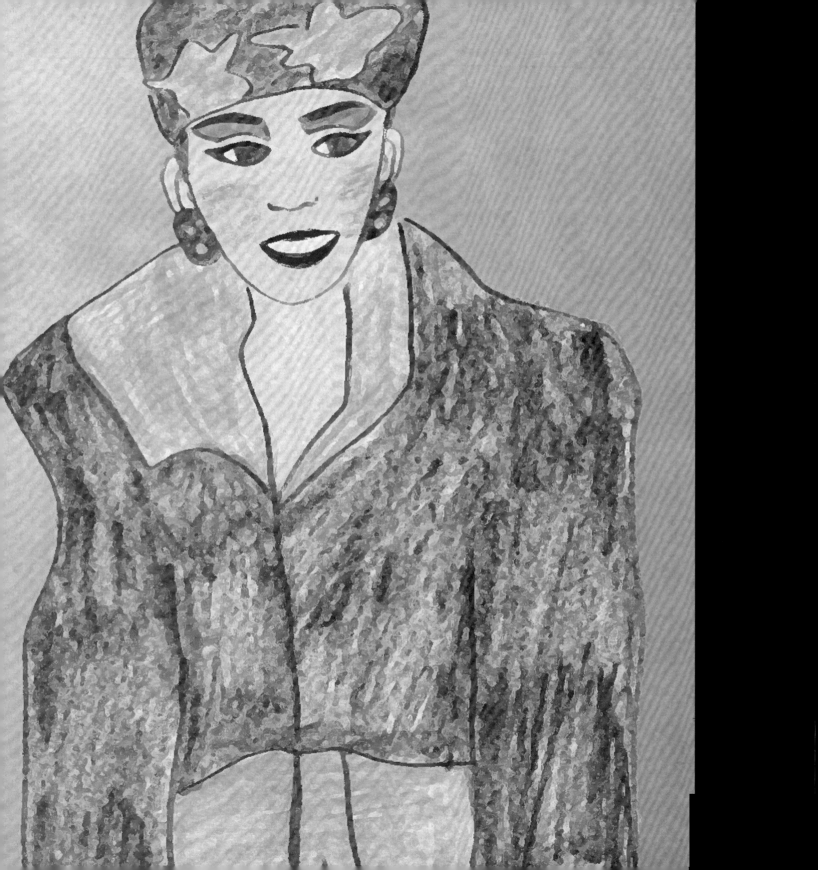

梅艷芳參與的電視劇
Anita Mui's TV Drama

《人在江湖》（1980）麗的電視
《小小心願》（1981）麗的電視
《女媧行動》（1981）麗的電視
《武俠帝女花》（1981）麗的電視
《甜甜廿四味》（1981）麗的電視
《對對糊》（1981）麗的電視
《香港八三》（1983）無綫電視
《香江花月夜》（1984）無綫電視

〔Blowing in the Wind〕(1980) Rediffusion Television Limited
〔Make A Wish〕(1981) Rediffusion Television Limited
〔Newark File〕(1981) Rediffusion Television Limited
〔Princess Cheung Ping〕(1981) Rediffusion Television Limited
〔Agency 24〕(1981) Rediffusion Television Limited
〔Four Couples〕(1981) Rediffusion Television Limited
〔Hong Kong 1983〕(1983) Television Broadcasts Limited (TVB)
〔Summer Kisses Winter Tears〕(1984) Television Broadcasts
Limited (TVB)

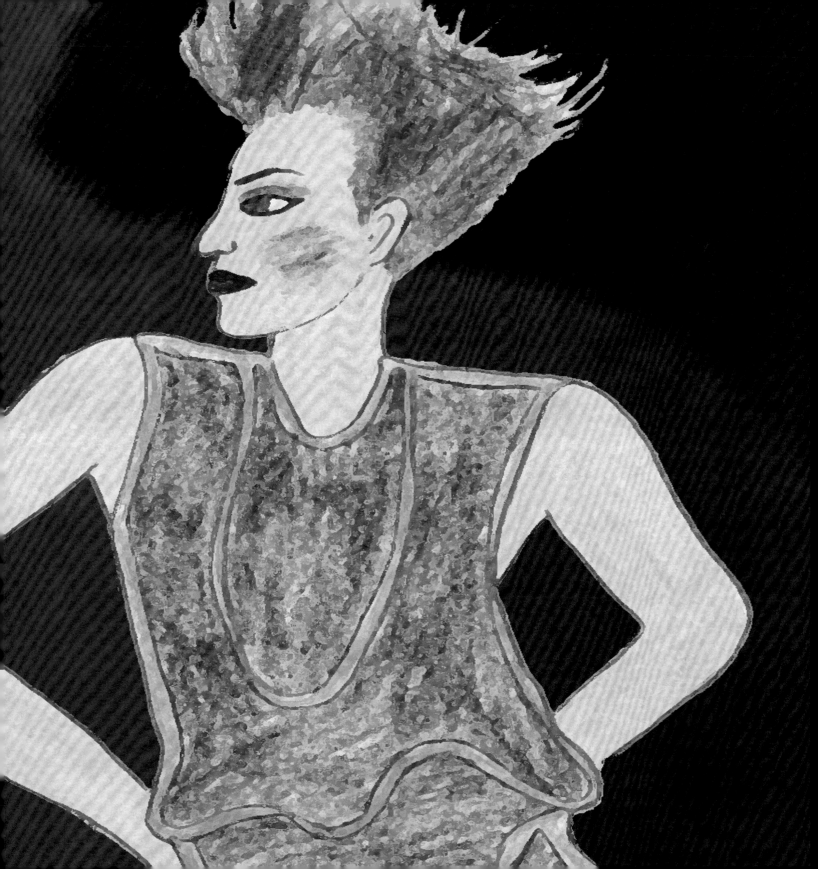

With
(2002)

01. 芳華絕代 **
 （張國榮合唱）
02. 約會
 （黃耀明合唱）
03. 花生騷
 （王菲合唱）
04. 相愛很難 **
 （張學友合唱）
05. 兩個女人
 （林憶蓮合唱）
06. 彈彈琴跳跳舞
 （劉德華合唱）
07. 夏娃，夏娃
 （陳慧琳合唱）
08. 路人甲乙
 （譚詠麟合唱）
09. 單身女子 **
 （鄭秀文合唱）
10. 兩粒糖
 （蘇永康合唱）
11. 先謊夜談
 （許志安合唱）
12. 芳華絕代亂世佳人
 (Lego Version)（張國榮合唱）
13. 路人甲乙

01. Glamour Forever **
 (Duet with Leslie Cheung)
02. Dating
 (Duet with Anthony Wong)
03. Fashion Show
 (Duet with Faye Wong)
04. Loving Is Difficult **
 (Duet with Jacky Cheung)
05. Two Women
 (Duet with Sandy Lam)
06. Play The Piano And Dance
 (Duet with Andy Lau)
07. Eve, Eve
 (Duet with Kelly Chen)
08. Passerby A and B
 (Duet with Alan Tam)
09. Single Woman **
 (Duet with Sammi Cheng)
10. Two Sugars
 (Duet with William So)
11. Lie First And Talk At Night
 (Duet with Andy Hui)
12. Glamour Forever Gone with the Wind
 (Lego Version) (Duet with Leslie Cheung)
13. Passerby A and B

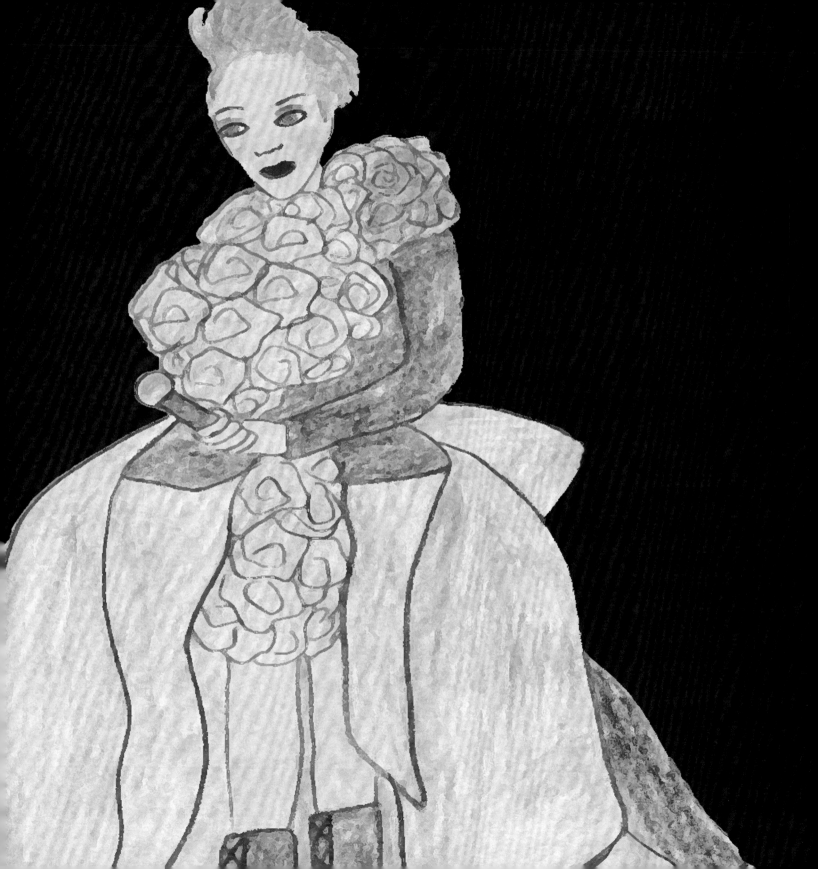

梅艷芳的出版錄音唱片專輯
Anita Mui's Studio Albums

心債 Debts Of The Heart (1982)
赤色 Red (1983)
唇をうばう前に Fantasy Of Love EP (1983)
白い花嫁 Marry Me Merry Me EP (1983)
飛躍舞台 Leaping In The Spotlight (1984)
似水流年 The Years Flow Like Water (1985)
壞女孩 Bad Girl (1985)
蔓珠莎華 Manjusaka (1986)
妖女 Temptress (1986)
似火探戈 Burning Tango (1987)
烈焰紅唇 Flaming Red Lips (1987)
百變梅艷芳烈餤紅唇 國語專輯 Everchanging Anita Mui: Flaming Red Lips Mandarin Album (1988)
百變梅艷芳再展光華 87-88 演唱會 Everchanging Anita Mui Live In Concert 87-88 (1988)
夢裡共醉 Drunk In Dreams Together (1988)
醉人情懷 Mellow EP (1988)
We'll Be Together EP (1988)
淑女 Lady (1989)
In Brasil (1989)
愛我便說愛我吧 Say It If You Love Me EP (1989)
封面女郎 Cover Girl (1990)
百變梅艷芳夏日耀光華演唱會 Everchanging Anita Mui Live In Concert 90 (1990)
親密愛人 Intimate Lover (1991)
慾望野獸街 Jungle Of Desire (1991)
The Legend Of Pop Queen ~ Part I (1992)
The Legend Of Pop Queen ~ Part II (1992)
是這樣的 It's Like This (1994)
小心 Caution (1994)
歌之女 Songtress (1995)
梅艷芳一個美麗的回響演唱會 Anita Mui Live In Concert 1995 (1995)
鏡花水月 Illusions (1997)
女人花 Flower Of Women (1997)
梅艷芳芳蹤乍現台北演唱實錄 Anita Mui Live In Taipei (1997)
變奏 Variation Of Rythmms (1998)
床前明月光 Moonlight On My Bed (1998)
Larger Than Life (1999)
沒話說 Nothing To Say (1999)
I'm So Happy (2000)
With (2002)
梅艷芳極夢幻演唱會 Anita Mui Fantasy Gig 2002 (2002)
永遠的... 梅艷芳 Forever... Anita Mui (2004)
Anita Classic Moment Live (2004)

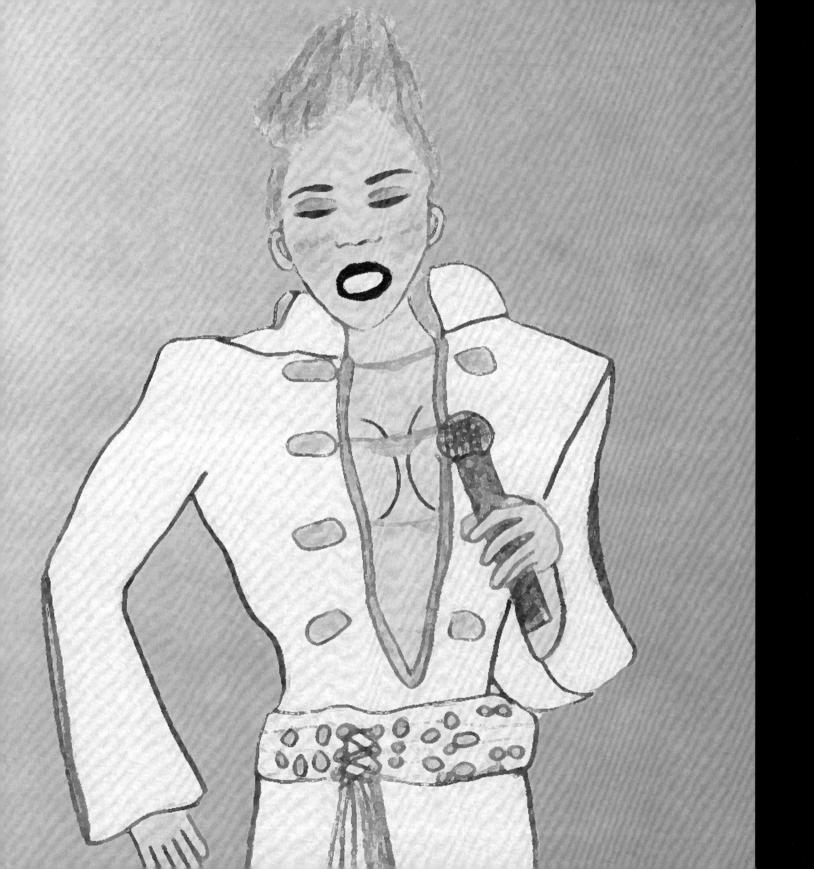

梅艷芳極夢幻演唱會
Anita Mui Fantasy Gig 2002
(2002)

01. Stand By Me	01. Stand By Me
02. 將冰山劈開	02. Break The Iceberg
03. 愛我便說愛我吧	03. Say It If You Love Me
04. 長藤掛銅鈴	04. Hanging The Bell On The Rattan
05. Medley：艷舞台 + 烈焰紅唇	05. Medley: Brilliant Stage + Flaming Red Lips
06. Medley：憑什麼 + 假如我是男人 + 黑夜的豹	06. Medley: On What Grounds + If I Were A Man + Night Leopard
07. 蔓珠莎華	07. Manjusaka
08. Oh No! Oh Yes!	08. Oh No! Oh Yes!
09. Wonderful Tonight	09. Wonderful Tonight
10. 是這樣的	10. It's Like This
11. 夢幻的擁抱	11. Dream Embrace
12. 夢姬	12. Dream Temptress
13. 烈女	13. Tough Girl
14. 心債	14. Debts Of The Heart
15. 一舞傾情	15. Love At First Dance
16. 約會	16. Dating
17. 胭脂扣	17. Rouge
18. 床前明月光	18. Moonlight On My Bed
19. 心窩已瘋	19. My Heart Is Crazy
20. 芳華絕代	20. Glamour Forever
21. 似水流年	21. The Years Flow Like Water
22. 似是故人來	22. Like An Old Friend Comes
23. 抱緊眼前人	23. Embrace The One In Front Of Your Eyes
24. 親密愛人	24. Intimate Lover
25. Medley：孤身走我路 + 夕陽之歌	25. Medley: Walking My Way Alone + Song Of The Sunset
26. Medley：愛將 + 壞女孩 + 淑女 + 妖女 + 放開你的頭腦 + 夢伴 + 冰山大火	26. Medley: Love Warrior + Bad Girl + Lady + Temptress + Free Your Head And Mind + Dream Partner + Flame On The Iceberg

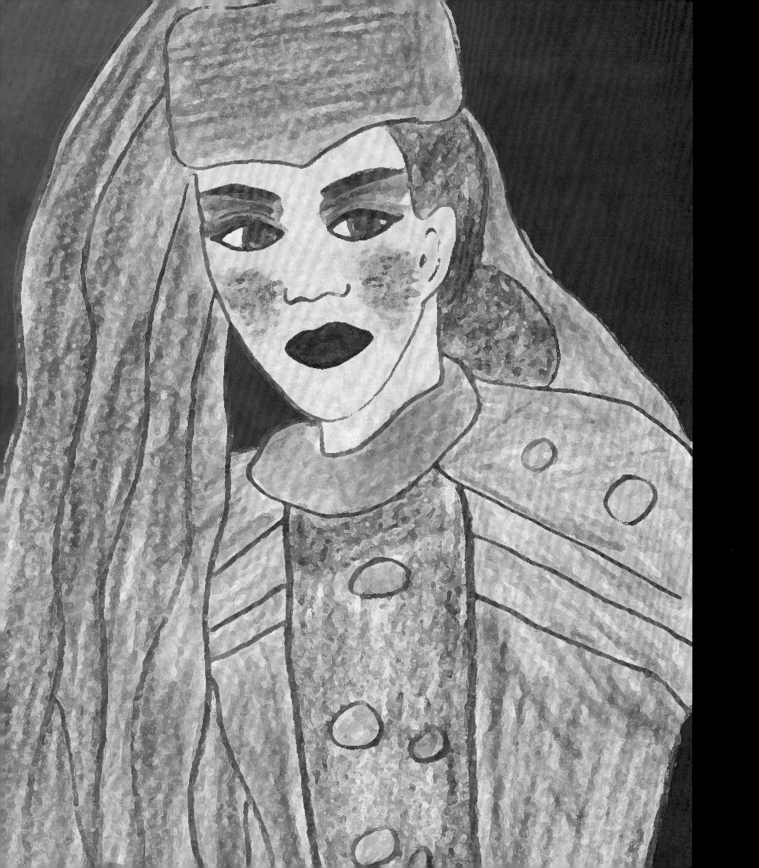

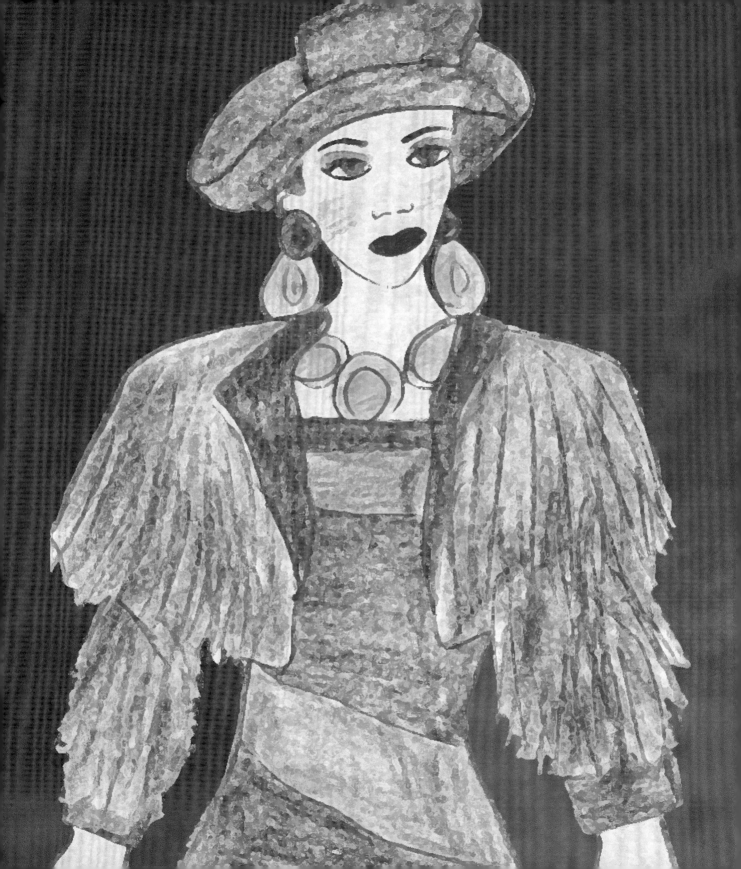

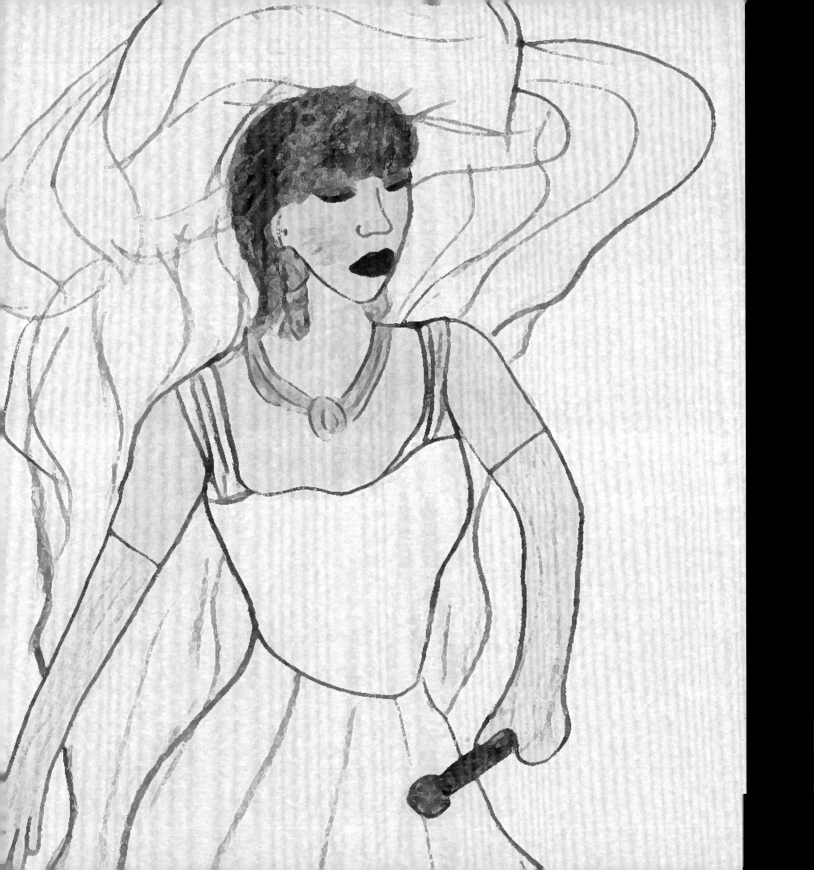

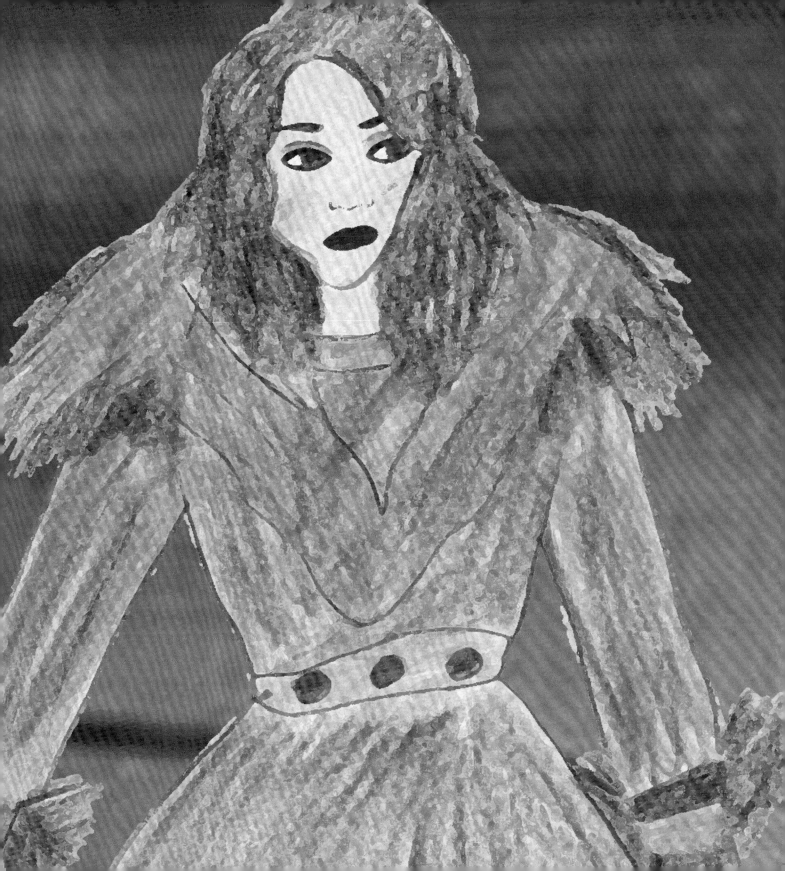

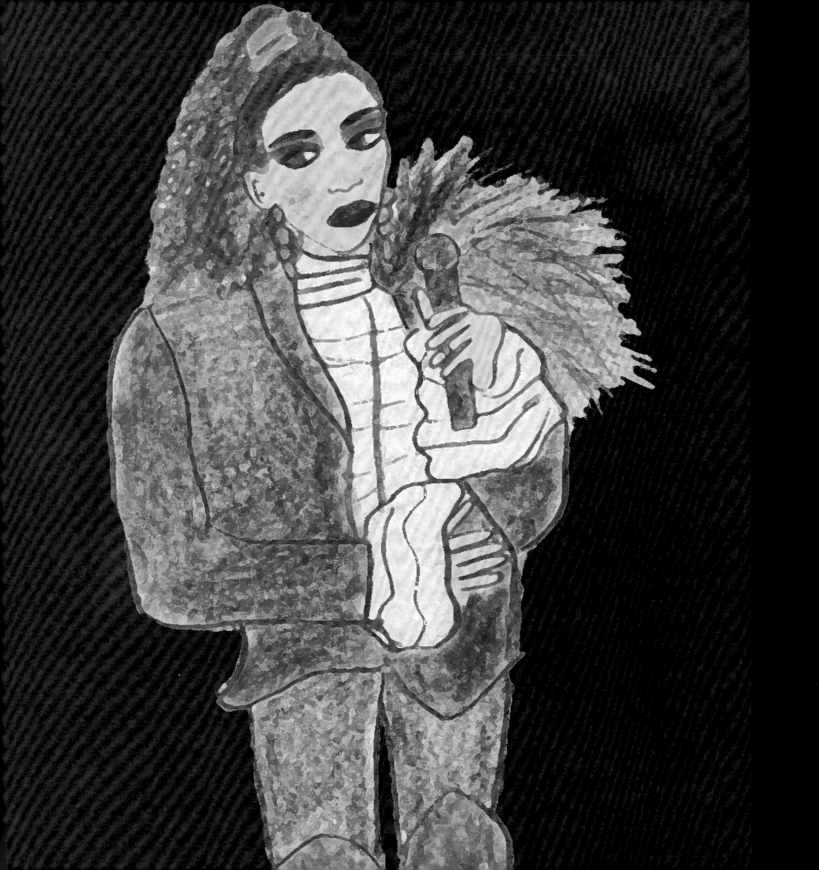

懷念往年　　外貌早改變　　處境都變　　情懷未變
《似水流年》　　作詞：鄭國江

Nostalgia for the past　　The appearance has changed long ago　　The situation has changed
The feelings have not changed
〔The Years Flow Like Water〕　　Lyricist: Cheng Kwok Kong

我在尋找可依偎的胸膛　　愛在何方我笑我始終希罕
《情歸何處》　　作詞：張美賢

I am looking for a chest to lean on　　Where is love I laugh I really wonder
〔Where Does Love Belong〕　　Lyricist: Sandy Cheung Mei Yin

拿出一百樣動作　　來顯出我的鋒芒　　只得一個渴望　　問你想到了什麼
《艷舞台》　　作詞：周耀輝

Come up with a hundred moves　　To show my spotlight　　Only one desire　　Ask what you think of
〔Brilliant Stage〕　　Lyricist: Chow Yiu-fai

黑衣黑如黑寡婦　　孤單也像黑寡婦　　偏繼續流露　　人造冷傲　　冷傲
《似火探戈》　　作詞：林振強

Black clothes are black like a black widow
Loneliness is also like a black widow But still continue to reveal
Artificially cold and arrogant　　Cold and arrogant
〔Burning Tango〕　　Lyricist: Richard Lam

鏡內人紅唇烈焰極待撫慰　　柔情慾望迷失得徹底
《烈焰紅唇》　　作詞：潘偉源

The red lips of the person in the mirror are waiting to be comforted
And the tenderness and desire are completely lost
〔Flaming Red Lips〕　　Lyricist: Poon Wai Yuen

妖女叉腰側望 Bad Boy　　腰間的火花可蒸發每個深海
《妖女》　　作詞：林振強

The temptress with arms akimbo looks sideway to bad Boy with her arms akimbo
The sparks in her waist can evaporate every deep sea
〔Temptress〕　　Lyricist: Richard Lam

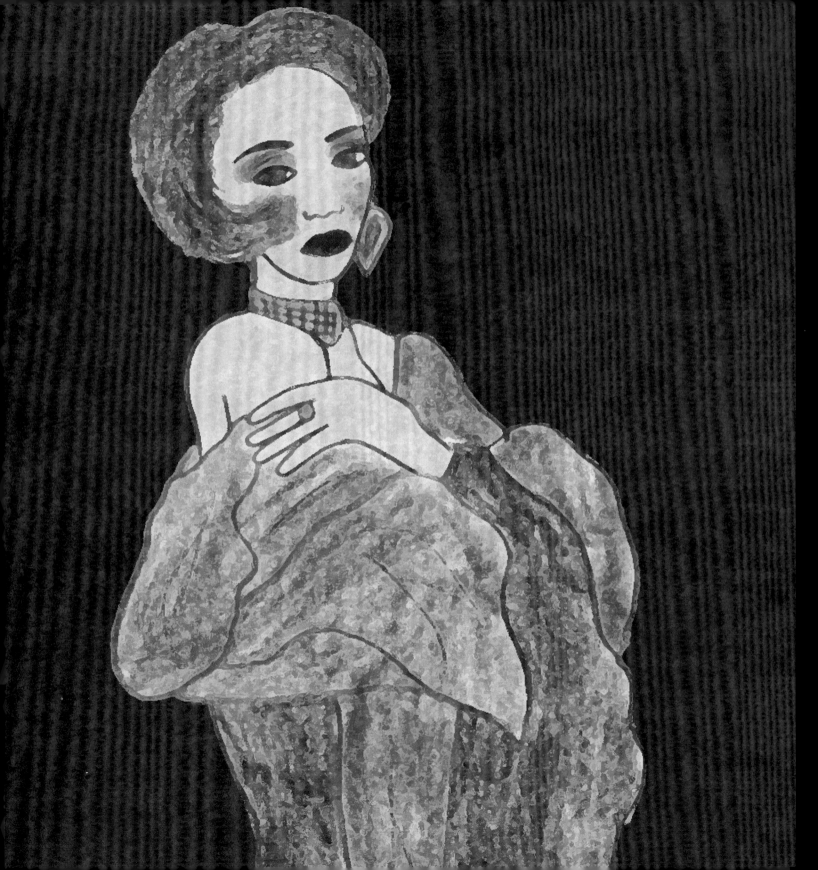

壞女孩
Bad Girl
(1985)

01. 壞女孩 **
02. 夢伴 **
03. 不了情
04. 抱你十個世紀 **
05. 魅力的散發
06. 倆心未變
 (TVB 電視劇《開心女鬼》主題曲)
07. 冰山大火 **
08. 顛多一千晚
09. 喚回快樂的我
 (電影《歡樂叮噹》主題曲)
10. 點都要愛
11. 孤身走我路 **

01. Bad Girl **
02. Dream Partner **
03. Love Without End
04. Hold You For Ten Centuries **
05. The Distribution Of Charm
06. Two Hearts Haven't Changed
 (Theme Song of the TVB Drama [Happy Spirit])
07. Flame On The Iceberg **
08. Crazy For One Thousand More Nights
09. Recall The Happy Me
 (Theme Song of the Movie [Happy Ding Dong])
10. Love At Every Point
11. Walking My Way Alone **

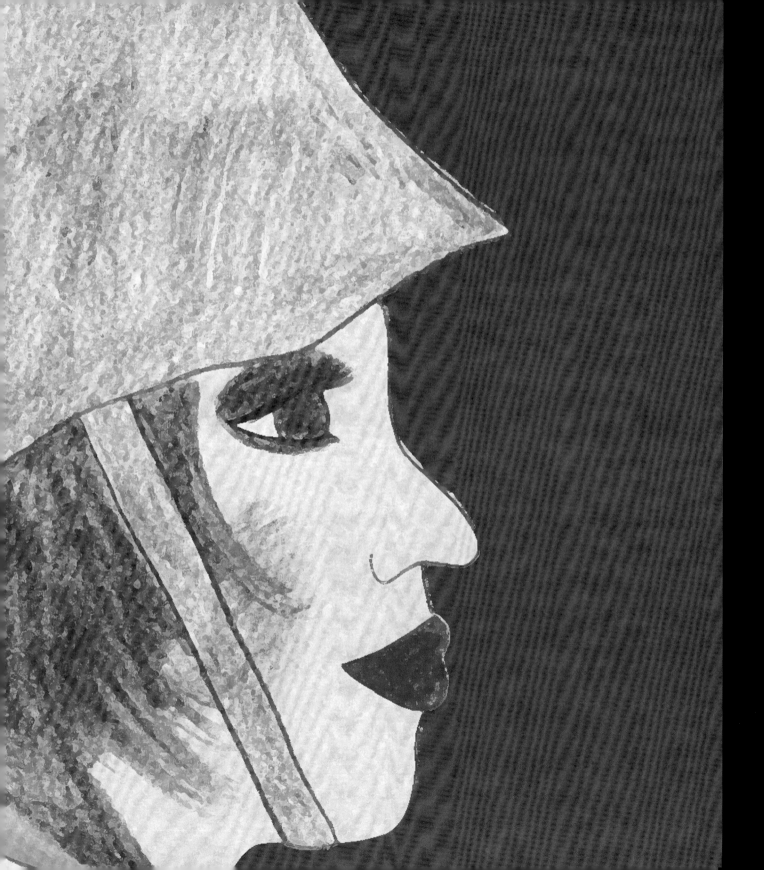

小心
Caution
(1994)

01. 落葉不歸根 **
02. 只羨鴛鴦不羨仙 **
 （電視劇《俠義見青天》單元片尾曲）
03. 醉朦朧 **
04. 情歸何處
05. 再陪你一晚
06. 放開你的頭腦 **
07. 大家都要快樂
08. 天使愛魔鬼
09. 蝶舞
10. 小心 **

01. Fallen Leaves Do Not Return
 To Their Roots **
02. Only Envy Mandarin Ducks
 But Not Immortals **
 (Ending Theme Song of the Taiwan
 Drama [The Chevaliers])
03. Drunk Twilight **
04. Where Does Love Belong
05. One More Night With You
06. Free Your Head And Mind **
07. Everyone Wants To Be Happy
08. Angels Love Devils
09. Butterfly Dance
10. Caution **

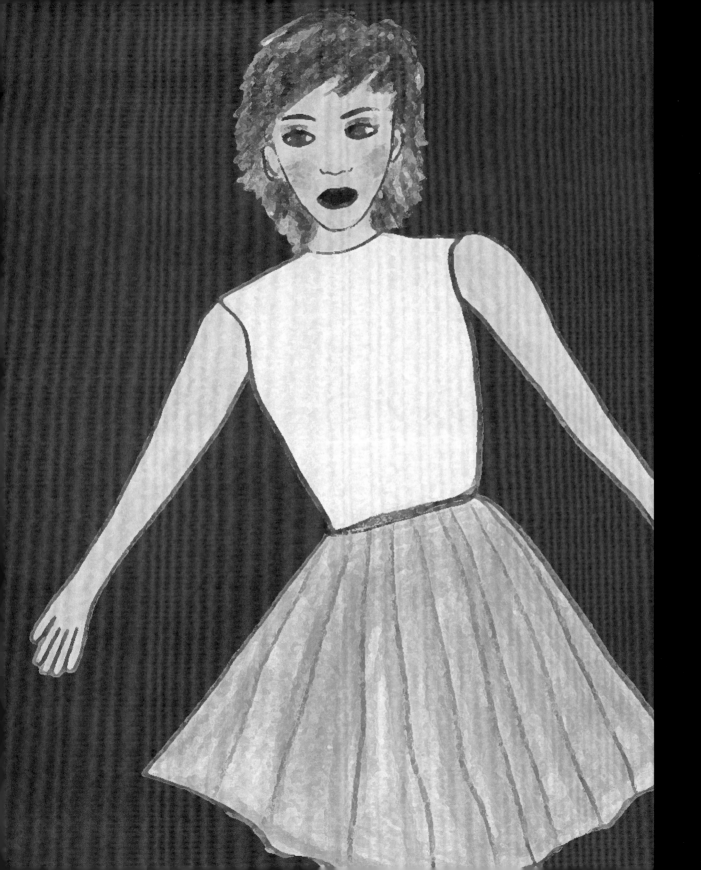

I'm So Happy
(2000)

<table>
<tr><td>01.</td><td>童夢失魂夜</td><td></td></tr>
<tr><td>02.</td><td>我很快樂 **</td><td></td></tr>
<tr><td>03.</td><td>笑</td><td></td></tr>
<tr><td>04.</td><td>同聲一哭</td><td>（陳奕迅合唱）</td></tr>
<tr><td>05.</td><td>斷章一</td><td></td></tr>
<tr><td>06.</td><td>美女與怪獸</td><td></td></tr>
<tr><td>07.</td><td>愛的教育 **</td><td></td></tr>
<tr><td>08.</td><td>陰差陽錯</td><td></td></tr>
<tr><td>09.</td><td>全日凶</td><td></td></tr>
<tr><td>10.</td><td>床呀！床！**</td><td></td></tr>
<tr><td>11.</td><td>由十七歲開始...</td><td></td></tr>
<tr><td>12.</td><td>斷章二</td><td></td></tr>
</table>

01. Child's Dream Lost Soul Night
02. I'm So Happy **
03. Laugh
04. Cry Together (Duet with Eason Chan)
05. Broken Chapter One
06. Beauty And The Monster
07. Love Education **
08. By Accident
09. All Day Fierce
10. Bed Ah! Bed! **
11. From The Age Of Seventeen...
12. Broken Chapter Two

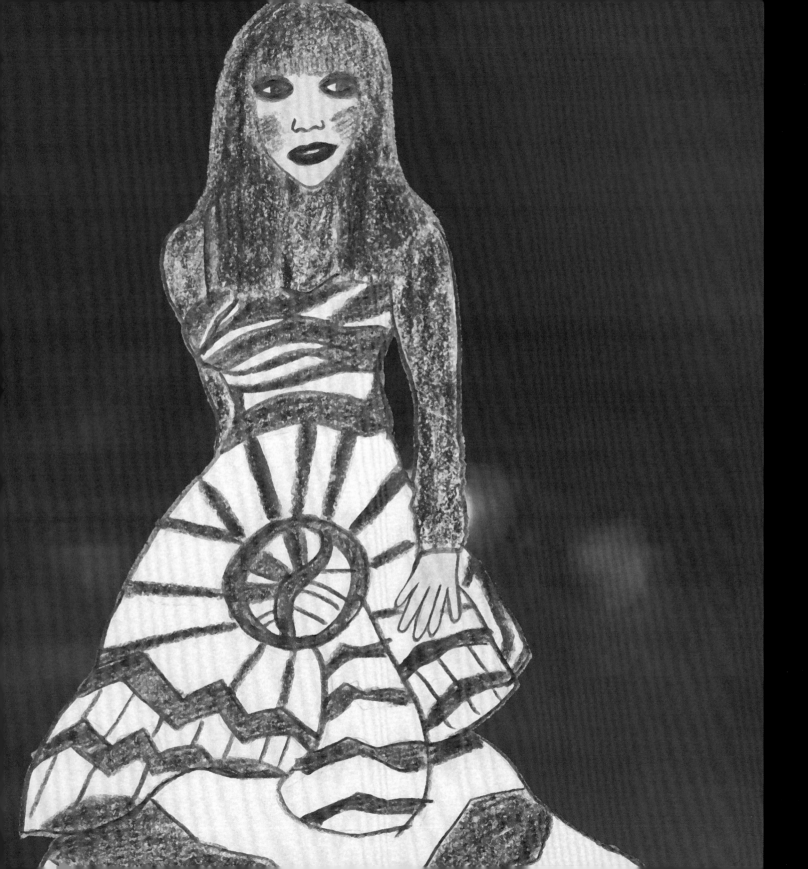

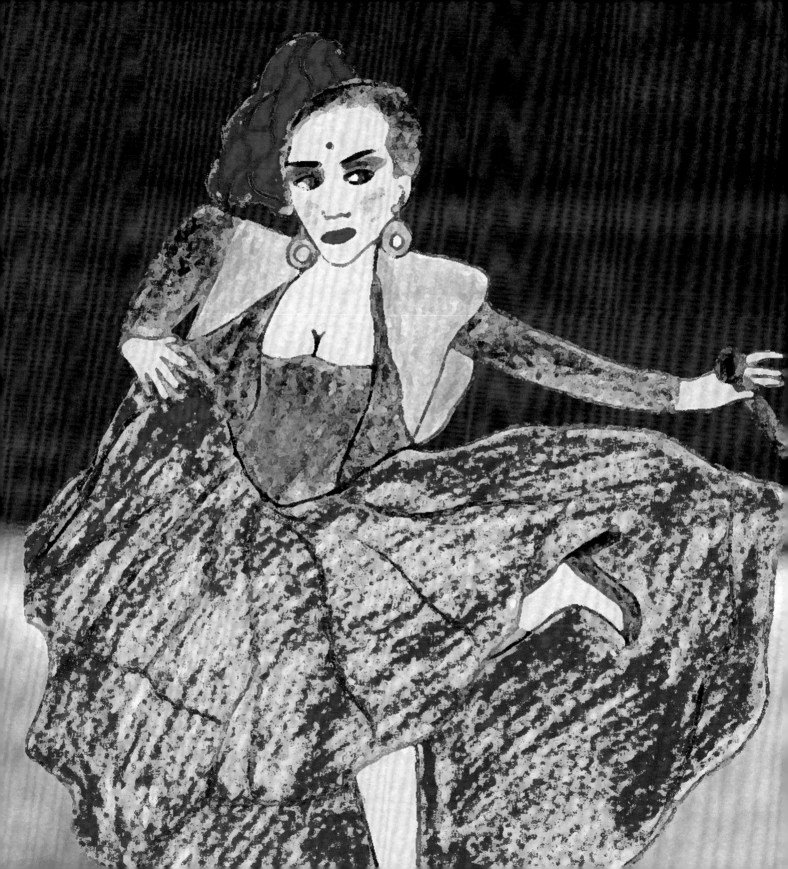

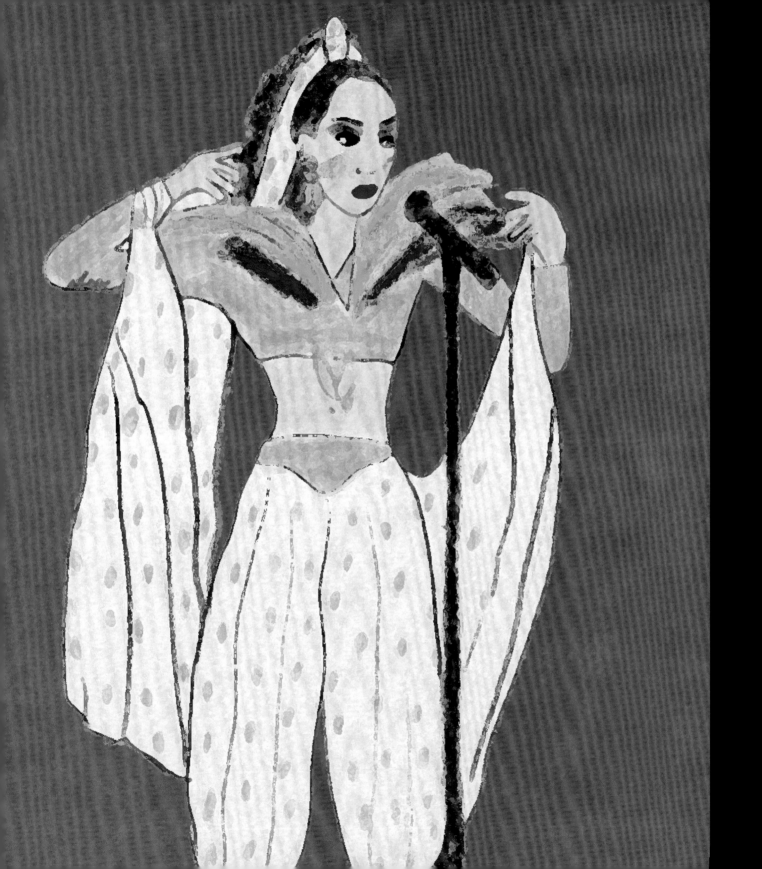

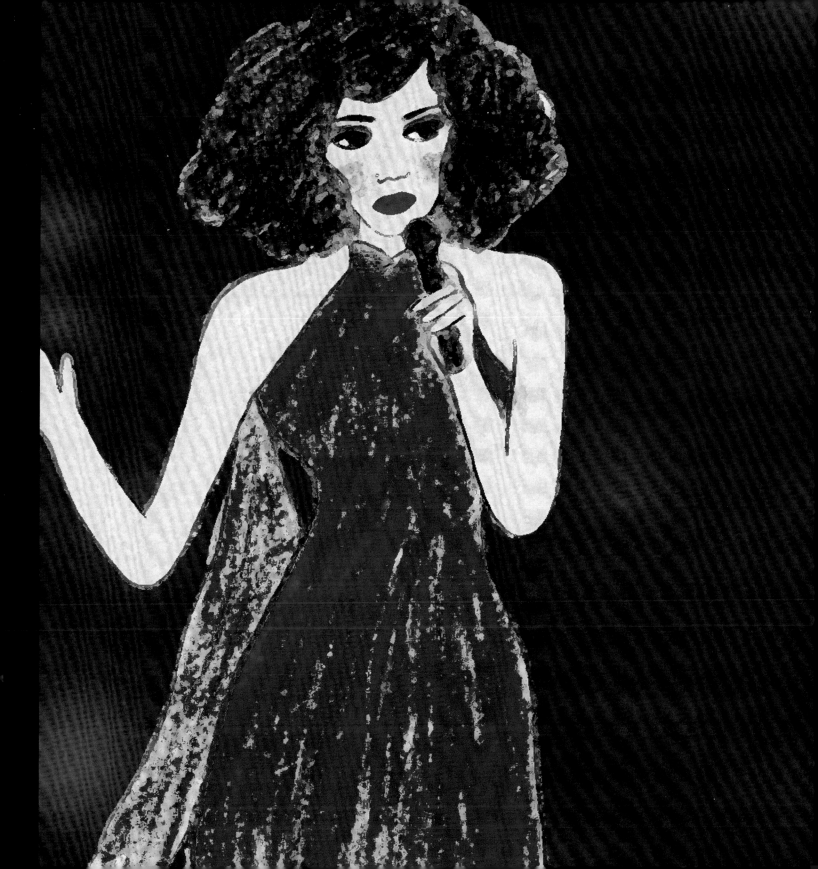

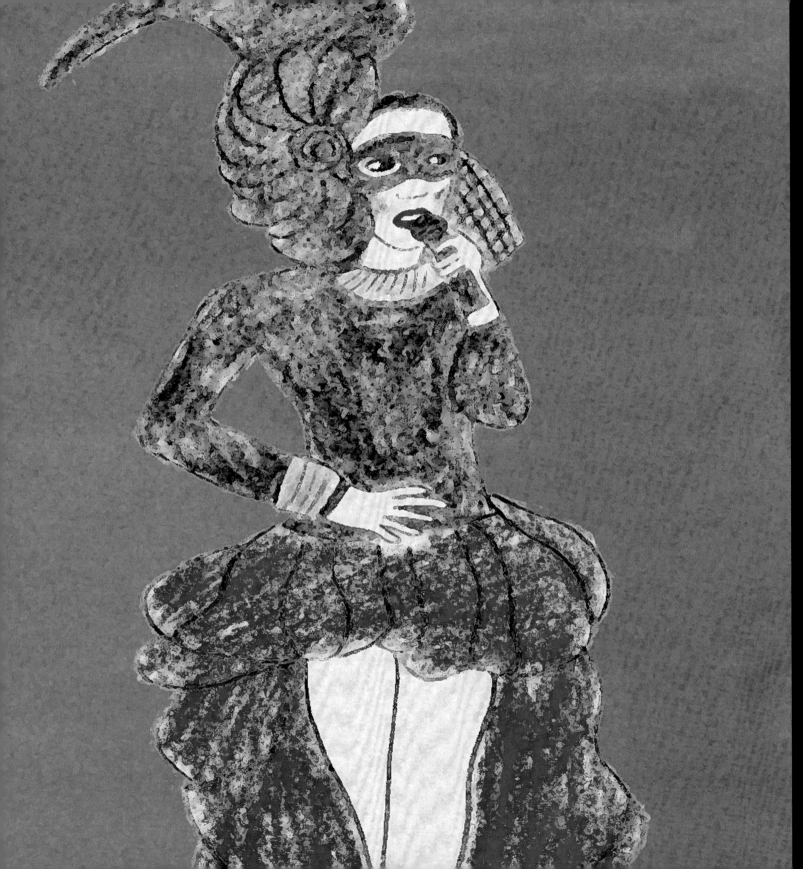

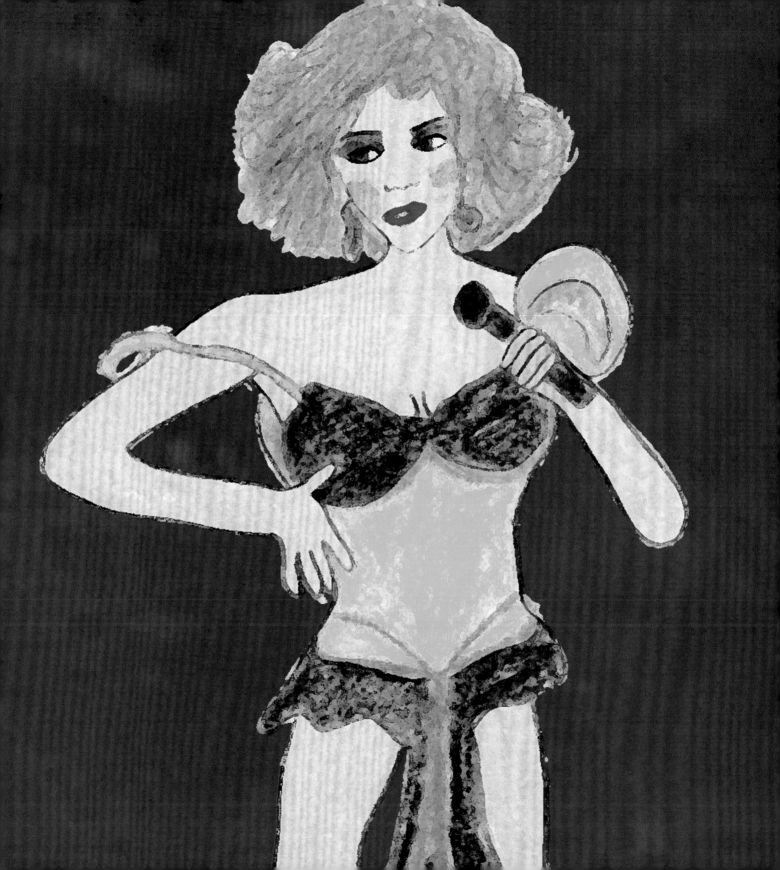

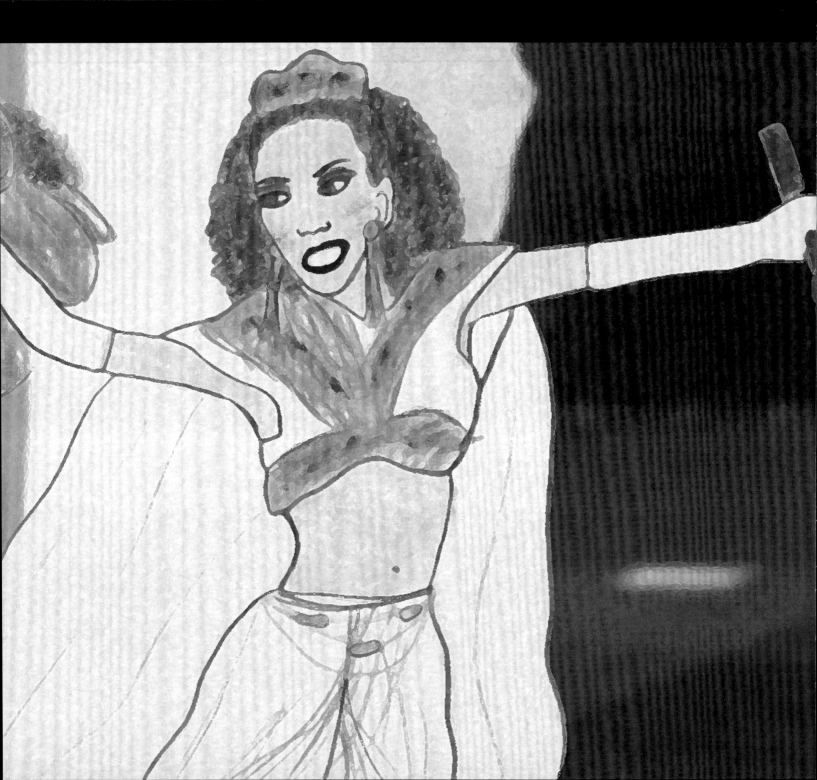

百變梅艷芳夏日耀光華演唱會90
Everchanging Anita Mui Live In Concert 90
(1990)

<table>
<tr><td>01. 愛我便說愛我吧</td><td>01. Say It If You Love Me</td></tr>
<tr><td>02. 正歌</td><td>02. Nice Song</td></tr>
<tr><td>03. 第四十夜</td><td>03. Fortieth Night</td></tr>
<tr><td>04. 一舞傾情</td><td>04. Love At First Dance</td></tr>
<tr><td>05. 愛情基本法</td><td>05. The Basic Law of Love</td></tr>
<tr><td>06. 心窩已瘋</td><td>06. My Heart Is Crazy</td></tr>
<tr><td>07. 心仍是冷 （倫永亮合唱）</td><td>07. Heart Remains Cold (Duet with Anthony Lun)</td></tr>
<tr><td>08. 明天你是否依然愛我 （倫永亮合唱）</td><td>08. Will You Still Love Me Tomorrow
(Duet with Anthony Lun)</td></tr>
<tr><td>09. Stand By Me</td><td>09. Stand By Me</td></tr>
<tr><td>10. Dancing Boy</td><td>10. Dancing Boy</td></tr>
<tr><td>11. 玫瑰、玫瑰、我愛你</td><td>11. Rose, Rose, I Love You</td></tr>
<tr><td>12. 不如不見</td><td>12. Better Not To Meet</td></tr>
<tr><td>13. 最愛是誰</td><td>13. Who Is The Favorite</td></tr>
<tr><td>14. 倦</td><td>14. Tired</td></tr>
<tr><td>15. 焚心以火</td><td>15. Burning Heart With Fire</td></tr>
<tr><td>16. 黑夜的豹</td><td>16. Night Leopard</td></tr>
<tr><td>17. Medley：壞女孩 + 妖女 +
　　　　　烈焰紅唇 + 淑女</td><td>17. Medley: Bad Girl + Temptress +
　　　　　Flaming Red Lips + Lady</td></tr>
<tr><td>18. 封面女郎</td><td>18. Cover Girl</td></tr>
<tr><td>19. 血染的風采</td><td>19. Bloody Elegant Demeanor</td></tr>
<tr><td>20. 夕陽之歌</td><td>20. Song Of The Sunset</td></tr>
<tr><td>21. 耶利亞</td><td>21. Yelia</td></tr>
</table>

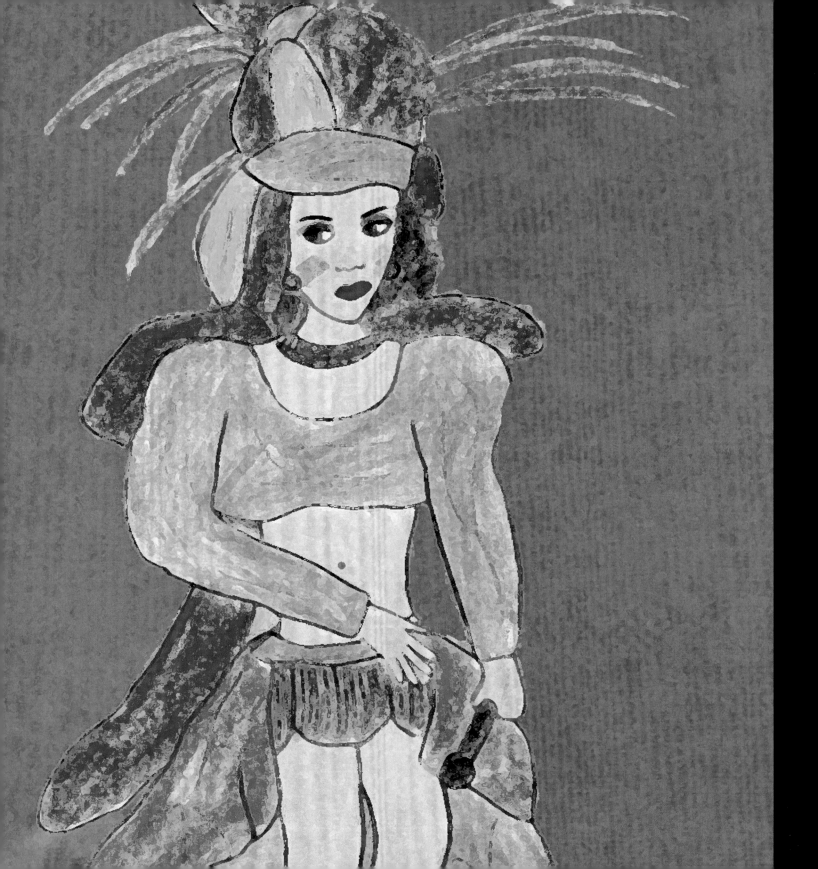

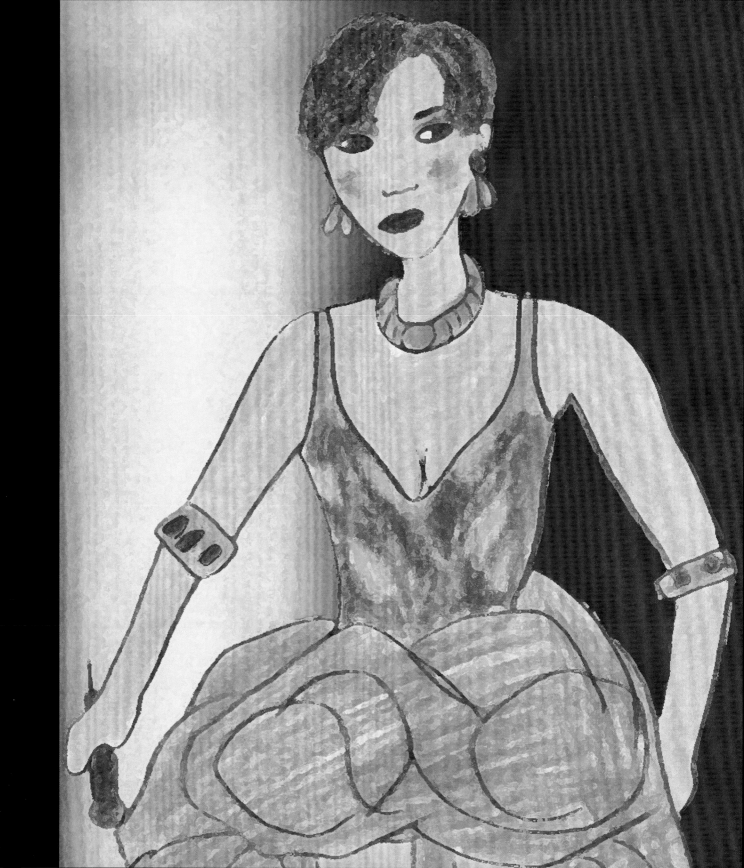

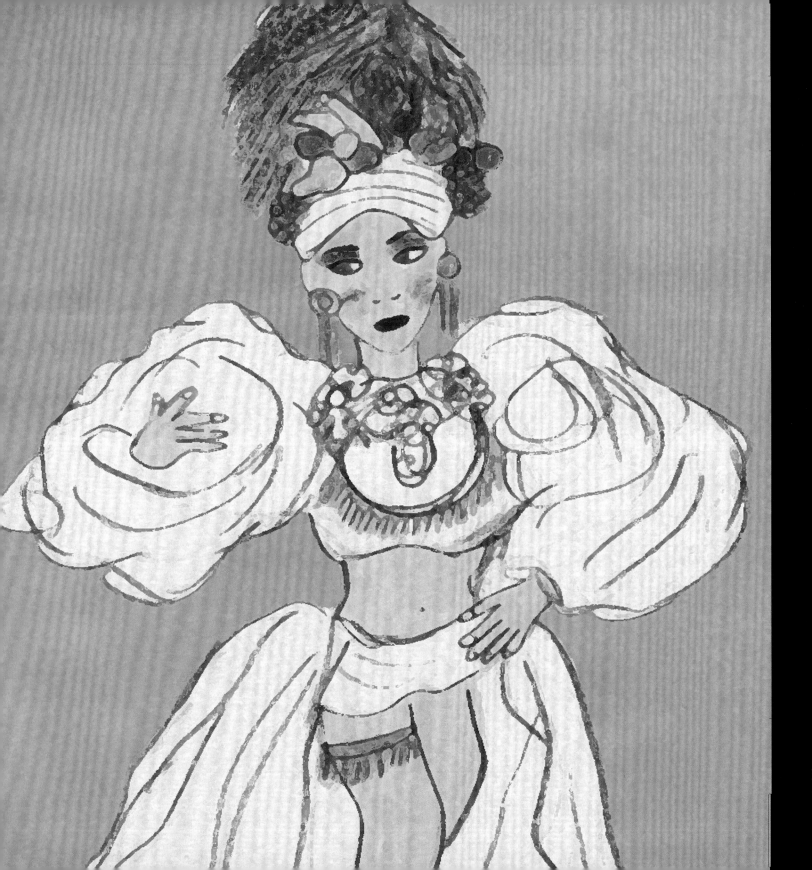

淑女豈會貪新鮮　　淑女尋夢都要臉　　淑女形象只應該冷艷
《淑女》　　作詞：潘偉源

How can a lady be greedy for freshness　　A lady has to be elegant when looking for a dream
The image of a lady should only be cold and glamorous
〔Lady〕　　Lyricist: Poon Wai Yuen

在台上我覓理想　　係要找到理想　　一於要站在台上
《飛躍舞台》　　作詞：鄧偉雄

I look for ideals on the stage　　I want to find my ideals　　I must to stand on the stage
〔Leaping In The Spotlight〕　　Lyricist: Tang Wai Hung

原來今生心債　　償還不是一世　　千代千生難估計
《心債》　　作詞：黃霑

It turns out that heart debts in this life　　Repayment is not within a lifetime
It is difficult to estimate for thousands of generations
〔Debts Of The Heart〕　　Lyricist: James Wong

來吟一首老詩　　喝一杯老酒　　明月啊　　別笑我癡　　別笑我狂
《床前明月光》　　作詞：李安修

Come and sing an old poem　　Drink a glass of old wine　　Bright moon
Don’t laugh at my stupidness　　Don’t laugh at my craziness
〔Moonlight on My Bed〕　　Lyricist: Preston Lee

再會說了再莫要想以後　　這一生的光輝　　已足夠
《回頭已是百年身》　　作詞：潘源良

Say goodbye don't think about the future　　The glory of this life　　It's enough
〔Too Late to Turn Back〕　　Lyricist: Calvin Poon Yuen Leung

唯獨是天姿國色　　不可一世　　天生我高貴艷麗到底
《芳華絕代》　　作詞：黃偉文

Only thing is the indescribably beauty　　Is insufferably arrogant
I am born to be noble and beautiful to the end
〔Glamour Forever〕　　Lyricist: Wyman Wong

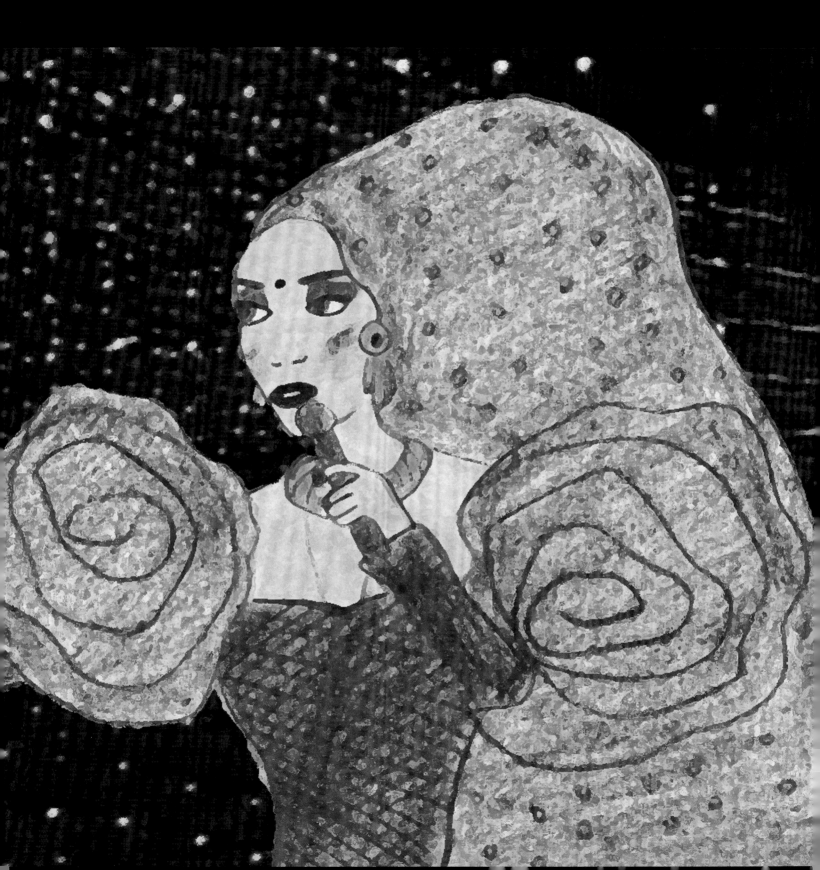

百變梅艷芳再展光華 87-88 演唱會
Everchanging Anita Mui Live In Concert 87-88
(1988)

01. Medley: 冰山大火 + 征服他 +
　　　　心魔 + 冰山大火
02. 緋聞中的女人
03. 妖女
04. 愛將
05. Medley: 戀之火 + 殘月碎春風
06. Medley: 夢 + 紗籠女郎
07. Medley: 嘆息 + 歌衫淚影 +
　　　　千枝針刺在心
08. 胭脂扣
09. 夢伴
10. 壞女孩
11. 放鬆
12. 蔓珠莎華
13. 烈焰紅唇
14. 似火探戈
15. 傷心教堂
16. 似水流年
17. 珍惜再會時

01. Medley: Flame On The Iceberg +
　　　　Conquer Him +
　　　　Devil Of Heart +
　　　　Flame On The Iceberg
02. Gossip Girl
03. Temptress
04. Love Warrior
05. Medley: Fire Of Love + The Crescent
　　　　Moon Breaks The Spring Breeze
06. Medley: Dream + Sarong Girl
07. Medley: Sigh +
　　　　Tears' Shadow On The Stage +
　　　　A Thousand Needles Pierce The
　　　　Heart
08. Rouge
09. Dream Partner
10. Bad Girl
11. Relax
12. Manjusaka
13. Flaming Red Lips
14. Burning Tango
15. Church Of Sadness
16. The Years Flow Like Water
17. Cherish When We Meet Again

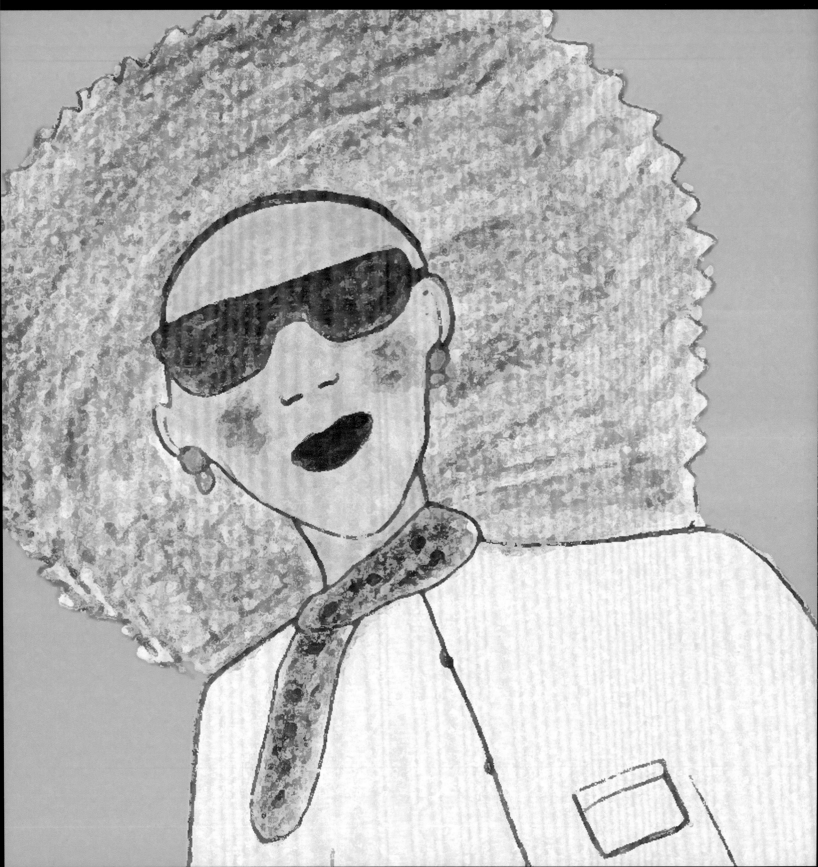

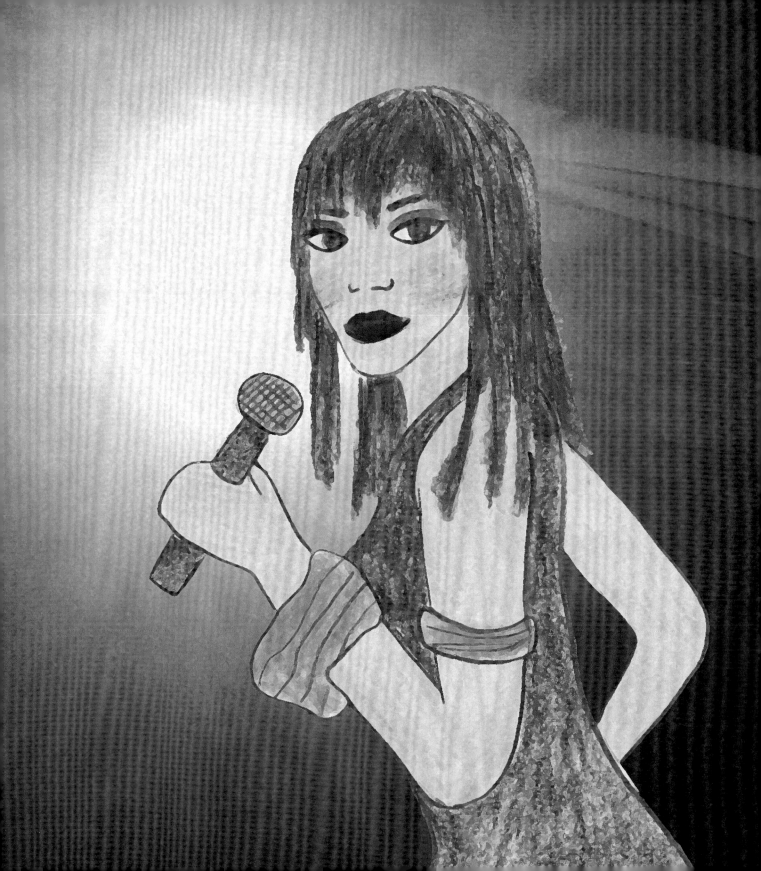

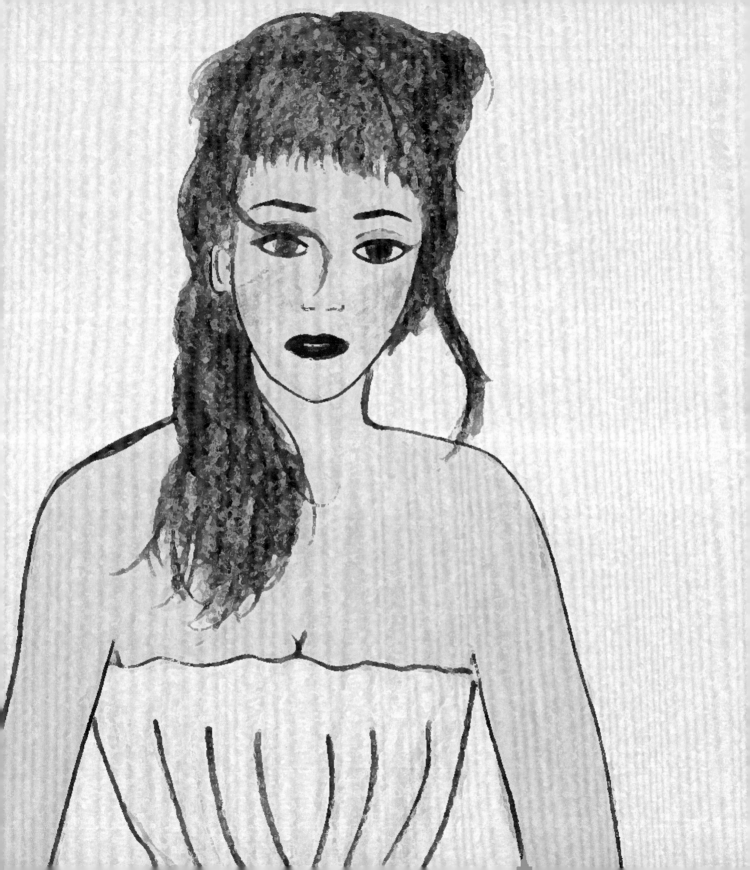

歌之女
Songtress
(1995)

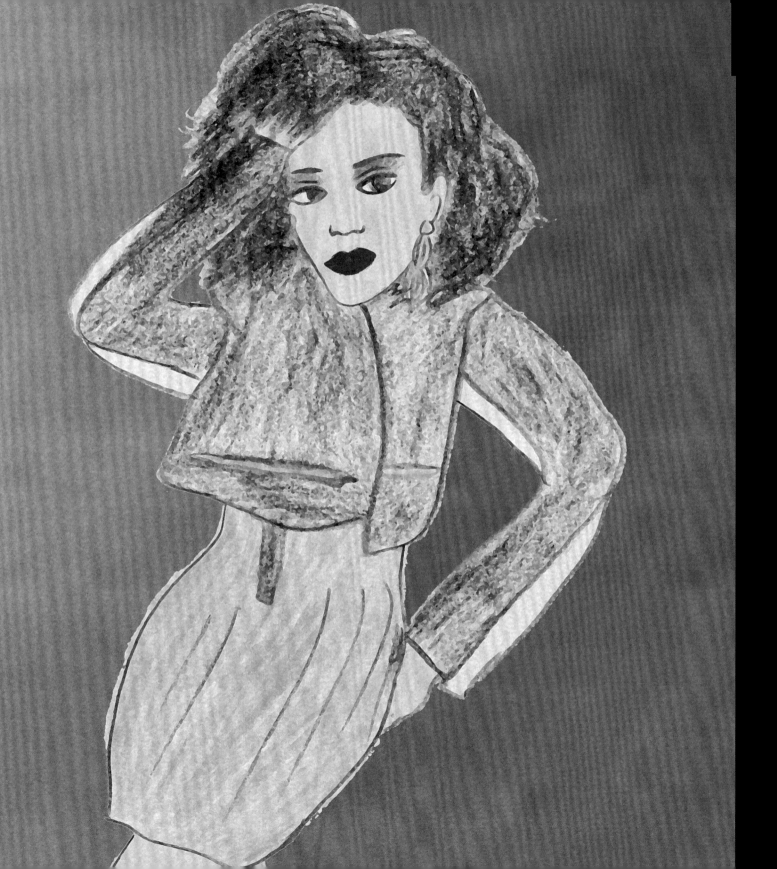

封面女郎
Cover Girl
(1990)

01. 愛情基本法
02. 封面女郎 **
03. 心仍是冷 ** （倫永亮合唱）
04. 情敵角色
05. 笑看風雲變 ** （許志安合唱）
　　 （無線電視劇《我本善良》主題曲）
06. 耶利亞 **
07. 心窩已瘋
08. 憑什麼
09. 意亂情迷
10. Anita
11. 心仍是冷（獨唱版）

01. The Basic Law of Love
02. Cover Girl **
03. Heart Remains Cold **
　　 (Duet with Anthony Lun)
04. Rival Role Of Love
05. Facing Fate With A Smile Old **
　　 (Duet with Andy Hui)
　　 (Theme Song of the TVB Drama
　　 ［Blood of Good and Evil］)
06. Yelia **
07. My Heart Is Crazy
08. On What Grounds
09. Confusion
10. Anita
11. Heart Remains Cold (Solo Version)

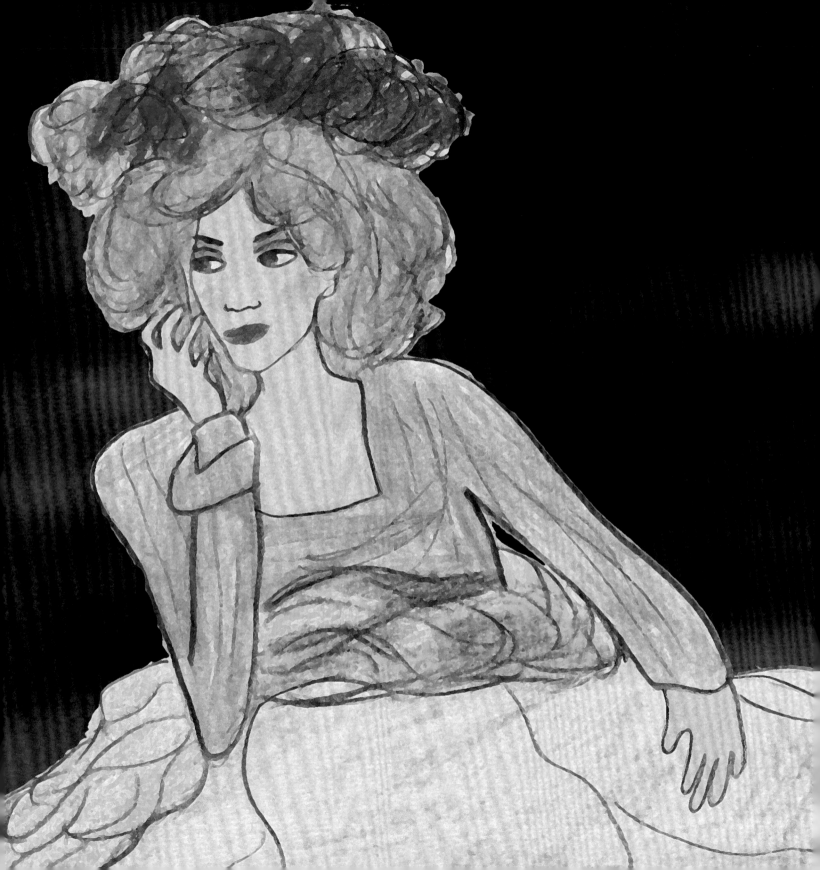

鏡花水月
Illusions
(1997)



01. 火鳳凰之舞
02. 愛的感覺
03. 鏡花水月
04. 為什麼是你
05. 什麼都有的女人
06. 夜蛇 **
07. 第六個星期
08. 有心人 （倫永亮合唱）
09. 抱緊眼前人 **
（無線電視劇《大鬧廣昌隆》主題曲）
（電影《馬永貞》主題曲）
10. 鏡花水月......Reprise
11. Goodnight

01. Dance Of The Fire Phoenix
02. The Feeling Of Love
03. Illusions
04. Why Is You
05. The Woman Who Has Everything
06. Night Snake **
07. The Sixth Week
08. Caring Person
(Duet with Anthony Lun)
09. Embrace The One In Front Of
Your Eyes **
(Theme Song of the TVB Drama
［Time Before Time］)
(Theme Song of the Movie
［Boxer from Shantung］)
10. IlusionsReprise
11. Goodnight



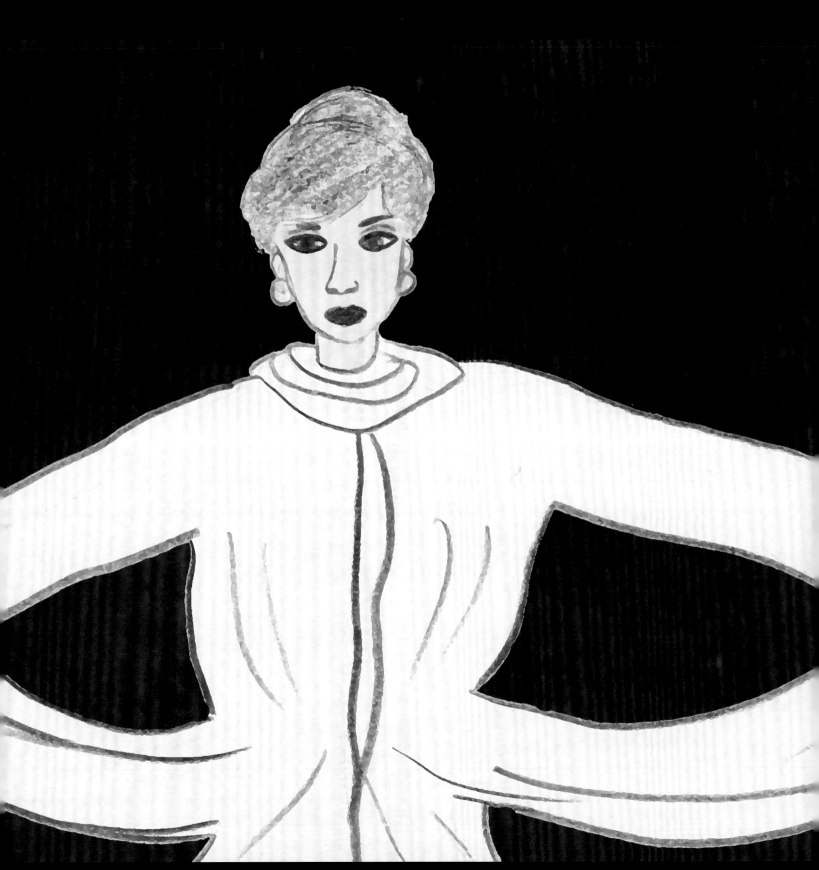

梅艷芳的其他榮譽
Anita Mui's Other Honours

1992：※ 美國三藩市定下 4 月 18 日為梅艷芳日
1993：※ 加拿大多倫多定下 10 月 23 日為梅艷芳日
2002：※ 獲美國加州州長頒發「傑出慈善藝人」榮譽
　　　※ 美國奧克蘭市定下 6 月 23 日為梅艷芳日
2003：※ 抗 SARS 傑出獎選舉 – 非醫護科技人員組 " 第五傑出獎
2004：※「世界紀錄協會」評選，梅艷芳以全球個人演唱會總計 292 場紀錄確定為
　　　　「全球華人個人演唱會最多女歌手」
2018：※ 天文學家楊光宇先生以梅艷芳（Muiyimfong）命名 55384 號小行星表揚梅艷
　　　　芳為粵語流行音樂做出了巨大貢獻
2019：※ 第 2 屆馬來西亞女人行表揚會 2019，大會特別頒發「個人榮譽獎」

1992：※ San Francisco, USA set April 18 as 'Anita Mui Day'
1993：※ Toronto, Canada designated October 23 as 'Anita Mui Day'
2002：※ Received the honor of "Outstanding Charity Artist" by the Governor
　　　　of California, USA
　　　※ The city of Oakland, USA set June 23 as 'Anita Mui Day'
2003：※ Anti-SARS Outstanding Award Election – Fifth Outstanding Award in
　　　　Non-Medical Technological Personnel Group
2004：※ Selected by the "World Record Association", Anita Mui certified
　　　　as the "Most Global Solo Concerts by a Chinese female Singer"
　　　　with a total of 292 solo concerts worldwide
2018：※ Astronomer Mr. Yeung Kwong Yu named asteroid 55384 to truibute
　　　　Anita Mui's great contribution to Cantonese pop music
2019：※ At the 2nd Malaysian Women's Walk Commendation Meeting 2019,
　　　　the conference specially awarded Anita Mui the "Personal Honor
　　　　Award"

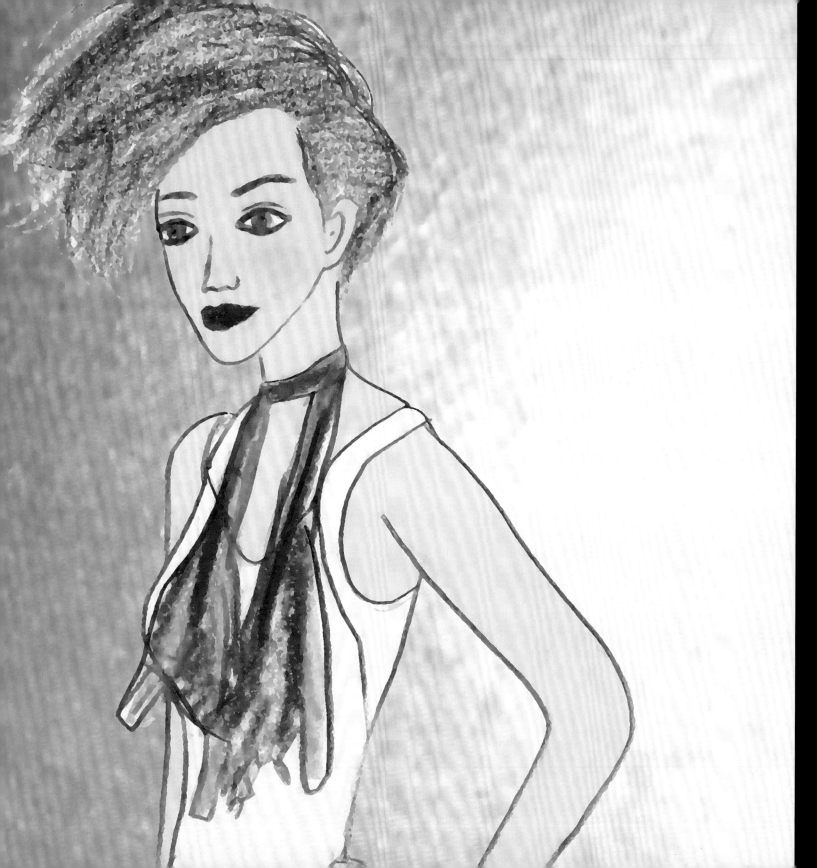

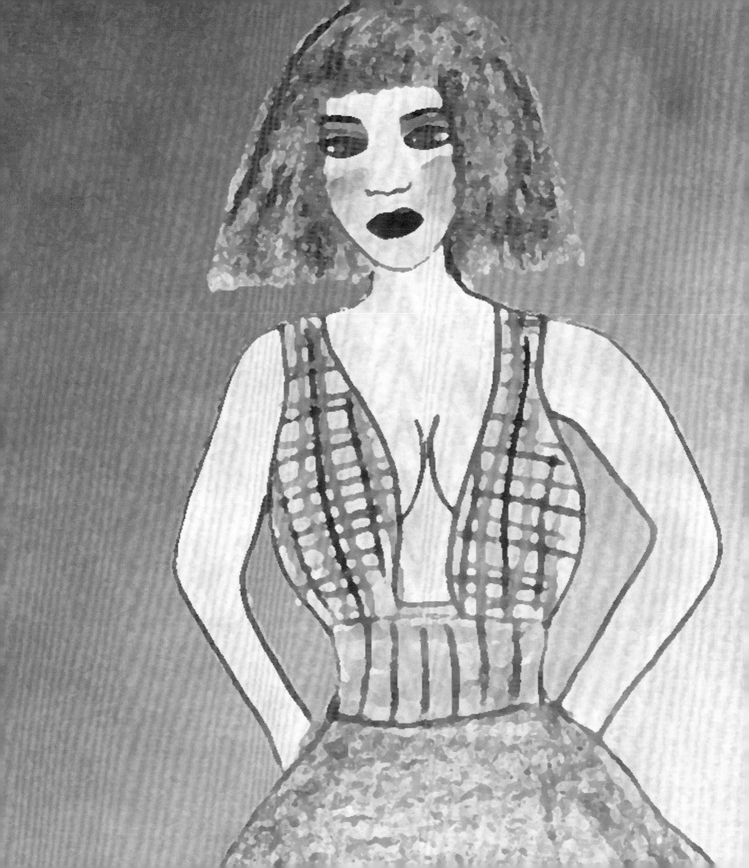

梅艷芳的個人演唱會
Anita Mui's Live In Concert

※《梅艷芳海洋皇宮演唱會》1985 年 6 月 14 日至 28 日（15 場）
　　@香港海洋皇宮大酒樓夜總會
※《梅艷芳盡顯光華演唱會》1985 年 12 月 31 日至 1986 年 1 月 14 日（15 場）
　　@香港紅磡體育館
※《梅艷芳世界巡迴演唱會》1986 年 - 2003（超過 130 場）@中國、澳門、馬來西亞、
　　新加坡、台灣、歐洲、美國、加拿大、澳洲及紐西蘭
※《百變梅艷芳再展光華 87-88》1987 年 12 月 24 日至 1988 年 1 月 15 日、19 日至 23 日
　　（28 場）@香港紅磡體育館
※《百變梅艷芳夏日耀光華 90》1990 年 7 月 20 日至 8 月 18 日（30 場）
　　@香港紅磡體育館
※《梅艷芳獻上真我音樂會》1991 年 5 月 18 日（1 場）@香港大專會堂
※《梅艷芳 Kool 足一晚生日音樂會》1991 年 10 月 10 日（1 場）
　　@伊利沙伯體育館
※《百變梅艷芳告別舞台演唱會》 1991 年 12 月 23 日至 1992 年 1 月 5 日、8-17 日及
　　21-27 日（31 場）@香港紅磡體育館
※《情歸何處 II 梅艷芳感激歌迷演唱會》1994 年 7 月 8 日（1 場）@伊利沙伯體育館
※《梅艷芳一個美麗的迴響演唱會》1995 年 4 月 14 日至 29 日（15 場）@香港紅磡體育館
※《公益金梅艷芳友好演唱會》1995 年 4 月 30 日（1 場）@香港紅磡體育館
※《梅艷芳真心愛生命演唱會》1995 年 8 月 25、26 日（2 場）@台北國父紀念館
※《1997 芳蹤乍現台北演唱實錄》1997 年 6 月 17 日（1 場）@台北
※《百變梅艷芳演唱會 1999》1999 年 4 月 30 日至 5 月 6 日（7 場）@香港紅磡體育館
※《百變梅艷芳演唱會 99 延續篇》1999 年 9 月 9 日至 12 日（4 場）@香港紅磡體育館
※《梅艷芳 Mui Music Show》2001 年 12 月 9 日（1 場）@香港會議展覽中心
※《梅艷芳極夢幻演唱會》2002 年 3 月 28 日至 4 月 6 日（10 場）@香港紅磡體育館
※《梅艷芳經典金曲演唱會》2003 年 11 月 6 日至 11 日，11 月 14 日及 15 日（8 場）
　　@香港紅磡體育館

梅艷芳的個人演唱會
Anita Mui's Live In Concert

※〔Anita Mui Ocean Palace Live In Concert〕14th June 1985 - 28th June 1985 (15 Shows)
 @ Ocean Palace Restaurant Night Club

※〔Anita Mui Live In Concert〕31st December 1985 - 14th January 1986 (15 Shows)
 @ Hong Kong Coliseum

※〔Anita Mui World Tour〕1986 - 2003 (Over 130 Shows) @ China, Macau, Malaysia, Singapore,
 Taiwan, Europe, United States of America, Canada, Australia and New Zealand

※〔Everchnaging Anita Mui Live In Concert 87-88〕24th December 1987 - 15th January 1988,
 19th January 1988 - 23rd December 1988 (28 Shows) @ Hong Kong Coliseum

※〔Everchanging Anita Mui Live In Concert 90〕20th July 1990 - 18th August 1990 (30 Shows)
 @ Hong Kong Coliseum

※〔Anita Mui Offer Her True Self Concert〕18th May 1991 (1 Show) @ Academic Community Hall

※〔Anita Mui Kool For One Night Birthday Concert〕10th October 1991 (1 Show)
 @ Queen Elizabeth Stadium

※〔Everchanging Anita Mui Final Concert〕23rd December 1991 - 5th January 1992, 8th January
 1992 - 17th January 1992, 21st January 1992 - 27th January 1992 (31 Shows)
 @ Hong Kong Coliseum

※〔Where Does Love Belong II Anita Mui Grateful To Fans Concert〕 8th July 1994 (1 Show)
 @ Queen Elizabeth Stadium

※〔Anita Mui Live In Concert 1995〕 14th April 1995 - 29th April 1995 (15 Shows)
 @ Hong Kong Coliseum

※〔The Community Chest of Hong Kong - Anita & Her Best Friends Live In Concert〕30th April
 1995 (1 Show) @ Hong Kong Coliseum

※〔Anita Mui True Love Life Concert〕 25th August 1995 - 26th August 1995 (2 Shows)
 @ National Dr. Sun Yat-Sen Memorial Hall

※〔Anita Mui 1997 Live In Taipei〕17th June 1997 (1 Show) @Taipei

※〔Everchanging Anita Live In Concert 1999〕30th April 1999 - 6th May 1999 (7 Shows)
 @ Hong Kong Coliseum

※〔Everchanging Anita Live In Concert 99 Continuation〕9th September 1999 - 12th September
 1999 (4 Shows) @ Hong Kong Coliseum

※〔Mui Music Show〕9th December 2001 (1 Show) @ Hong Kong Convention and Exhibition Centre

※〔Anita Mui Fantasy Gig〕28th March 2002 - 6th April 2002 (10 Shows) @ Hong Kong Coliseum

※〔Anita Classic Moment Live〕 6th November 2003 - 11th November 2003, 14th November 2003
 and 15th November 2003 (8 Shows) @ Hong Kong Coliseum

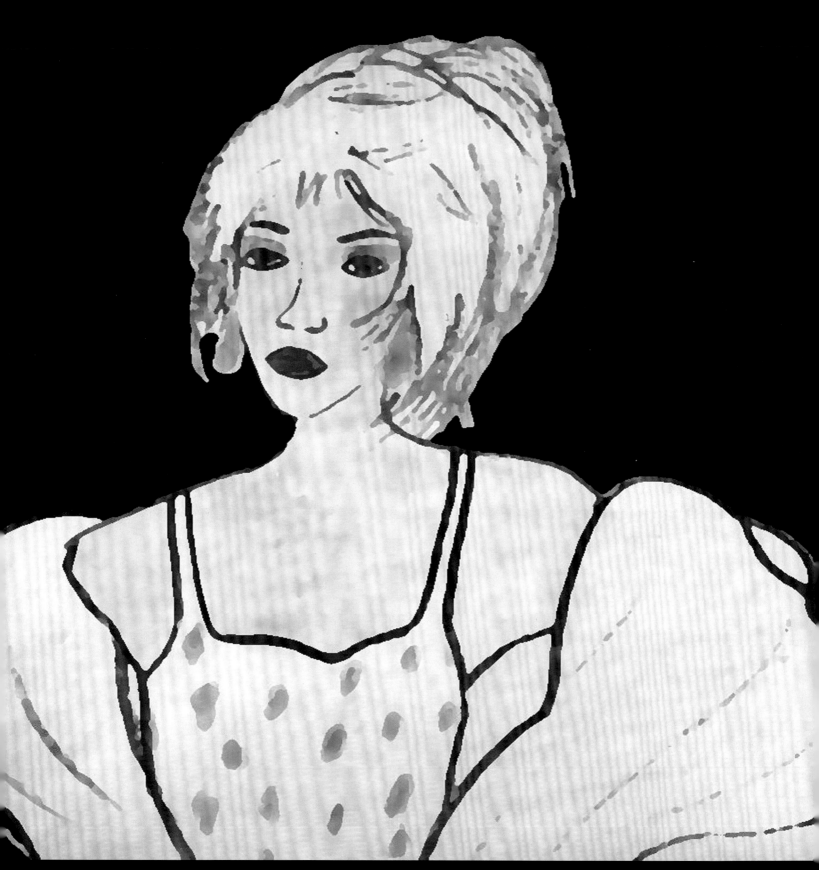

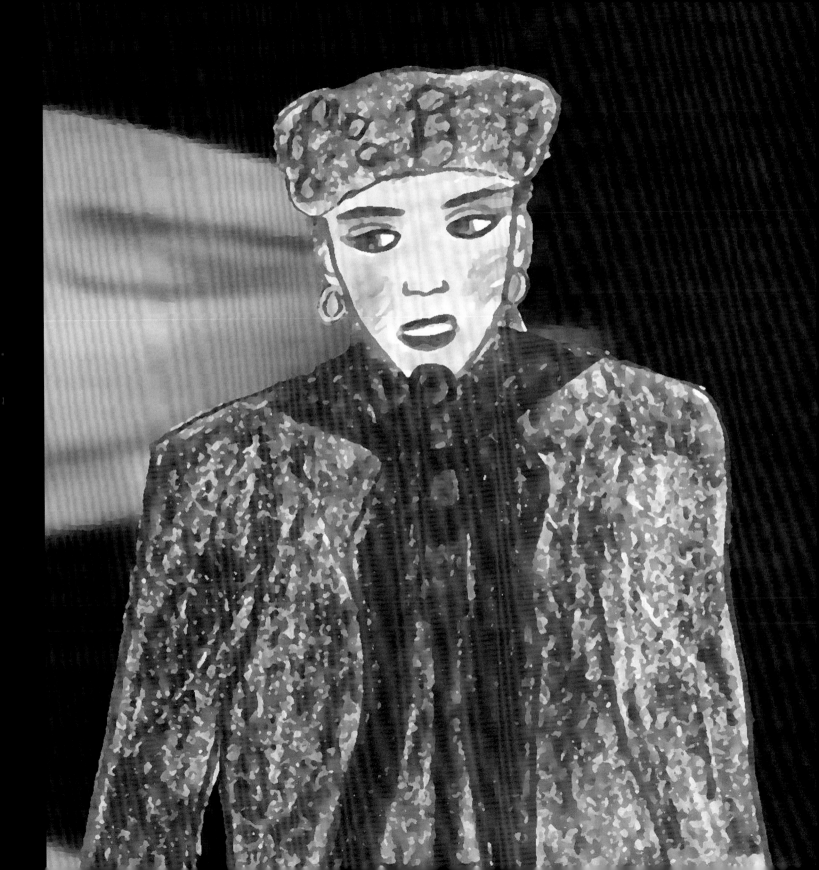

梅艷芳的電影獎項
Anita Mui's Movie Awards

1984 ： ※ 第 4 屆香港電影金像獎 – 最佳女配角 《緣份》
1987 ： ※ 第 24 屆金馬獎 – 最佳女主角 《胭脂扣》
1988 ： ※ 第 1 屆金龍獎 – 最佳女主角 《胭脂扣》
1989 ： ※ 第 8 屆香港電影金像獎 – 最佳女主角 《胭脂扣》
1998 ： ※ 第 17 屆香港電影金像獎 – 最佳女配角《半生緣》
　　　 ※ 第 3 屆香港電影金紫荊獎 – 獲獎最佳女配角《半生緣》
2001 ： ※ 明報第 2 屆演藝動力大獎頒獎禮 – 最突出電影女演員《鍾無艷》
2002 ： ※ 第 2 屆華語電影傳媒大獎 – 最佳女主角《男人四十》
　　　 ※ 第 6 屆長春電影節 – 最佳女主角《男人四十》
2004 ： ※ 第 24 屆香港電影金像獎 – 演藝光輝永恆大獎
2005 ： ※ 中國百大影星光耀百年 – 百年影星獎
　　　 ※ 第 5 屆華語電影傳媒大獎 – 百大演員獎
　　　 ※ 第 25 屆香港電影金像獎 – 銀禧影后
　　　 ※ UA 院線全港最高票房電影頒獎典禮 1985-2005 – 20 年最高票房女演員第 3 位

1984 ： ※ The 4th Hong Kong Film Awards – Best Supporting Actress Award
　　　　 [Behind The Yellow Line]
1987 ： ※ The 24th Golden Horse Awards – Best Actress Award [Rouge]
1988 ： ※ The 1st Golden Dragon Award – Best Actress Award [Rouge]
1989 ： ※ The 8th Hong Kong Film Awards – Best Actress Award [Rouge]
1998 ： ※ The 17th Hong Kong Film Awards – Best Supporting Actress Award [Eighteen Springs]
　　　 ※ The 3rd Golden Bauhinia Award – Best Supporting Actress Award [Eighteen Springs]
2001 ： ※ Ming Pao 2nd Performing Arts Power Awards Ceremony – Most Outstanding Movie Actress
　　　　 Award [Wu Yen]
2002 ： ※ The 2nd Chinese Film Media Awards – Best Actress Award [July Phapsody]
　　　 ※ The 6th Changchun Film Festival – Best Actress Award [July Phapsody]
2004 ： ※ The 24th Hong Kong Film Awards – The Brilliant Eternal Award for Performing Arts
2005 ： ※ China's Top 100 Film Stars Shine For A Century – The Centennial Movie Star Award
　　　 ※ The 5th Chinese Film Media Awards – Top 100 Actors Award
　　　 ※ The 25th Hong Kong Film Awards – Silver Jubilee Best Actress Award
　　　 ※ UA Cinemas Hong Kong's Highest – Grossing Film Awards Ceremony

Why why tell me why 夜會令禁忌分解 引致淑女暗裏也想變壞
《壞女孩》 作詞：林振強

Why why tell me why The night will break down taboos
Casuing ladies to secretly want to turn bad
〔Bad Girl〕 Lyricist: Richard Lam

放開你的頭腦 不必在乎什麼 Funky Fun Funky
《放開你的頭腦》 作詞：小蟲

Let your mind go Don't need to care anything Funky Fun Funky
〔Free Your Head And Mind〕 Lyricist: Johnnybug Chen

為你歌為你歌 謝你始終不棄掉我 凝望你找到愛找到我
《歌之女》作詞：林振強

Sing for you sing for you Thank you for never abandoning me
Looking forward to you finding love and finding me
〔Songtress〕 Lyricist: Richard Lam

情人伴著到老始終不多 情愛每捉弄我 常在跌跌碰碰處境來渡過
《心仍是冷》 作詞：小美

Lovers accompany me until I grow old Every time love plays tricks on me
I often stumble through the situation to get through it
〔Heart Remains Cold〕 Lyricist: Siu Mei

你望著我我望著你心境今晚極靚 若要盡放 Tell me when
《正歌》 作詞：林振強

You look at me I look at you my mood is very beautiful tonight If you want to let go
Tell me when
〔Nice Song〕 Lyricist: Richard Lam

捨不得不愛 巴不得一世 唯願抱緊眼前人
《抱緊眼前人》 作詞：潘源良

I can't bear to love I can't wait for the rest of my life
I only wish to hold the person in front of me tightly
〔Embrace The One In Front Of Your〕 Lyricist: Calvin Poon Yuen Leung

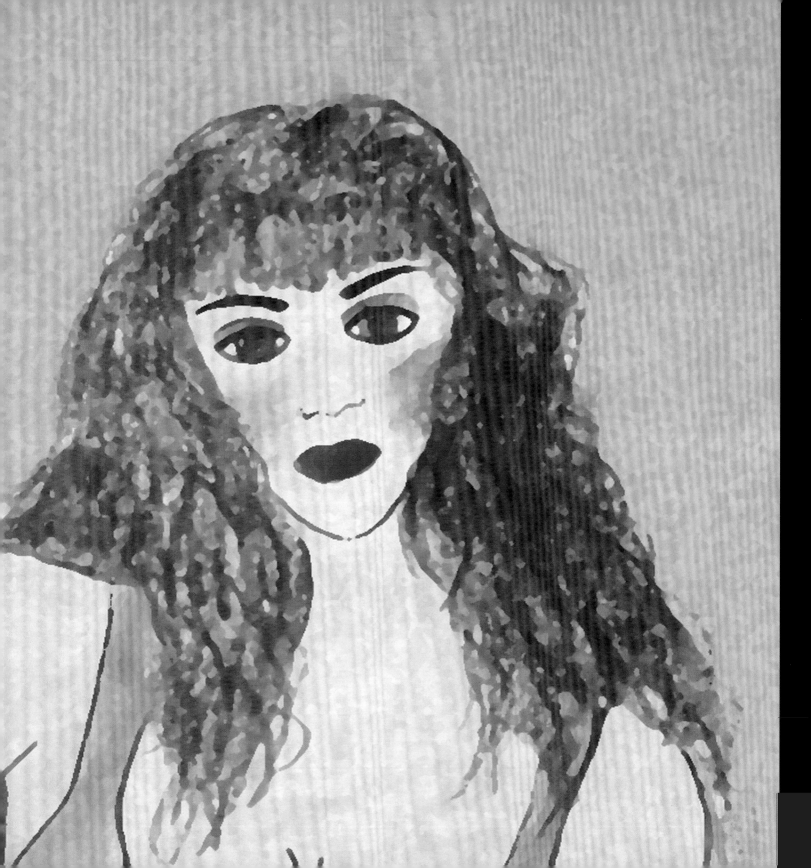

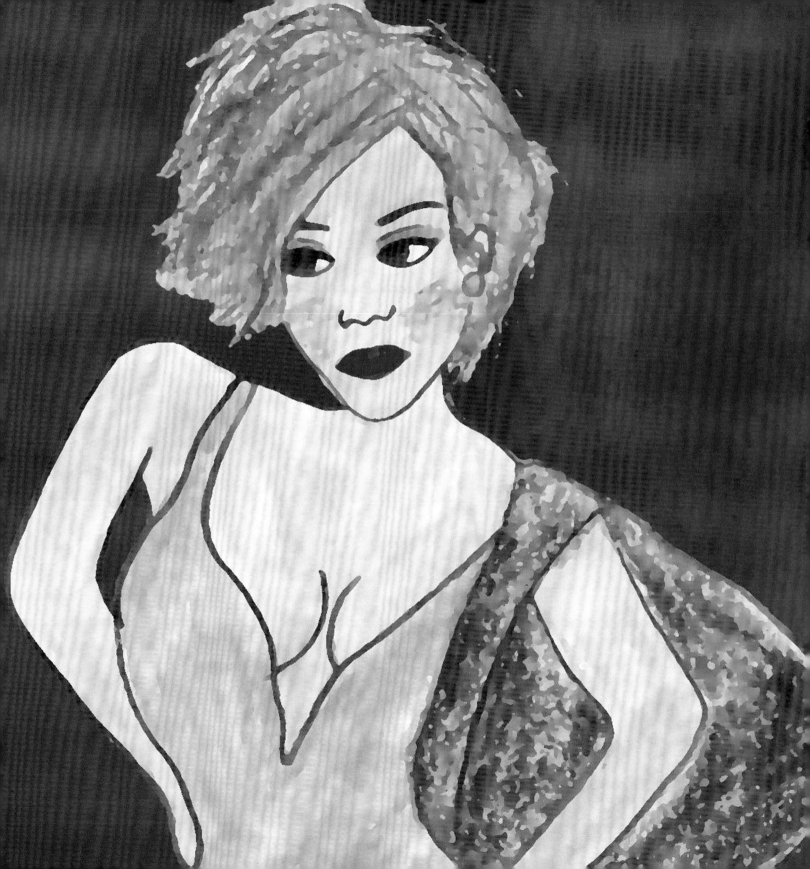

斜陽無限　無奈只一息間燦爛　隨雲霞漸散　逝去的光彩不復還
《夕陽之歌》　作詞：陳少琪

The slanting sun is infinite　It only shines brightly for a while with no choice
As the clouds gradually disperse　The lost colourful glory will never return
【Song Of The Sunset】　Lyricist: Keith Chan

台下你望　台上我做　你想做的戲　前事故人　忘憂的你　可曾記得起
《似是故人來》　作詞：林夕

You watch off stage　I will do the show you want to on stage
Old friends of the previous matter　The forgettable youy　Do you remember once
【Like An Old Friend Comes】　Lyricist: Albert Leung

你我都須要　在人前被仰望　連造夢亦未敢想像　我會這樣硬朗
《女人心》　作詞：林夕

But you and I need　To be looked up to in front of people　I never dared to imagine
That I would be so tough
【Woman's Heart】　Lyricist: Albert Leung

交出我一生　憑一顆愛心　交付每分誠懇
《交出我的心》　作詞：黃霑

Hand over my whole life　With a loving heart　To deliver every sincerity
【Hand Over My Heart】　Lyricist: James Wong

平時如冰山的心開始　Rock and Roll　跳　跳　跳　跳　熱到要跳舞　我被他的眼光擦到著火
《冰山大火》　作詞：林振強

My heart which is usually like an iceberg begins to　Rock and Roll　Jump Jump Jump Jump
So hot that I want to dance　I was caught on fire by his gaze
【Flame On The Iceberg】　Lyricist: Richard Lam

夢裡共醉　讓我拋開掛累　共你編織愛字句
《夢裡共醉》　作詞：黎彼得

Drunk in dreams together　Let me put aside my tiredness　And weave words of love with you
【Drunk In Dreams Together】　Lyricist: Peter Lai

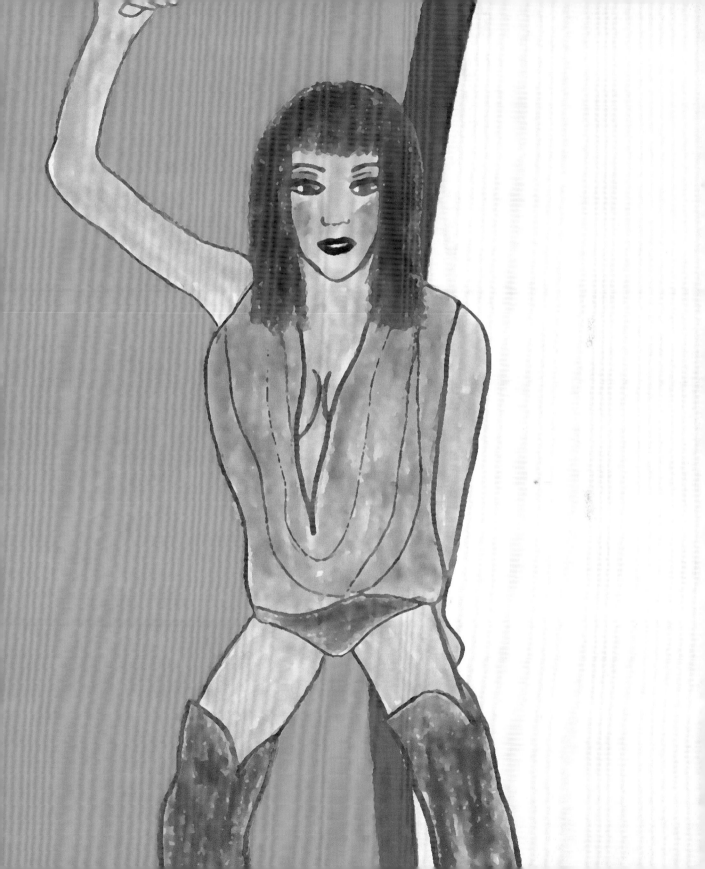

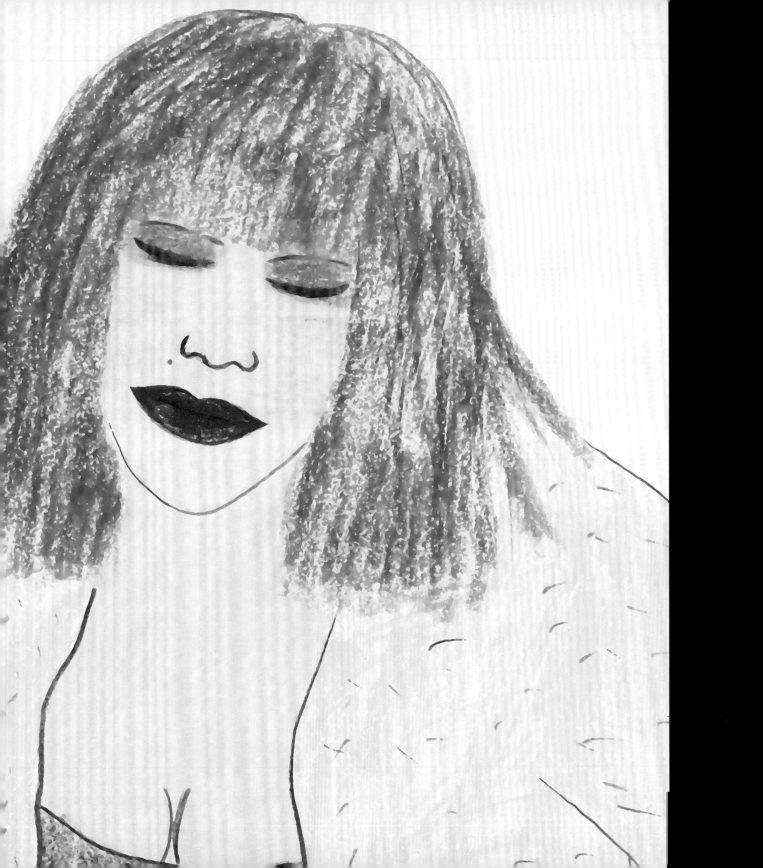

梅艷芳主演及參與演出的電影

※ 叔侄・縮窒 The Sensational Pair (1983)
※ 瘋狂 83 Mad Mad 93 (1983)
※ 表錯七日情 Let's Make Laugh (1983)
※ 緣份 Behind The Yellow Line (1984)
※ 歌舞昇平 The Musical Singer (1985)
※ 祝你好運 Lucky Diamond (1985)
※ 青春差館 Young Cops (1985)
※ 壞女孩 Why, Why, Tell Me Why? (1986)
※ 歡樂叮噹 Happy Din Don (1986)
※ 偶然 Last Song In Paris (1986)
※ 殺妻 2 人組 100 Ways To Murder Your Wife (1986)
※ 神探朱古力 Chocolate Inspector (1986)
※ 小生夢驚魂 Scared Stiff (1987)
※ 一屋兩妻 happy Bigamist (1987)
※ 開心勿語 Troubling Couples (1987)
※ 胭脂扣 Rouge (1988)
※ 一妻兩夫 One Husband Too Many (1988)
※ 公子多情 The Grestest Lover (1988)
※ 黑心鬼 Three Wishes (1988)
※ 奇蹟 The Canton Godfather (1989)
※ 英雄本色 III: 夕陽之歌
　　A Better Tomorrow 3: Love & Death In Saigon (1989)
※ 富貴兵團 The Fortune Code (1990)
※ 川島芳子 Kawashima Yoshiko (1990)
※ 亂世兒女 Shanghai Shanghai (1990)

Anita Mui's Starring and Participated Films

※ 賭霸 The Top Bet (1991)
※ 何日君再來 Au Revoir, Mon Amour (1991)
※ 豪門夜宴 The Banquet (1991)
※ 九一神鵰俠侶 Saviour Of The Soul (1991)
※ 審死官 Justice, My Foot (1992)
※ 戰神傳說 Moon Warriors (1992)
※ 逃學威龍 3 之龍過雞年 Fight Back To School III (1993)
※ 東方三俠 The Heroic Trio (1993)
※ 濟公 The Mad Monk (1993)
※ 新仙鶴神針 The Magic Crane (1993)
※ 現代豪俠傳 Executioners (1993)
※ 醉拳 II Drunken Master II (1994)
※ 紅番區 Rumble In The Bronx (1995)
※ 給爸爸的信 Mt Father Is A Hero (1995)
※ 運財智叻星 Twinkle Twinkle Lucky Stars 1996 (1996)
※ 金枝玉葉 2 Who's The Woman, Who's The Man (1996)
※ 半生緣 Eighteen Springs (1997)
※ 鍾無艷 Wu Yen (2001)
※ 慌心假期 Midnight Fly (2001)
※ 男歌女唱 Let's Sing Along (2001)
※ 愛君如夢 Dance Of A Dream (2001)
※ 男人四十 July Phapsody (2002)
※ 十面埋伏 House Of Flying Daggers (2003)

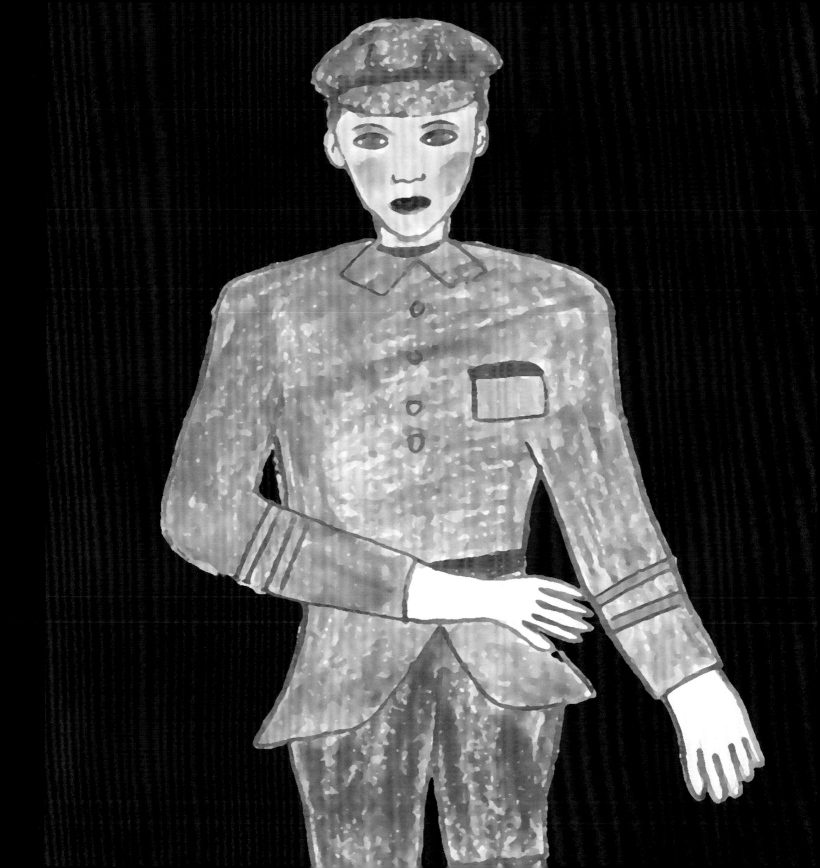

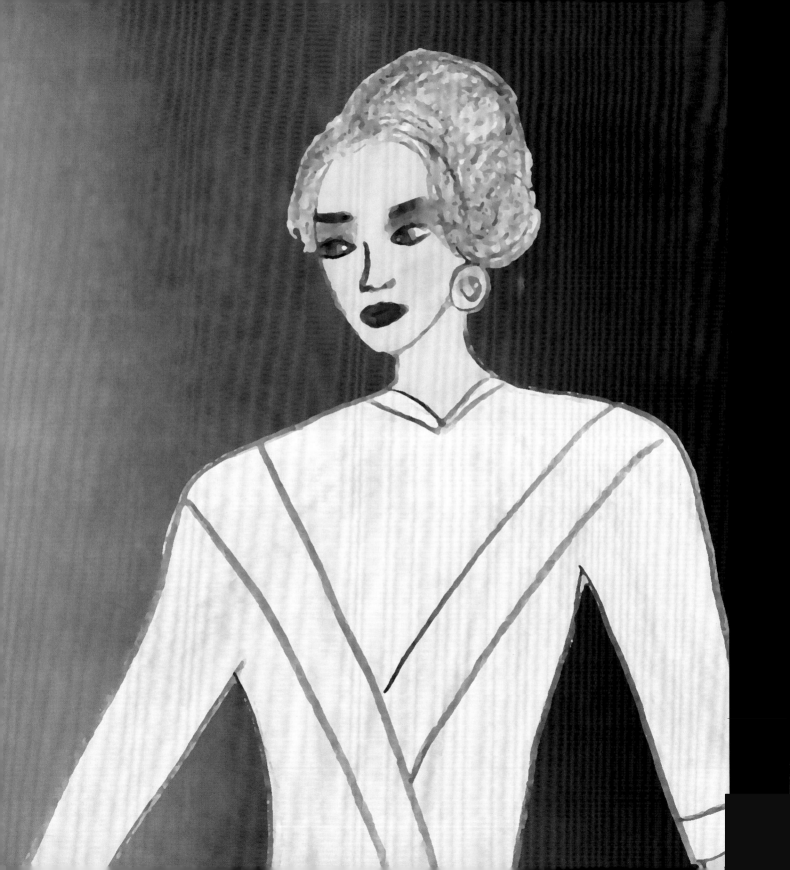

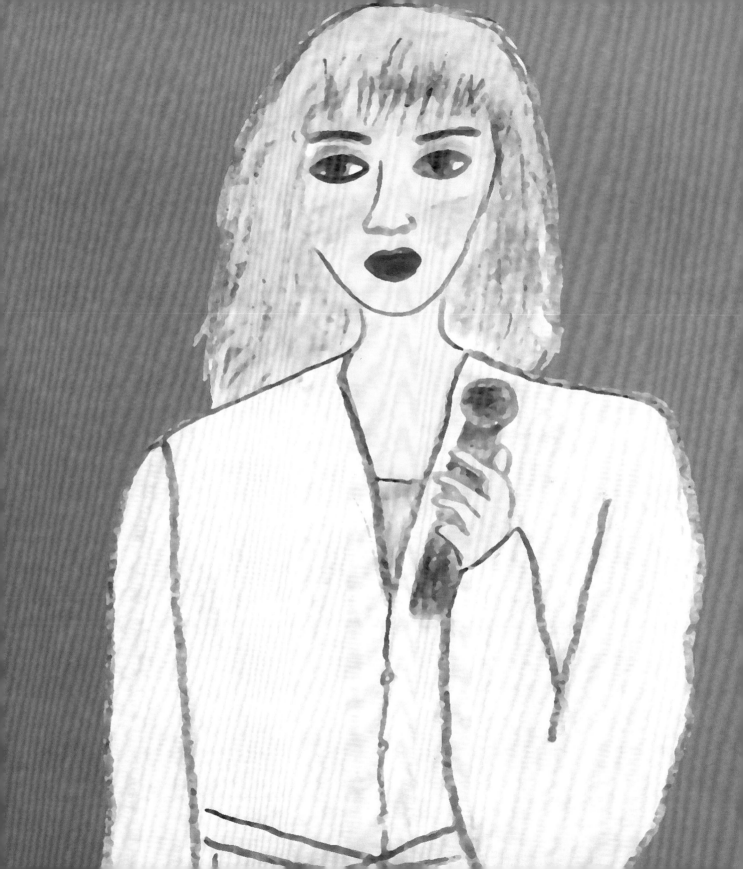

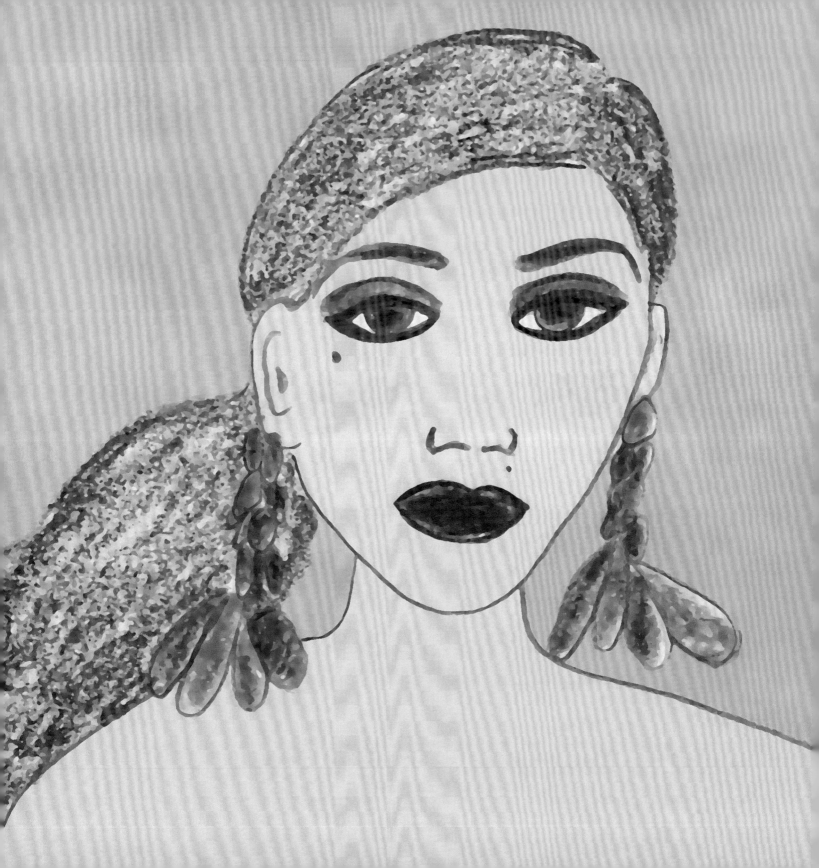

基宏說梅艷芳

說起梅艷芳，我對她的印象極為深刻，因為她是我生平中的第一個超級偶像。在我的小時候，每當我在外婆家，我總是找尋舅父錄影有關她舞台表演的眾多錄影帶放入錄影機，然後打開電視機觀賞她的動人的歌聲，及獨特的台風，看得我痴痴如醉。

我記得第一次看梅艷芳的舞台表演，便是她 1986 年於無綫電視十大勁歌金曲中憑《壞女孩》一曲獲獎時的精彩表演。她那誇張的眼妝及舞台衣服，加上她的迷人舞姿，簡直魅力十足。從此，我便深深確認梅艷芳是我的偶像。

在小學的時期，每當我考完期考那天，我回家的第一件事就是觀看百變梅艷芳再展光華演唱會 87-88 的錄影帶。每次當我觀看時，我的外婆也必然坐在我的旁邊一起欣賞她的演出。所以，這也算是當年兩婆孫的恆常娛樂節目之一。在這次演唱會中，我最愛梅艷芳的黑色修女造型，因為這基本上完美呈現她外在與內心的形象與性格。我想如果我有機會現場看到她那造型唱着《似水流年》，加上在紅館內打徐徐升起的連串燈泡，簡直就像在聖堂朝聖，一定難忘震撼。

說到我最害怕梅艷芳的造型，就是阿拉伯女郎的妖女造型，以及似火探戈中的誇張黑色怨婦造型。雖然那些造型當年給予我一些恐懼感，我也堅持要觀看《妖女》及《似火探戈》的音樂錄影帶，因為當時還是小孩的我，已抵擋不住她的音樂及造型化合出來的神秘及奇幻的感覺。

我有幸看到梅艷芳在紅館舉行的兩次大型演唱會。一次是 1999 年 4 月【百變梅艷芳演唱會】。我記得當年爸爸叮嚀着媽媽一定要買到某一場的演唱會門票，甚為着緊。第二次是 2003 年 11 月最後的【梅艷芳經典金曲演唱會】。這次演唱會我聽到梅艷芳唱第一部份歌曲時的聲線比較柔弱，但之後越唱越夠氣。

其實，當年大眾也不知道梅艷芳已經診斷為子宮頸癌症末期，但我相信每個人的心裏都抱着這個念頭：「我們都要珍惜這次的演唱會，因為可能是梅艷芳的最後一次演出，錯過了以後就沒有機會現場看她的表演。」我還記得當時每位入場觀眾都有附送一盞心形紅色發光棒，在梅艷芳唱《似水流年》的時候，整個紅館都會變成一片溫暖的紅心海，場面十分壯觀及華麗。

要說到可惜的是，本來我有機會可以在 1992 年 1 月到紅館觀看【百變梅艷芳告別舞台演唱會】，因為媽媽已買了當年最貴的 $400 門票予我們一家四口觀看。不幸的是，此場便是梅艷芳扭傷雙腳而最後無奈要取消的場次，所以當年無緣欣賞她的告別演出。直至 2006 年華星唱片推出她這次演唱會的影音產品前，我一直都對這次演唱會感到好奇，因為我好想知道整場演唱會的曲目，及欣賞她當年模仿麥當娜的大膽狂野舞台演出。另外，本來我在 2002 年也有機會到紅館觀看梅艷芳 20 周年的【梅艷芳極夢幻演唱會】，我的 Auntie 也有問我看不看，但因為當年功課繁重，加上預計她一定會對此次演唱會推出影音產品，所以最後決定不去看，現在想起也覺得有着一點遺憾。

基宏說梅艷芳

梅艷芳於 1992 年的引退後，因為成長而確定身份價值的關係，受姊姊的影響下，我便在同年遇上第二位生平中的超級偶像王菲。其實在華人樂壇中，最頂級的女歌手繼鄧麗君後，就是梅艷芳的天下。梅艷芳的引退，造就了王菲，繼承她在華人樂壇中一姐的地位。我記得 1998 年 8 月無線賑災節目中，王菲與梅艷芳在後台偶遇下，各大傳媒提議她們來個合照，所以便造就了她們破天方及唯一最親密的合照。另外，在梅艷芳的大碟《With》當中，梅艷芳竟然邀請王菲合唱《花生騷》，實在令人驚喜。雖然當年唱片公司不用此歌作主打，但在樂迷的心目中，這首歌確是一首難得的經典大作。翻查 2002 年的無線電視的採訪中，主持問梅艷芳誰是她最喜歡的女歌手，她二話不說是王菲，因為她的歌很獨特及聲線柔美，所以喜歡聽她唱的歌。

身邊有很多接觸過梅艷芳的長輩們，他們雖然與梅艷芳並不相識，但透過偶遇見證她的為人及處事態度，都說她確實是一個好人，她很隨和、善良、不計較及非常有愛心和善心。我相信梅艷芳因為如此，所以與她能夠真心交往的朋友例如劉培基、曾志偉、梁家輝及楊紫瓊等都均在訪談節目中提及梅艷芳時都不約而同自然地流淚滿面，不捨得她及十分嚮往和懷念與她昔日共處的時光。

作為梅艷芳的一個忠實歌迷，如果要說我的心願，當然是希望中國、香港及台灣電視台或電台可以破天荒攜手合作輯錄梅艷芳過往的珍貴舞台片段及音樂錄影帶製成相關影音產品，以及相關唱片公司繼續推出梅艷芳未曾發行過的全頁封面黑膠唱片，和梅艷芳所有未曝光、未發行過或經重新剪接的足本版的歷年演唱會影音產品，讓仍然存在的一班廣大的樂迷可以繼續珍藏及大眾可以欣賞梅艷芳的精彩演出。因為，隨着時代的變遷及時間的流逝，歌迷的年華老去，甚至離逝，如果在有生之年收藏及觀賞不到這些被隱藏的片段，確為其生命留下大大小小的遺憾。

出版梅艷芳圖畫集的構思，是我 23 年前已明確地定立的目標。藉着這個構思，我希望可以完整地把梅艷芳每一個重要的百變形象記錄下來，並加上有關她全面的資料，讓認識或不認識她的人，去懷念或重新認識這一個不需用性別來區分的頂級天皇巨星。我第一次畫人像的時候，就是畫梅艷芳，聽着她的歌聲，放下我繁重的功課，蒐集她每個形象的照片，拿起筆去畫及上色的時候，我的精神完全能夠放鬆，很寫意地享受每一刻。在 2006 年，我參加日本 Epson 舉辦的全球 Color Imagining Contest，幸運地憑梅艷芳的圖畫集《Anita Mui - The Legend Of The Pop Queen》被評審獲選為香港區評審特別獎，本人感到很意外及榮幸可以為梅艷芳作一些小小的貢獻及致敬。

最後，我希望曾經活在梅艷芳的年代的人，不要忘記她為我們帶來無限的歡樂。而年輕的一輩，希望可以從頭認識這一個不可多得、無可替代的真正天皇巨星。希望大家會喜歡我這本圖書，好好永遠珍藏在你家的一個角落。

Gawan On Anita Mui

Speaking of Anita Mui, I am very impressed with her everchanging images, because she is the first super idol in my life. When I was young, whenever I was at my grandmother's home, I would always look for all the videotapes which were recorded by my uncle about her stage performances, inserted them into the videocassette recorder, and turned on the TV to watch her unique style of evry stage perfomance, which made me fascinated and exciting.

I remember the first time I saw Anita Mui's stage performance was when she won the award for the song "Bad Girl" in the TVB Solid Gold Best 10 Awards Presentation in 1986. Her exaggerated eye makeup and stage clothes, coupled with her charming dance and moves, are simply charming. Since then, I have deeply confirmed that Anita Mui is my idol.

When I was in primary school, whenever I finished my term exams, the first thing I would do when I got home was to watch the videotape of Everchaning Anita Mui Live In Concert 87-88. Every time I watch it, my grandmother must sit next to me and enjoy her performance together. Therefore, this can be regarded as one of the regular entertainment programs between my grandmother and I. In this concert, I love Anita Mui's black nun image the most, because it basically and perfectly presents her external and inner image and character. I think if I have the opportunity to see her singing [The Years Flow Like Water] in the Hong Kong Coliseum, with lighting up a series of light bulbs slowly rising, it will be like a pilgrimage in a temple, and it must be unforgettable and shocking.

When it comes to the look that I am most afraid of Anita Mui, it is the the Arabian girl image for her song [Temptress] and the exaggerated black resentful woman image for her song [Burning Tango]. Although those looks gave me some fear back then, I also insisted on watching the music videos of [Temptress] and [Burning Tango], because although I was a child at that time, I couldn't resist the mystery and beauty combined by her music and images.

I was fortunate to see Anita Mui's two major concerts at the Hong Kong Coliseum. One was [Everchanging Anita Mui Live In Concert] in April 1999. I remember my father reminding my mother to endeavour to buy tickets of this concert as she could. The second one was Anita Mui's last concert - [Anita Class Moment Live] in November 2003. In this concert, I heard that Anita Mui's voice was relatively weak when she sang the songs in the first part, but her voice was strong as usual thereafter. In fact, at that time, the public did not know that Anita Mui had been diagnosed with the last stage of cervical cancer, but I believe everyone had this thought in their hearts: "We should cherish this concert, because it may be Anita Mui's last performance. If you miss it this time, you may never see her singing live again." Addtionally, I also remember that every audience were given a heart-shaped red light stick when they entered the entrances of the Hong Kong Coliseum. When Anita Mui sang [The Years Flow Like Water], a warm sea of red heart light appeared surrounding the stage. The scene was very spectacular and gorgeous.

Gawan On Anita Mui

It is a pity that I had the opportunity to watch [Everchaning Anita Mui Final Concert] at the Hong Kong Coliseum in January 1992, because my mother had already bought the most expensive $400 tickets for our family of four to watch. Unfortunately, this show was the one in which Anita Mui sprained her legs and had no choice but to cancel it, so I didn't have the chance to enjoy her farewell performance. Until 2006 when Capital Artist Records released VCD/ DVD of that concert, I was always curious about it because I really wanted to know the rundown and appreciate Anita Mui's bold and wild stage performance that imitated Madonna. In addition, in 2002, I also had the opportunity to watch Anita Mui's 20th Anniversary Concert - [Anita Mui Fantasy Gig] at the Hong Kong Coliseum. My Auntie also asked me if I would like to go to see it, but because of the heavy homework back then, and I was expected that she would definitely release audio-visial products for this concert, I decided not to go for it in the end, and I feel a little regretful when I think about it now.

After Anita Mui retired in 1992, because of my growing up and determining the value of my identity, under the influence of my elder sister, I met my second super idol Faye Wong in the same year. In fact, in the Chinese music inductsry, after Teresa Teng, the top female singer is dominated by Anita Mui. Anita Mui's retirement made Faye Wong to inherit her status as the toppest mega-diva in the Chinese music industry. I remember Faye Wong and Anita Mui ran into each other backstage on TVB's charity show in August 1998, the journalists requested them to take photograph together and that's why their unique and intimate photos were publized. In addition, in Anita Mui's last recording album "With", she actually invited Faye Wong to sing the song "Fashion Show" together, which is really surprising. Although the record company didn't use this song as one of the album's leading singles, in the eyes of fans, this song is indeed a rare classic. In a TVB interview in 2002, the host asked Anita Mui who was her favorite female singer, and she said it was Faye Wong immediately, because her songs are very unique and her voice is soft, so she liked to listen to her songs.

There are many elders around me who have been in contact with Anita Mui. Although they are not familiar with Anita Mui, they all say that she is indeed a good, loving, caring and kind hearted person through encounters with her. I believe that is true and that's why Anita Mui's sincere friends like Eddie Lau, Eric Tsang, Leung Ka Fai Tony and Michelle Yeoh all shed tears naturally when they mentioned Anita Mui in the talk show, which showed they miss her much and yearn for and miss the time they spent with her in the past.

Gawan On Anita Mui

As a loyal fan of Anita Mui, if I want to say my wish, surely, I hope that China, Hong Kong, Taiwan TV stations and radio stations can work together to provide the precious stage clips and music videos of Anita Mui in the past and make related audio-visual products, and the related record companies will continue to release Anita Mui unreleased full-page cover vinyl records, and all unexposed, unreleased or re-edited full-length concerts of Anita Mui over the years and release those related audio-visual products, so that a large group of music fans that still exist can continue to collect and share with the public and enjoy Anita Mui's wonderful performances. Because, with the changes of the times and the passage of time, fans of Anita Mui are getting old or even passing away. If they cannot collect and watch these hidden clips in their lifetime, they will indeed leave big and small regrets in their lives.

The idea of publishing Anita Mui's painting book was a goal I had clearly set 23 years ago. With this idea, I hope that I could completely record every important and ever-changing image of Anita Mui, and add comprehensive information about her, so that people who know her or don't know her can memorize or recognize Anita Mui who is a mega superstar without the need to be distinguished by gender. The first time I painted portraits was Anita Mui. When I listened to her songs, put down my tedious homework, collected photos of each of her images, and picked up colour pencils to paint and color, my mind and soul was completely relaxed and enjoyed that moment very freely. In 2006, I participated in the global Color Imagining Contest held by Epson, Japan. Fortunately, Anita Mui's painting book [Anita Mui - The Legend Of The Pop Queen] was selected as the Special Award by the Hong Kong judges. I was so surprised and elighted since I could make some small contributions and tributes to my beloved Anita Mui.

Finally, I hope that those who grew up or lived in Anita Mui's era would not forget the infinite joy she brought us. To the younger generations, I hope they would get to know more about this rare and irreplaceable true emperor superstar from the beginning. I hope everyone would like this painting book and keep it in your homes forever.

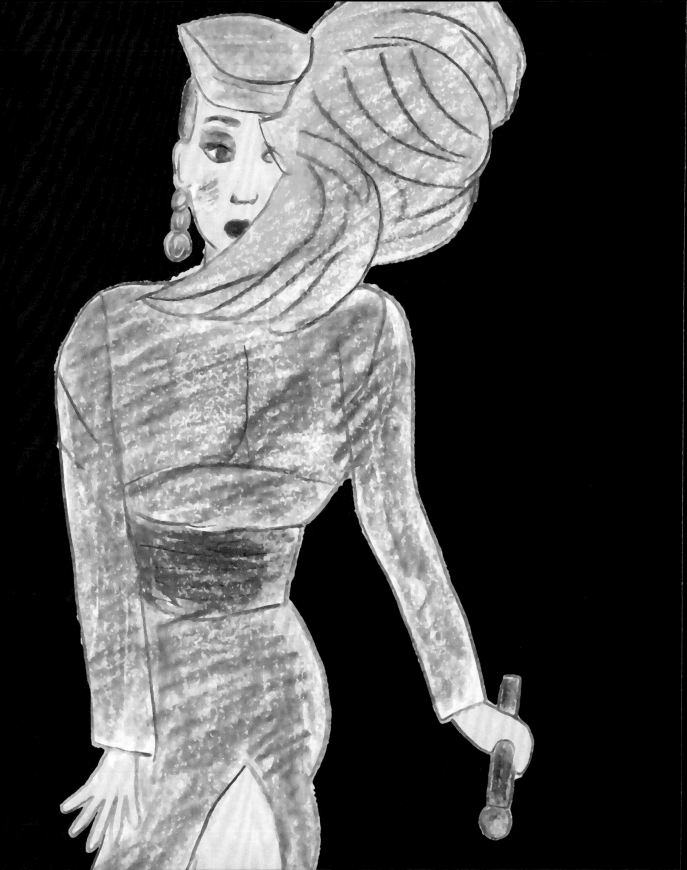

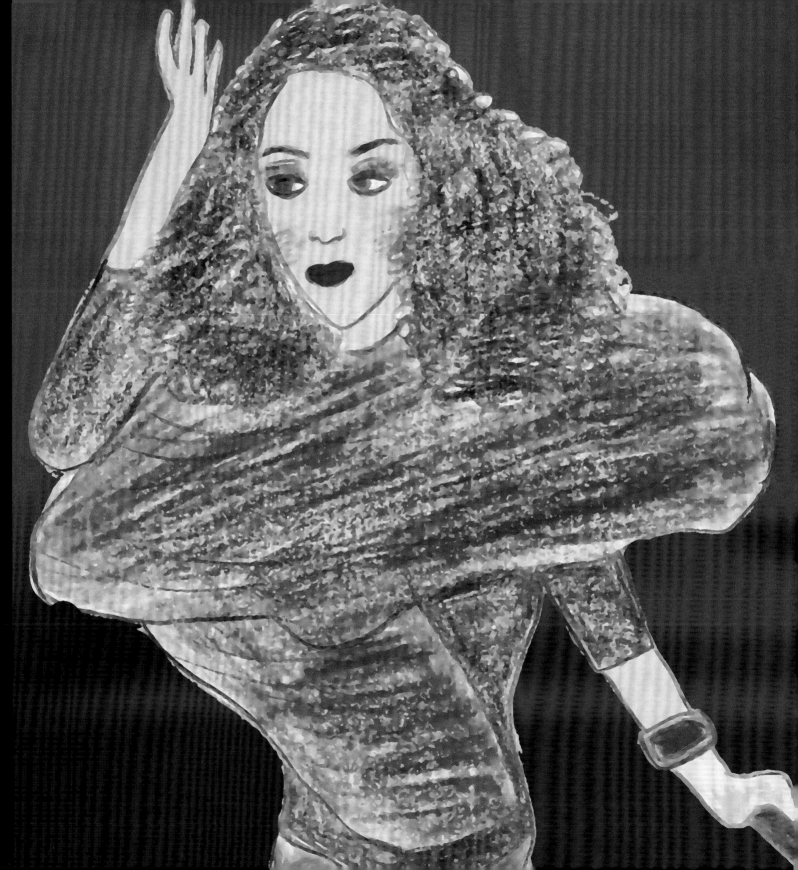

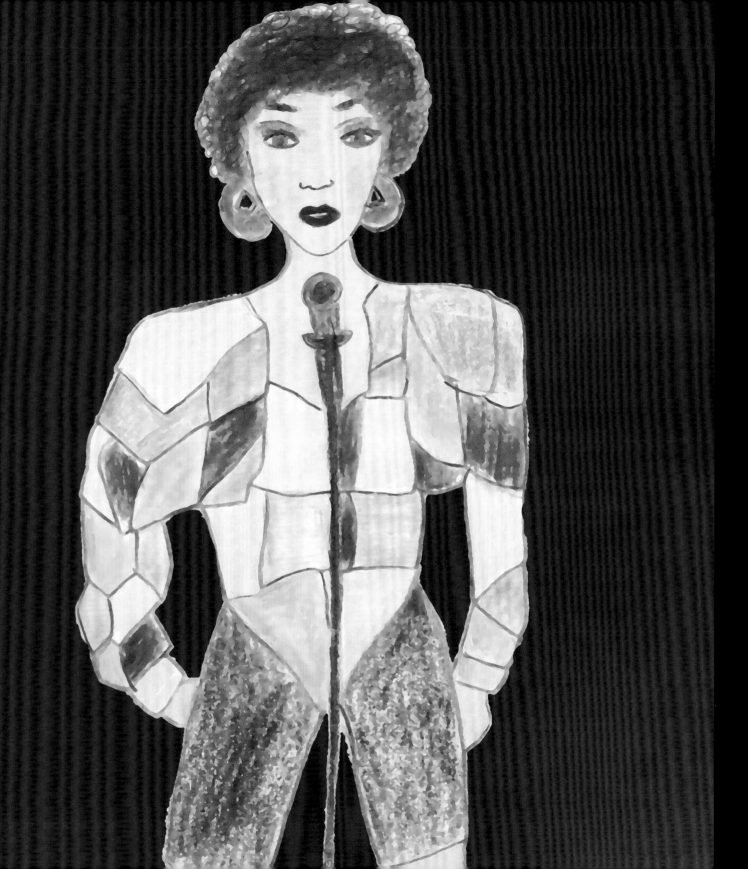

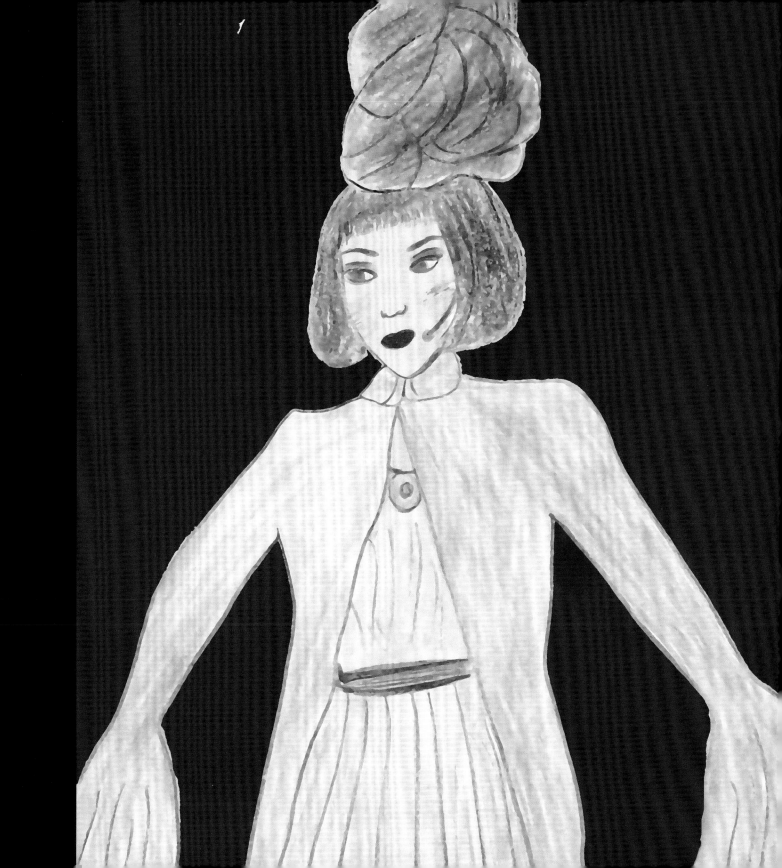

孤身走我路　　獨個摸索我路途　　Oh...　　問誰伴我走我路　　寂寞時伴我影歌中舞
《孤身走我路》　作詞：鄭國江

Walk my way alone　　Grope my way alone　　Oh...　　Ask who will accompany me to walk my way
When I am lonely accompany me to sing and dance in the shadow
〔Walk My Way Alone〕　　Lyricist: Cheng Kwok Kong

蔓珠莎華　　舊日艷麗已盡放　　花不再香　　但美麗心中一再想
《蔓珠莎華》　作詞：潘偉源

Manjusaka　　The old splendor is gone　　The flowers are no longer fragrant　　But the
beautiful heart thinks again and again
〔Manjusaka〕　　Lyricist: Poon Wai Yuen

人類每天談情　　誰又夠膽發誓保證　　我懂得　　愛戀真正風景
《愛的教育》　作詞：黃偉文

Human beings talk about love every day　　Who is brave enough to swear　　I know　　The real
scenery of love
〔Love Education〕　　Lyricist: Wyman Wong

憑熱吻他人的嘴蓋掩心碎　　麻醉了的身軀　　把昨日拚命的撕碎
《裝飾的眼淚》　作詞：陳少琪

Kissing someone's mouth to cover up heartbreak　　An anesthetized body　　Tearing up
yesterday's painstakingly
〔Decorated Tears〕　　Lyricist: Keith Chan

情軟若綿柔情閃閃嘴邊　　暴力暴行現在沒法蔓延　　人人為了我　　天天都不再作戰
《愛將》　作詞：潘偉源

Love is soft as cotton and tenderness flashes on the lips　　Violence and atrocities can't
spread now Everyone for me　　No longer fighting every day
〔Love Warrior〕　　Lyricist: Poon Wai Yuen

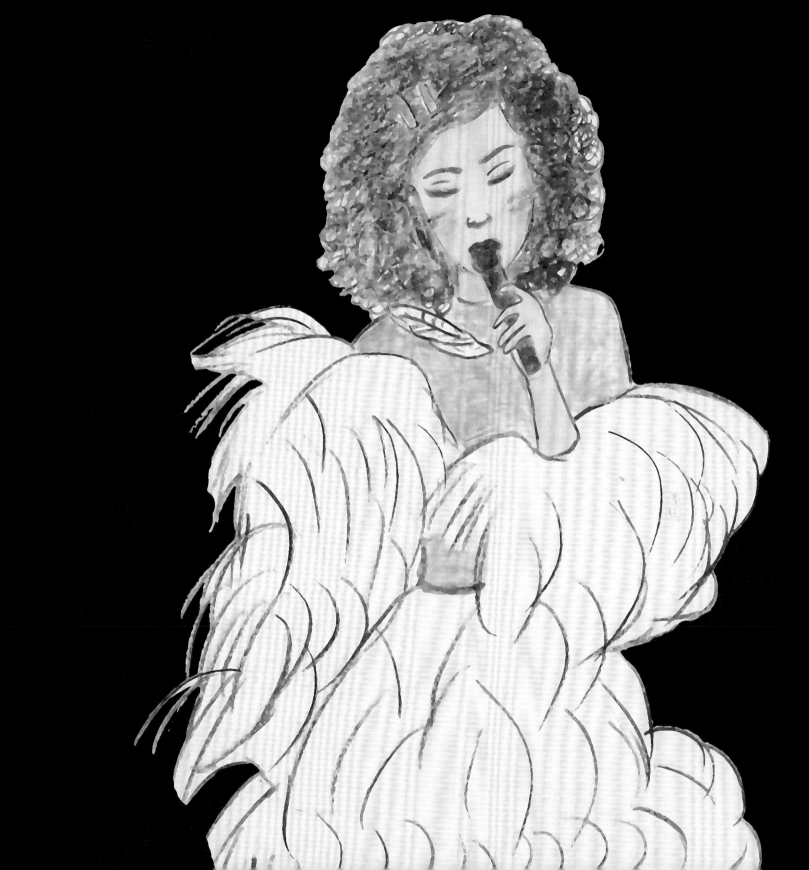

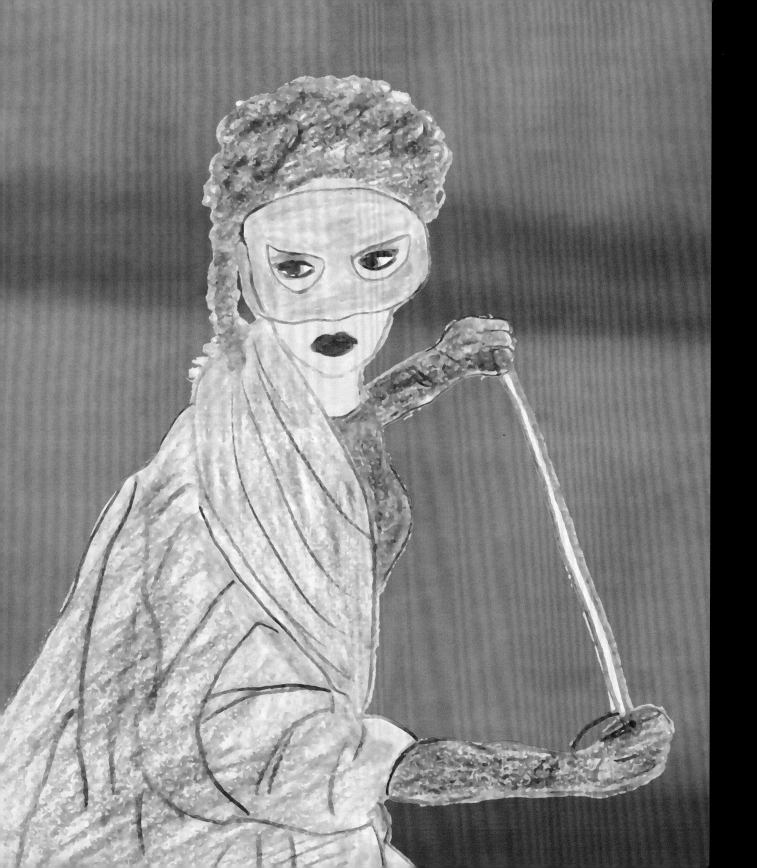

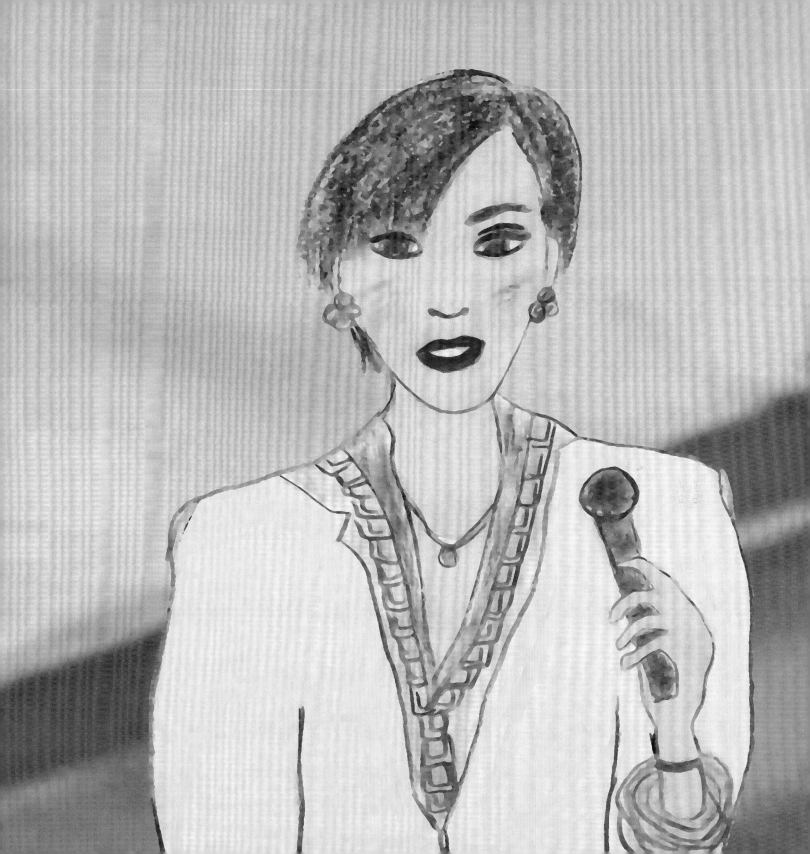

梅艷芳的音樂大獎
Anita Mui's Music Awards

1982 : ※ 第 1 屆新秀歌唱大賽 – 冠軍
　　　　※ 第 12 屆東京音樂節 – 亞洲特別獎、TBS 獎

1982 : ※ The 1st TVB International Chinese New Talent Singing Championship – Champion
　　　　※ The 12th Tokyo Music Festival – Asia Special Award and TBS Award

1983 : ※ IFPI 香港唱片年會 – 新人獎
　　　　※ 第 6 屆十大中文金曲頒獎音樂會 – 金典獎「赤的疑惑」
　　　　※ 第 1 屆十大勁歌金曲頒獎典禮 – 金曲獎「赤的疑惑」、「交出我的心」
　　　　※ 十大勁歌金曲季選 – 金曲獎「赤的疑惑」、「交出我的心」、「赤的衝擊」
　　　　※ 第 5 屆中文歌曲擂台獎 – 「赤的疑惑」
　　　　※ 第 7 屆金唱片頒獎典禮 – 白金唱片《心債》

1983 : ※ IFPI Hong Kong Record Annual Conference – Newcomer Award
　　　　※ The 6th Top Ten Chinese Gold Songs Award Concert – Golden Song Award "Red Doubt"
　　　　※ The 1st Jade Solid Gold Best 10 Awards Presentation – Golden Song Award "Red Doubts" &
　　　　　　"Hand Over My Heart"
　　　　※ The Jade Solid Gold Best 10 Awards Seasonal Presentation – Golden Song Award "Red Doubts",
　　　　　　"Hand Over My Heart" & "Red Impact"
　　　　※ The 5th Chinese Song Challenge Awards – "Red Doubts"
　　　　※ The 7th Hong Kong Gold Disc Award Presentation – Platinum Disc〔Debts Of The Heart〕

1984 : ※ 第 7 屆十大中文金曲頒獎音樂會 – 金曲獎「似水流年」
　　　　※ 第 7 屆十大中文金曲頒獎音樂會 – 最佳唱片封套《飛躍舞台》
　　　　※ 第 2 屆十大勁歌金曲頒獎典禮 – 金曲獎「似水流年」
　　　　※ 十大勁歌金曲季選 – 金曲獎「似水流年」、「飛躍舞台」
　　　　※ 第 6 屆中文歌曲擂台獎 –「飛躍舞台」
　　　　※ 第 8 屆金唱片頒獎典禮 – 白金唱片《赤色》

1984 : ※ The 7th Top Ten Chinese Gold Songs Award Concert – Golden Song Award "The Years Flow Like
　　　　　　Water" & Best Album Cover Award〔Leaping In The Spotlight〕
　　　　※ The 2nd Jade Solid Gold Best 10 Awards Presentation – Golden Song Award "The Years Flow Like
　　　　　　Water"
　　　　※ The Jade Solid Gold Best 10 Awards Seasonal Presentation – Golden Song Award
　　　　　　"The Years Flow Like Water" & "Leaping In The Spotlight"
　　　　※ The 6th Chinese Song Challenge Awards – "Leaping In The Spotlight"
　　　　※ The 8th Golden Disc Awards Ceremony – Platinum Disc〔Red〕

梅艷芳的音樂大獎
Anita Mui's Music Awards

1985 : ※ 第 3 屆十大勁歌金曲頒獎典禮 – 金曲獎「壞女孩」及最受歡迎女歌星
　　　 ※ 十大勁歌金曲季選 – 金曲獎「夢幻的擁抱」、「蔓珠沙華」、「邁向新一天」、「壞女孩」
　　　 ※ 第 8 屆十大中文金曲頒獎音樂會 – 金曲獎「蔓珠莎華」
　　　 ※ 第 6 屆中文歌曲擂台獎 –「似水流年」
　　　 ※ 香港商業電台 – 最受歡迎女藝人
　　　 ※ 第 9 屆金唱片頒獎典禮 – 白金唱片《似水流年》、《飛躍舞台》

1985 : ※ The 3rd Jade Solid Gold Best 10 Awards Presentation – Golden Song Award "Bad Girl" and
　　　　 Most Popular Female Singer Award
　　　 ※ The Jade Solid Gold Best 10 Awards Seasonal Presentation – Golden Song Award "Dream Embrace",
　　　　 "Manjusak", "Towards A New Day" & "Bad Girl"
　　　 ※ The 8th Top Ten Chinese Gold Songs Award Concert – Golden Song Award "Manjusaka"
　　　 ※ The 6th Chinese Song Challenge Awards – "The Years Flow Like Water"
　　　 ※ Commercial Radio Hong Kong – Most Popular Female Artist Award
　　　 ※ The 9th Hong Kong Gold Disc Awards Presentation – Platinum Disc [The Years Flow Like Water] &
　　　　 [Leaping In The Spotlight]

1986 : ※ IFPI 全年最佳銷量大碟《壞女孩》
　　　 ※ 第 4 屆十大勁歌金曲頒獎典禮 – 金曲獎「夢伴」、「將冰山劈開」及最受歡迎女歌星
　　　 ※ 十大勁歌金曲季選 – 金曲獎「夢伴」、「妖女」、「將冰山劈開」
　　　 ※ 第 9 屆十大中文金曲頒獎音樂會 – 金曲獎「愛將」
　　　 ※ 第 7 屆中文歌曲擂台獎 –「壞女孩」
　　　 ※ 香港商業電台 – 最受歡迎女藝人
　　　 ※ 香港電台 – 十大最受歡迎人物

1986 : ※ IFPI Best-selling Album of the Year [Bad Girl]
　　　 ※ The 4th Jade Solid Gold Best 10 Awards Presentation – Golden Song Award "Dream Partner" &
　　　　 "Break The Iceberg" and Most Popular Female Singer Award
　　　 ※ The Jade Solid Gold Best 10 Awards Seasonal Presentation – Golden Song Award "Dream Partner",
　　　　 "Temptress" & "Break The Iceberg"
　　　 ※ The 9th Top Ten Chinese Gold Songs Award Concert – Golden Song Award "Love Warrior"
　　　 ※ The 7th Chinese Song Challenge Awards – "Bad Girl"
　　　 ※ Commercial Radio Hong Kong – Most Popular Female Artist Award
　　　 ※ Radio Television Hong Kong – Top Ten Most Popular People Award

梅艷芳的音樂大獎
Anita Mui's Music Awards

1987 ：※ 第 5 屆十大勁歌金曲頒獎典禮 – 金曲獎「烈燄紅唇」、最佳音樂錄影帶演出獎「似火探戈」及
　　　　最受歡迎女歌星
　　　※ 十大勁歌金曲季選 – 金曲獎「似火探戈」、「裝飾的眼淚」、「烈焰紅唇」
　　　※ 第 10 屆十大中文金曲頒獎音樂會 – 金曲獎「烈燄紅唇」
　　　※ 香港商業電台 – 最受歡迎女藝人獎
　　　※ 香港電台 – 十大最受歡迎人物

1987 ：※ The 5th Jade Solid Gold Best 10 Awards Presentation – Golden Song Award "Flaming Red Lips",
　　　　Best Music Video Performance Award "Burning Tango" and Most Popular Female Singer Award
　　　※ The Jade Solid Gold Best 10 Awards Seasonal Presentation – Golden Song Award "Burning Tango",
　　　　"Decorative Tears" & "Flaming Red Lips"
　　　※ The 10th Top Ten Chinese Gold Songs Award Concert – Golden Song Award "Flaming Red Lips"
　　　※ Commercial Radio Hong Kong – Most Popular Female Artist Award
　　　※ Radio Television Hong Kong – Top Ten Most Popular People Award

1988 ：※ 第 6 屆十大勁歌金曲頒獎典禮 – 金曲獎「Stand By Me」、「胭脂扣」、最佳音樂錄影帶獎「夢裡共醉」及
　　　　最受歡迎女歌星
　　　※ 十大勁歌金曲季選 – 金曲獎「胭脂扣」、「Stand By Me」、「夢裡共醉」
　　　※ 第 11 屆十大中文金曲頒獎音樂會 – 金曲獎「Stand By Me」
　　　※ 香港電台 – 十大最受歡迎人物
　　　※ 第 10 屆金唱片頒獎典禮 – 白金唱片《壞女孩》、《妖女》、《似火探戈》、《烈焰紅唇》、
　　　　《百變梅艷芳 87-88 再展光華演唱會》

1988 ：※ The 6th Jade Solid Gold Best 10 Awards Presentation – Golden Song Award "Stand By Me" & "Rouge",
　　　　Best Music Video Award "Drunk In Dreams Together" and Most Popular Female Singer
　　　※ The Jade Solid Gold Best 10 Awards Seasonal Presentation – Golden Song Award "Rouge",
　　　　"Stand By Me" & "Drunk In Dreams Together"
　　　※ The 11th Top Ten Chinese Gold Songs Award Concert – Golden Song Award "Stand By Me"
　　　※ Radio Television Hong Kong – Top Ten Most Popular People Award
　　　※ The 10th Hong Kong Gold Disc Awards Presentation – Platinum Disc [Bad Girl], [Temptress],
　　　　[Burning Tango], [Flaming Red Lips] & [Evercganging Anita Mui Live In Concert 87-88]

1989 ：※ 第 7 屆十大勁歌金曲頒獎典禮 – 金曲獎「夕陽之歌」、最受歡迎女歌星 及金曲金獎「夕陽之歌」
　　　※ 十大勁歌金曲季選 – 金曲獎「淑女」、「黑夜的豹」、「夏日戀人」、「夕陽之歌」、「愛我便說愛我吧」
　　　※ 第 12 屆十大中文金曲頒獎音樂會 – 金曲獎「淑女」、「夕陽之歌」及 IFPI 大獎
　　　※ 香港電台 – 十大最受歡迎人物
　　　※ 叱咤樂壇流行榜頒獎典禮 – 叱咤樂壇女歌手金獎
　　　※ 香港藝術家年獎 – 歌唱家獎
　　　※ 第 8 屆香港電影金像獎 – 最佳電影歌曲「胭脂扣」

梅艷芳的音樂大獎
Anita Mui's Music Awards

1989 ： ※ The 7th Jade Solid Gold Best 10 Awards Presentation – Golden Song Award "Song of the Sunset",
Most Popular Female Singer Awaard & Golden of the Goldern Song Award "Song Of The Sunset"
※ The Jade Solid Gold Best 10 Awards Seasonal Presentation – Golden Song Award "Lady",
"Night Leopard", "Summer Lover", "Song Of The Sunset" & "Say It If You Love Me"
※ The 12th Top Ten Chinese Gol獎d Songs Award Concert – Golden Song Award "Ladies",
"Songs of the Sunset" and IFPI Awards
※ Radio Television Hong Kong – Top Ten Most Popular People Award
※ Ultimate Song Chart Awards Presentation – Gold Award for the Most Broadcasting Female Singer
※ Hong Kong Arts Development Awards – Singer Award
※ The 8th Hong Kong Film Awards – Best Film Song "Rouge"

1990 ： ※ 第 8 屆十大勁歌金曲頒典禮 – 金曲獎「心仍是冷」
※ 十大勁歌金曲季選 – 金曲獎「封面女郎」、「心仍是冷」、「耶利亞」
※ 香港電台 – 80 年代十大最受歡迎演藝紅人
※ 第 11 屆金唱片頒獎典禮 – 白金唱片《夢裏共醉》、《淑女》、《In Brazil》
※ 韓國十大最受歡迎外國女歌手 – 第五名

1990 ： ※ The 8th Jade Solid Gold Best 10 Awards Presentation – Golden Song Award "Heart Remains Cold"
※ The Jade Solid Gold Best 10 Awards Seasonal Presentation – Golden Song "Cover Girl",
"Heart Remains Cold" & "Yelia"
※ Radio Television Hong Kong – Hong Kong's Top Ten Most Popular Artists In The 1980s Award
※ The 11th Golden Disc Awards Ceremony – Platinum Disc (［Drunk In Dreams Together］, ［Lady］&
［In Brazil］)
※ The Most Popular Foreign Female Singer In Korea - No. 5 Award

1991 ： ※ 叱咤樂壇流行榜頒獎典禮 – 叱咤樂壇女歌手銀獎
※ 第 27 屆金馬獎最佳電影歌曲「何日」
※ 第 10 屆香港電影金像獎最佳電影歌曲「似是故人來」

1991 ： ※ Ultimate Song Chart Awards Presentation – Silver Award for the Most Broadcasting Female Singer
※ The 27th Golden Horse Awards – Best Film Song "When Will It Be"
※ The 10th Hong Kong Film Awards – Best Film Song "Like An Old Friend Comes"

1992 ： ※ 第 14 屆十大中文金曲頒獎音樂會 – 鑽石偶像大獎
※ 第 10 屆十大勁歌金曲頒獎典禮 – 榮譽大獎

1992 ： ※ The 14th Top Ten Chinese Gold Songs Award Concert – Diamond Idol Award
※ The 10th Jade Solid Gold Best 10 Awards Presentation – Honor Award

梅艷芳的音樂大獎
Anita Mui's Music Awards

1994 : ※ 第 1 屆十大金彩虹演藝紅人獎
　　　 ※ 第 13 屆香港電影金像獎最佳電影歌曲「女人心」

1994 : ※ The 1st Top Ten Golden Rainbow Popular Artists Award
　　　 ※ The 13th Hong Kong Film Awards – Best Film Song "Women's Heart"

1995 : ※ 新加坡音樂頒獎禮 – 舞台至尊大獎

1995 : ※ Singapore Music Awards – Stage Supreme Award

1998 : ※ 香港電台廿載金曲十大最愛 –「似水流年」

1998 : ※ Top Ten Favorites of Radio Television Hong Kong's 20-year Golden Songs – "The Years Flow Like Water"

1999 : ※ 第 21 屆十大中文金曲頒獎音樂會 – 金針獎

1999 : ※ The 21st Top Ten Chinese Gold Songs Award Concert – Golden Needle Award

2001 : ※ 十大勁歌金曲頒獎典禮 2000 – 致敬大獎

2001 : ※ Jade Solid Gold Best 10 Awards Presentation Top Ten Golden Melody Awards Ceremony 2000 – Tribute Award

2002 : ※ 第 25 屆十大中文金曲頒獎音樂會 – 最受歡迎卡拉 OK 合唱歌曲「相愛很難」及金曲銀禧榮譽大獎
　　　 ※ 第 4 屆 CCTV-MTV 音樂盛典 – 港台音樂特殊貢獻獎及 MTV 風尚亞洲女歌手獎

2002 : ※ The 25th Top Ten Chinese Gold Songs Award Concert – Most Popular Karaoke Choral Song Award
　　　　 "Loving Is Difficult" and Golden Melody Silver Jubilee Honor Award
　　　 ※ The 4th CCTV-MTV Music Festival – Hong Kong and Taiwan Music Special Award and
　　　　 MTV Style Asian Female Singer Award

2003 : ※ 第 4 屆中國金唱片獎 – 藝術成就獎
　　　 ※ 中國原創歌曲獎頒獎禮 – 傑出成就獎

2003 : ※ The 4th China Golden Disc Awards – Artistic Achievement Award
　　　 ※ China Original Song Award Ceremony – Outstanding Achievement Award

2004 : ※ MTV 亞洲大獎 – 啟發精神大獎
　　　 ※ 第 4 屆百事音樂風雲榜頒獎盛典 – 突破渴望大獎

2004 : ※ MTV Asia Awards – Inspiration Spirit Award
　　　 ※ The 4th Pepsi Music Billboard Awards Ceremony – Breakthrough Desire Award

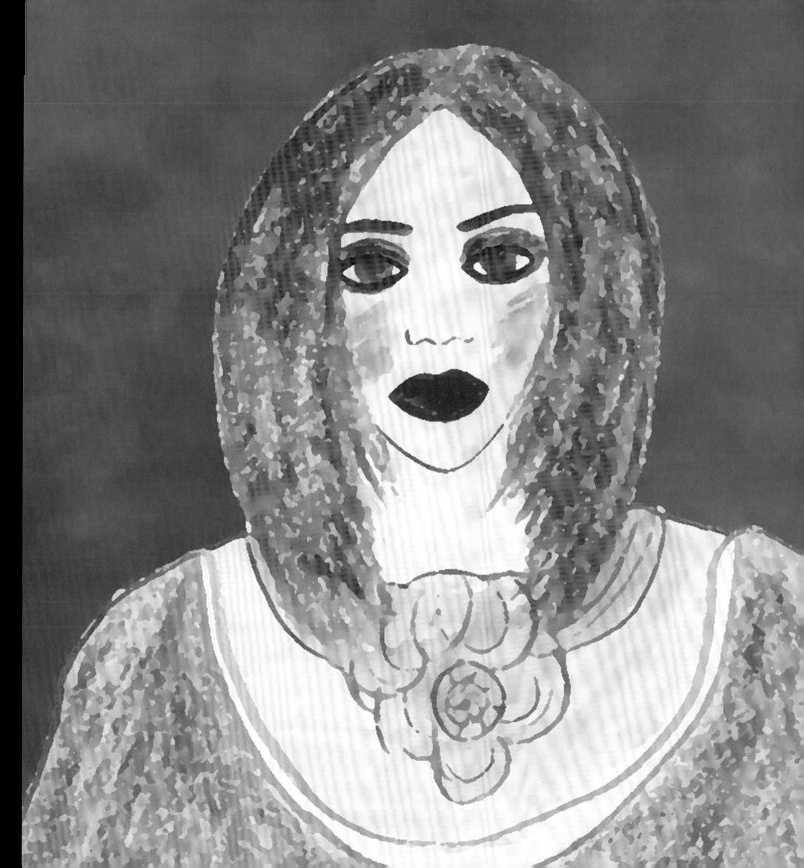

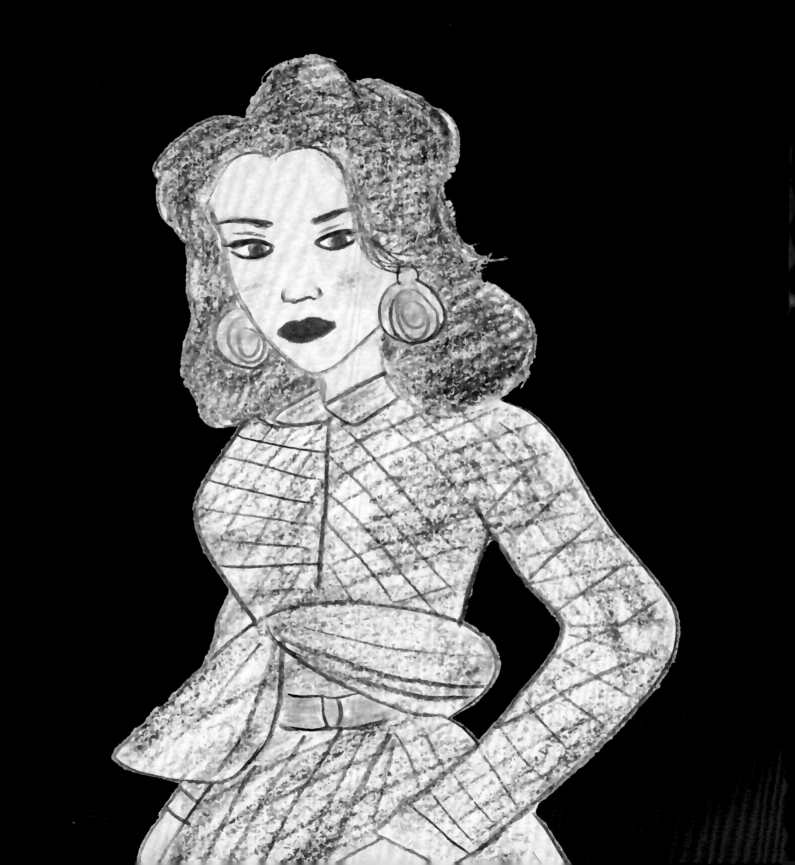

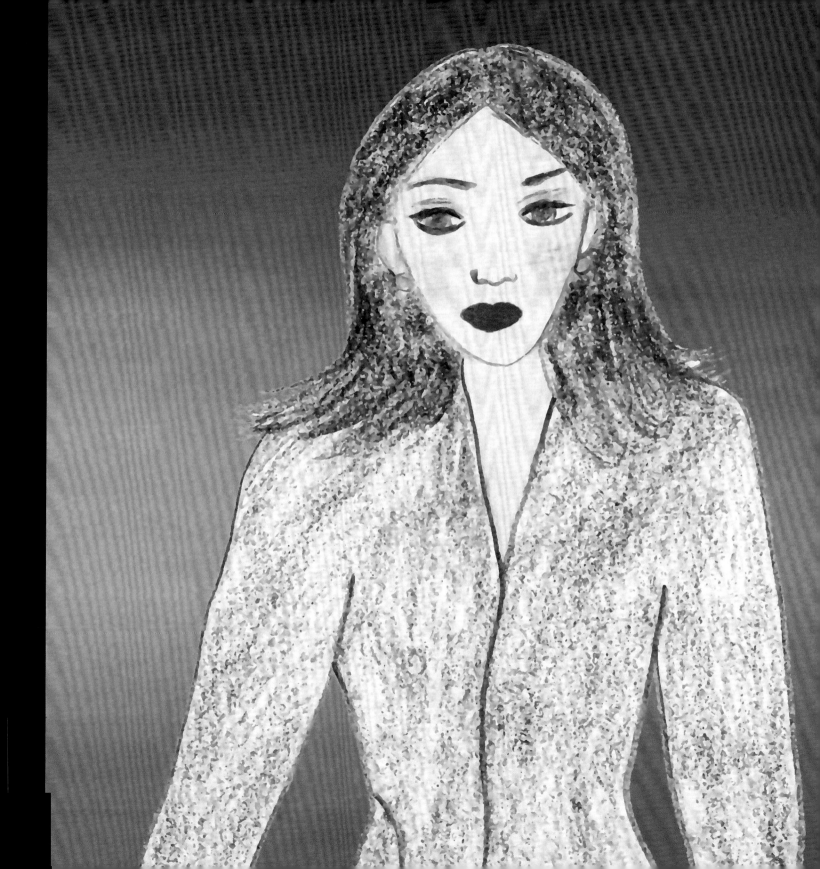

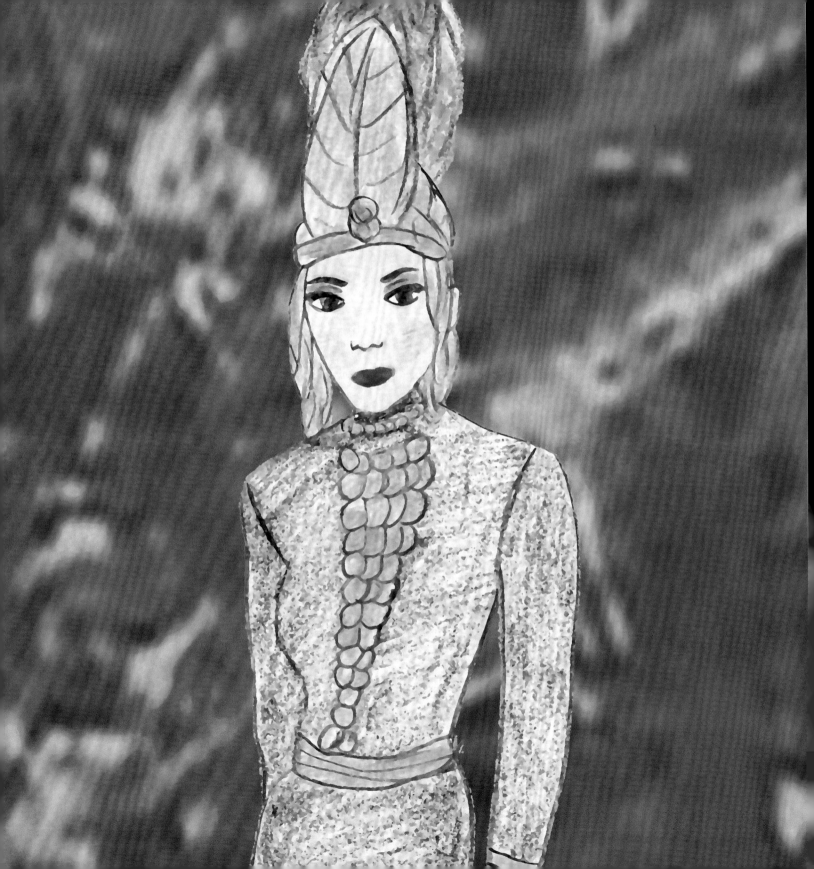

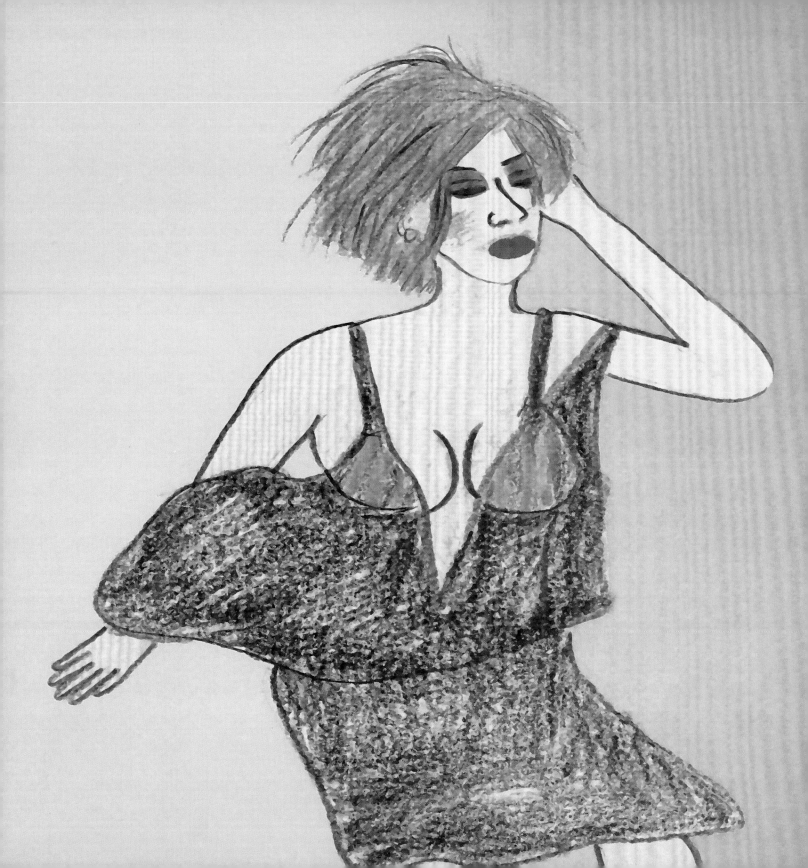

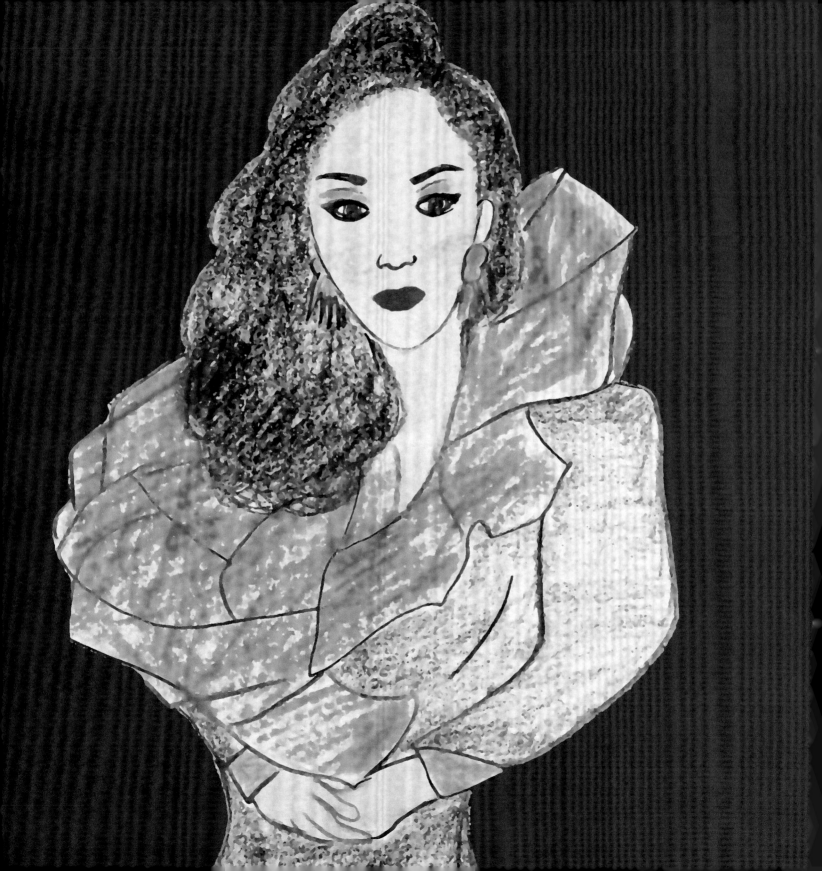

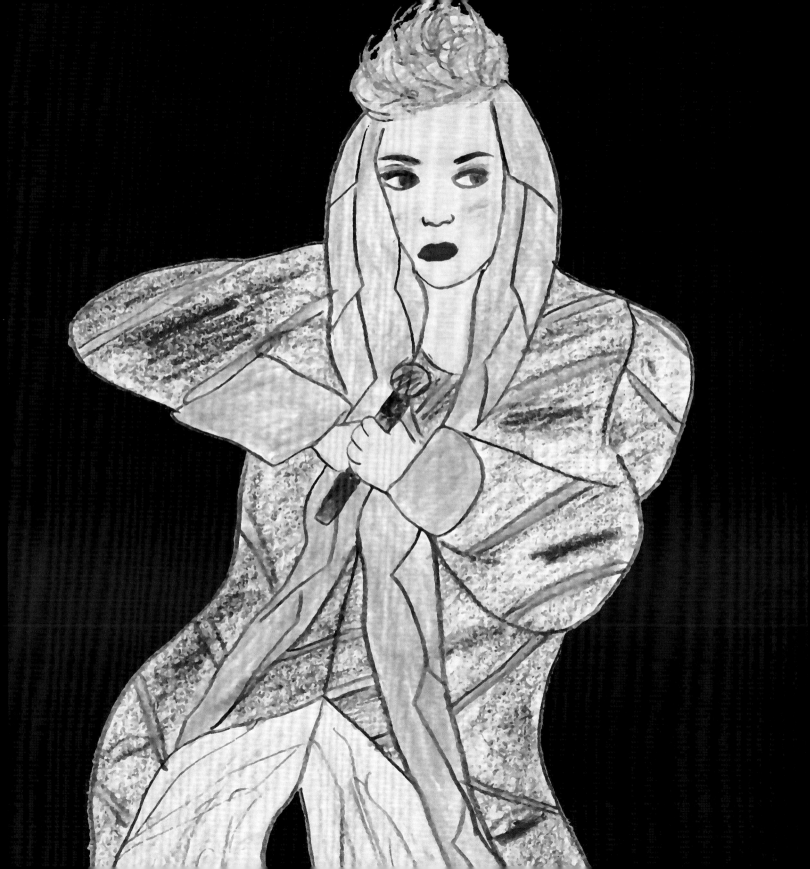

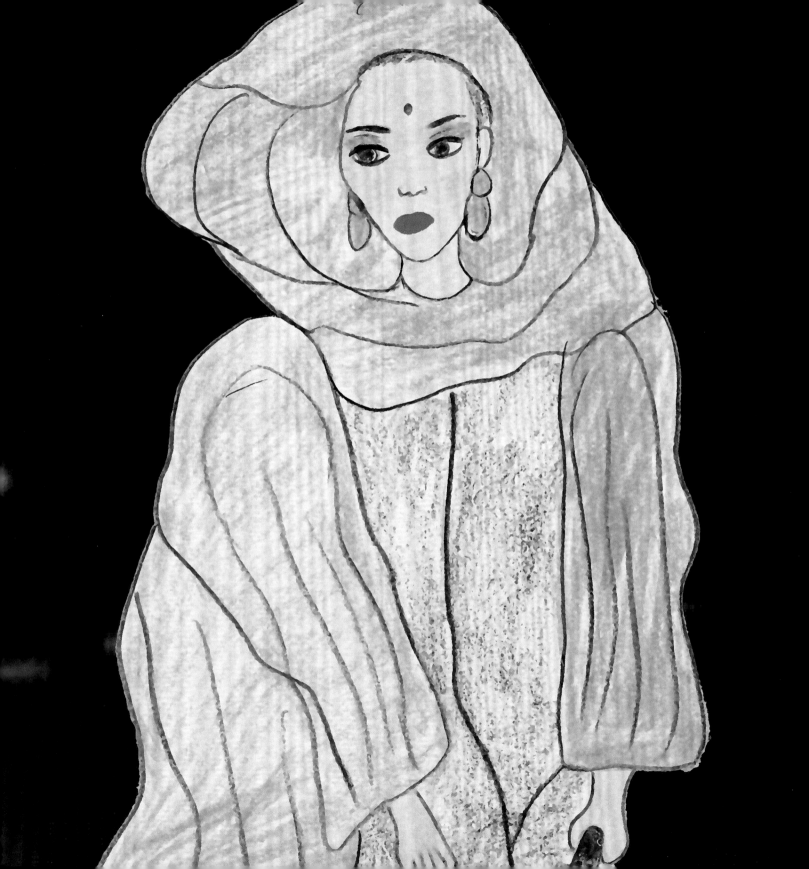

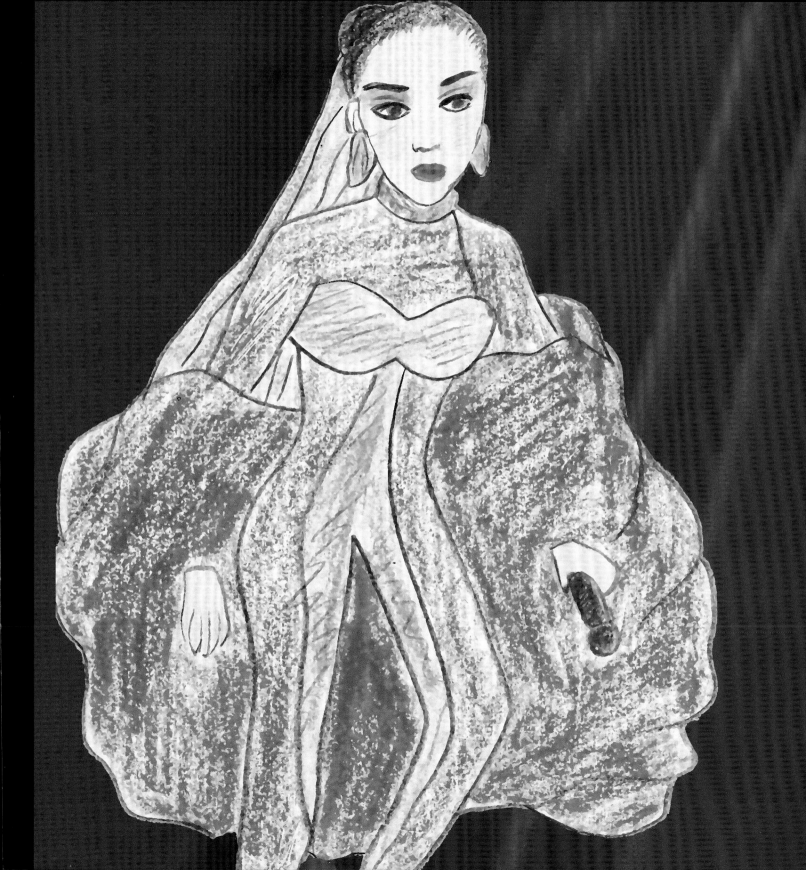

關於基宏
About Gawan

基宏是香港、澳洲及紐西蘭律師，也是一名作家、繪畫師及玩具精品收藏家。他自 1997 年起便開始繪畫人像，並於 2001 年起開始創作多首文曲，即以歌詞及新詩為體本的隨意創作文體。他於 2021 年 7 月首次在台灣出版首本實驗性質的文曲書本專輯「Who's That Virgin? He is.... Gawanlo」，並於 2024 年 7 月出版第一本正式的中英雙語的文曲書本專輯 「Virgin 處子」。

他喜歡自由創意，著重生活態度、文化時尚藝術及傳播資訊。他從不隨波逐流，不愛一切拘謹且守舊通俗的理念和概念。他認為人生不應為物質而盲目消費自己的身心，應該善待自己和享受簡單的生活。他喜歡聆聽別人的故事和經歷及體會社會和生活上的不同文化和點滴，並希望透過所創作的作品令世人得以回歸簡單自然、宣揚愛與和平及重新認識自己和淨化心靈。

Gawan is a Hong Kong, Australian and New Zealand lawyer, a writer, a painter and a toy and accessory collector. He began painting portraits in 1997, and in 2001 he began to compose a number of word songs, a casual style of writing based on the format of lyrics and modern poetry. He published his first experimental word song book album titled "Who's That Virgin? He is.... Gawanlo" in Taiwan in July 2021, and published his first official bilingual (Chinese & English) word song book album titled "Virgin" in July 2024.

He likes free creativity and focuses on life attitude, culture, fashion, arts and dissemination of information. He never follows the trend and does not like all rigid and conservative ideas and concepts. He believes that life should not blindly consume one's body and mind for material things, but should treat oneself well and enjoy a simple life. He likes to listen to other people's stories and experiences and embody different cultures and matters in society and life. He hopes that through the works he creates, people can return to simplicity and nature, promote love and peace, re-understand themselves and transform their souls spiritually.

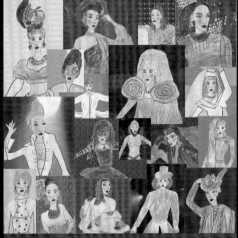

The Legend of the Pop Queen

※ EPSON COLOR IMAGING CONTEST 2006 - SPECIAL AWARD
※ EPSON 彩色影像大賞 2006 - 圖像組特別獎

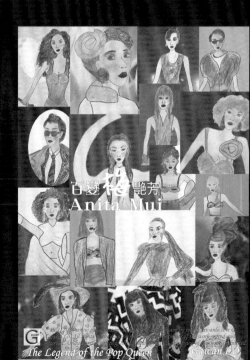

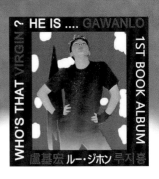

精裝書版本
HARDCOVER BOOK VERSION
收錄23首文曲
23 Word Songs Included

訂購請參閱基宏官方網站
To order, please refer to the official website of GAWAN
www.icongawan.com

基宏最初回實驗性文曲書本專輯

WHO'S THAT VIRGIN?
HE IS GAWANLO
1ST BOOK ALBUM

GAWAN 1ST EXPERIMENTAL WORD SONG BOOK ALBUM

600本限量珍藏精裝書版本
附送4張精細圖片文字卡
售完即止

**600 Limited Hardcopy Books
Inclusive Of 4 Mini Bonus Photo Word Cards
While Stocks Last**

他是誰 不重要
但你不能不看他的每一首文字歌曲
不感受他的每段真摯情感
不容錯過這個處子籌備了20年
首度登場
中英日韓四言對照的
23首流行文藝作品

Who is he
Unimportant
But you can't refuse to look at his every word songs
Don't feel every sincere emotion of him
Should not be missed
The preparation for 20 years by this Virgin
His first presentation
In 4 languages all-in-one: Chinese, English, Japanese and Korean
23 popular literary word songs

VIRGIN GAWAN

基宏首本文曲書本專輯

GAWAN 1ST WORD SONG BOOK ALBUM

訂購請參閱基宏官方網站
To order, please refer to the official website of GAWAN
www.icongawan.com

精裝書版本
HARDCOVER BOOK VERSION

電子書版本
E-BOOK VERSION

中英對照
In English & Chinese languages

精裝書版本、電子書版本 (PUBU / AMAZON KINDLE) 同步上市
HARDCOVER VERSION & E-BOOK VERSION (PUBU / AMAZON KINDLE) ARE ON SALES

由香港開始
拋開律師的公式身份
展開作家的創意旅程
不是新詩 不是短文
而是無型定體的文字歌曲
處子基宏
第一本中英對照大作
告訴你在流行文化中文曲是什麼

Starting from Hong Kong
Let go of being a mechanic lawyer
Embark on a writer′s creative journey
Not a modern poem Not an essay
It′s an amorphous word song
VIRGIN GAWAN
His First Chinese English Bilingual Book Album
Tell you what word songs are in popoluar culture

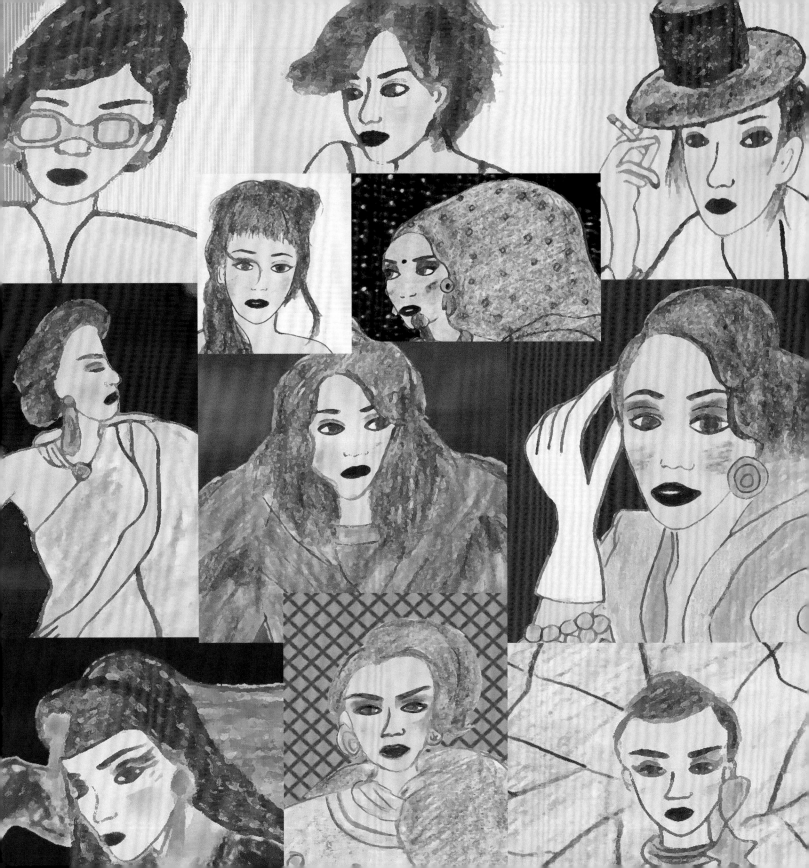

書名 Book Album Title：百變梅艷芳 Anita Mui The Legend Of The Pop Queen ~ Part I
作者 Author：基宏 Gawan

官方網頁 Official Website: www.icongawan.com
Facebook/Instalgram/Twitter: icongawan
小紅書：基宏
Linkedin: Gawan Lo
Youtube 頻道 Channel: Icon Gawan
電郵 E-mail: icongawan@gmail.com

出版 Publisher：超媒體出版有限公司 Systech Technology & Publications Limited
地址 Address：荃灣柴灣角街 34-36 號萬達來工業中心 21 樓 02 室
 Flat 2, 21/F., Million Fortune Industrial Centre,
 34-36 Chai Wan Kok St, Tsuen Wan, Hong Kong
電話 Tel：(+852) 3596 4296
傳真 Fax：(+852) 3003 3037
網頁 Website：www.easy-publish.org
電郵 E-mail: info@easy-publish.org
香港總經銷 Hong Kong Distributor：聯合新零售（香港）有限公司
 SUP Retail (Hong Kong) Limited

出版日期 Published Date: 2024 年 7 月 / July 2024
價目 Price：港幣 HKD$299

圖書分類 Book Category：繪本及音樂傳奇 / Painting & Music Legend
國際書號 ISBN：978-988-8839-76-6

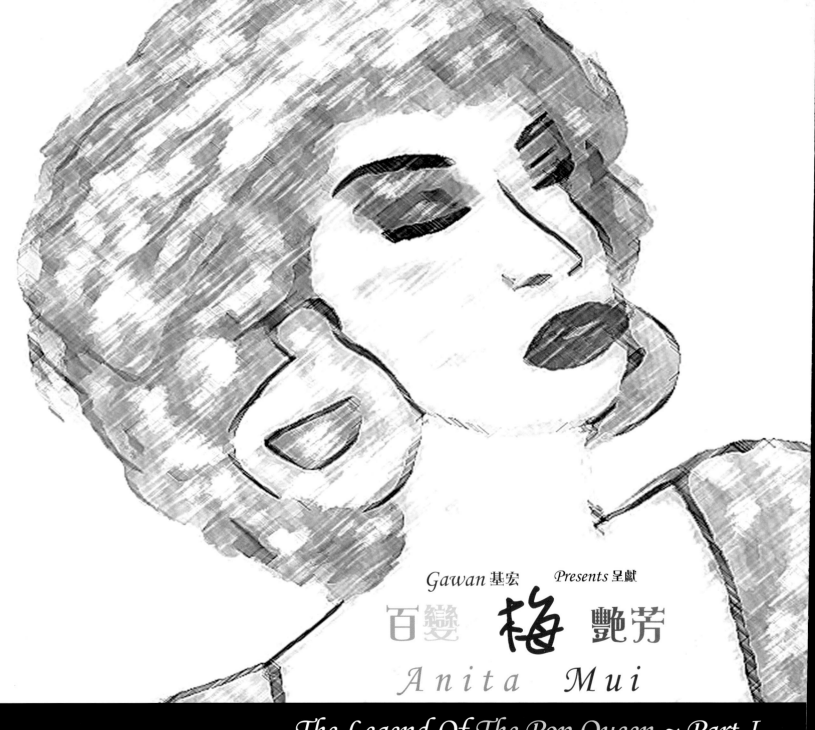